# BERLIN
# THEN & NOW

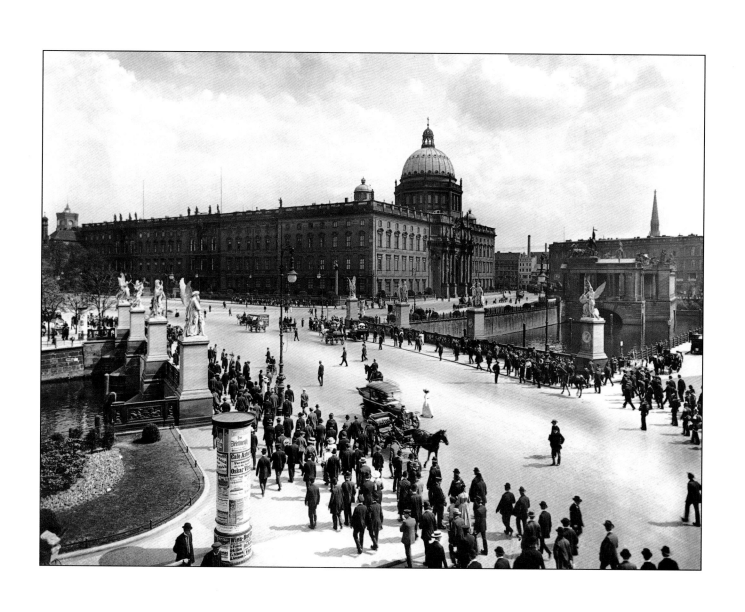

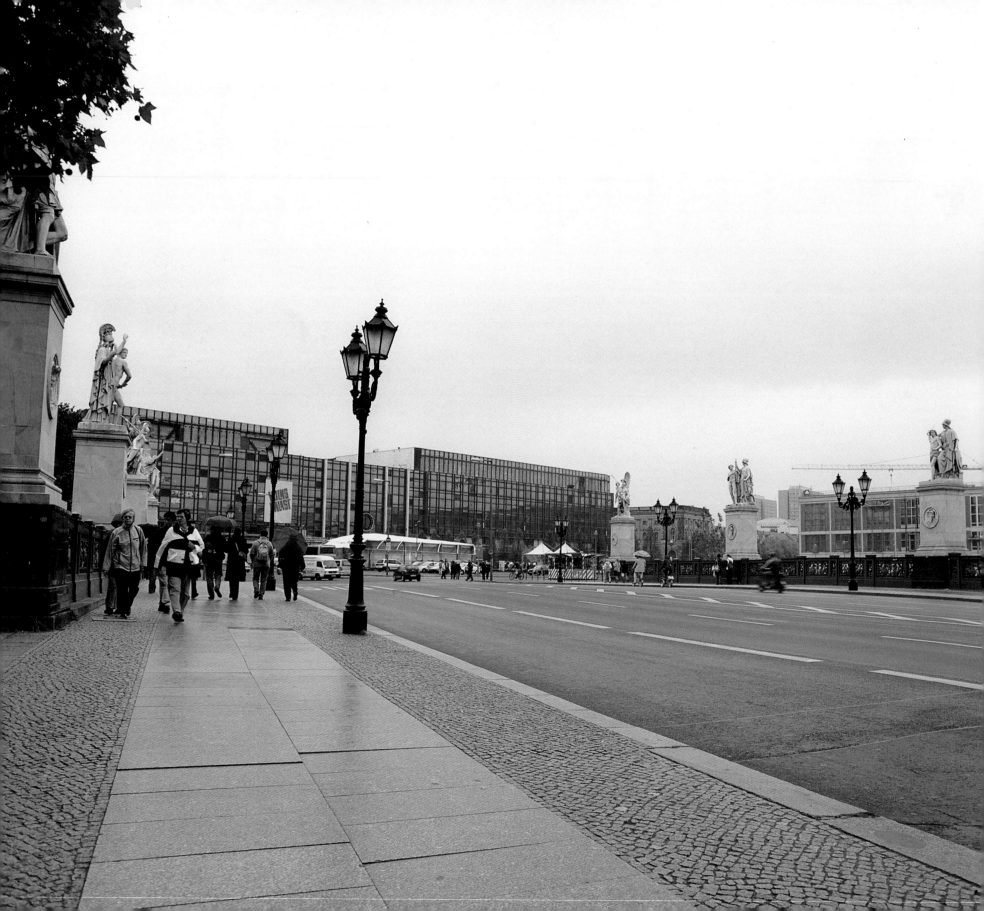

# BERLIN
# THEN & NOW

NICK GAY

THUNDER BAY
P·R·E·S·S

San Diego, California

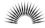

**Thunder Bay Press**
An imprint of the Advantage Publishers Group
5880 Oberlin Drive, San Diego, CA 92121-4794
www.thunderbaybooks.com

Produced by PRC Publishing,
The Chrysalis Building
Bramley Road, London W10 6SP, England

An imprint of **Chrysalis** Books Group plc

Library of Congress Cataloging-in-Publication Data

Gay, Nick
    Berlin then and now / Nick Gay.
        p. cm.
    ISBN 1-59223-408-9
    1. Berlin (Germany)--Pictorial works. 2. Berlin (Germany)--Buildings, structures,
etc.--Pictorial works. 3. Berlin (Germany)--History--Pictorial works. I. Title.

DD862.G39 2005
943´.155087--dc22

                                                    2004065924

Printed and bound in China

1 2 3 4 5 09 08 07 06 05

*Acknowledgments:*

The author would like to thank Sabine Bentlage of www.berlinwalks.de for her help in
researching this book.

*Picture Credits:*

The publisher wishes to thank the following for kindly supplying the photographs that
appear in this book:

Then photographs:
© Bildarchiv Preussischer Kulturbesitz (bpk), Berlin: 16, 78, 110L, 112, 120
© Landesarchiv, Berlin: 8, 10, 12, 14, 18, 20, 22 (inset), 24, 26, 28, 32, 36, 40, 42, 50, 54,
62, 64, 66, 74, 86, 96, 100, 104, 106, 108, 110R, 118 (inset), 122, 124, 126, 128, 142,
© Landesarchiv, Berlin/Lenhartz, Klaus: 34L, 36 (inset), 82, 90, © Landesarchiv,
Berlin/Otto Hagemann: 22, 38, 56, 76, 102, 116, 118, 132, © Landesarchiv,
Berlin/Waldermar Titzenthaler: 1, 34R, 44, 46, 48, 52, 58, 60, 84, 88, 92, 94, 98, 114, 130,
© Landesarchiv Berlin/Edmund Kasperski: 68, © Landesarchiv, Berlin/Hermann
Ruckwardt: 70, © Landesarchiv, Berlin/E Tosch: 72, © Landesarchiv, Berlin/Gert Schutz:
80, 136, 138, © Landesarchiv, Berlin/Ludwig Ehlers: 116 (inset), © Landesarchiv,
Berlin/Bert Sass: 132 (inset)
Library of Congress, Prints and Photographs Division: [LC-USZ62-109083]: 30, Library of
Congress, Prints and Photographs Division/Leni Reifenstahl [LC-USZ62-78893]: 134,
Library of Congress, Prints and Photographs Division/Badekow Archiv, [LC-USZ62-
112367]: 140
© USHMM, courtesy of Debra Gierach: 6

Now Photographs:
All photographs were taken by David Watts (© Chrysalis Image Library)

# INTRODUCTION

When you consider the recent past, it is perhaps surprising that Berlin exists at all. The firebombing and shelling of World War II left Berlin in rubble-strewn chaos. The city was then carved up by the Allies, and over the next forty years it was surrounded by a Soviet satellite state. This was followed by the stasis of the Cold War. East Berlin, under Communist rule, was starved of investment and many of its remaining prewar buildings quietly disintegrated. West Berlin, sealed in behind the Berlin Wall, was propped up with regular transfusions of money from West Germany.

Today, less than twenty years after the fall of the Berlin Wall, reunited Berlin has metamorphosed into perhaps the most exciting capital city in Europe. Innovative architecture, vibrant nightlife, and world-renowned museums and galleries are here in abundance. But what many visitors first look for when they arrive in the city are traces of its turbulent twentieth-century history. By no means were these all eradicated by carpet-bombing or the dictates of city planners.

Berlin's troubled history goes back to the Middle Ages. Twin fishing villages established on the banks of the Spree river in the twelfth century in the Margrave of Brandenburg soon developed as a trading hub, thanks to the east-west river connection on a route halfway between Prague and the Baltic. Berlin-Cölln, as they were known, grew in prosperity and joined the Hanseatic League. In the fifteenth century, the Hohenzollerns became the new electors of Brandenburg. This family influenced the city for nearly 500 years, until the last Hohenzollern was forced into exile by the defeat of Germany in World War I.

Two of the Hohenzollerns stand out for the good they did the city. Friedrich Wilhelm (Frederick William), the "Great Elector," was born into a rapidly changing world; on the one hand, the fortunes of Brandenburg had been improved by the union with the Duchy of Prussia in the early 1600s; on the other, this world was being torn apart by the Thirty Years' War between the Protestants and the Catholics. He was unusually tolerant by the standards of his age and invited many persecuted minorities to come and settle in the city: Protestant Huguenots forced out of Catholic France, Jews from Vienna, and others. Dutch engineers were also brought in to build a new canal linking the Spree and Oder rivers. This encouraged trade between the Baltic and North Seas to come through the city. By the 1690s, Berlin's citizens enjoyed the newly opened boulevards outside the city walls, including Unter den Linden (Under the Linden Trees), while the Huguenots worshipped in their own church on Gendarmenmarkt.

Friedrich Wilhelm's great-grandson's legacy is perhaps more controversial and had even more far-reaching effects: Friedrich der Grosse (Frederick the Great) doubled the size of Brandenburg-Prussia (known simply as Prussia) during his reign at the expense of the Austro-Hungarian empire and Poland. He enlarged the palace built by his grandmother at Charlottenburg and built a square on Unter den Linden, providing an opera house, Catholic cathedral, and royal library.

Friedrich gave a part of the old royal hunting grounds to the citizens of Berlin for their amusement, creating the famous Tiergarten park. Soon after his death, his big-spending nephew Friedrich Wilhelm burned up the public finances, saved by his uncle over decades, on large quantities of champagne and a few public works, including a new royal entrance to the city: the Brandenburg Gate, which rapidly became the new symbol of the city.

As the industrial revolution got underway, Berlin developed as the largest industrial center in Prussia, and more and more people came to the city in search of work. By the middle of the nineteenth century, the Jewish community here was by far the largest in Germany and enjoyed relative security; in 1866, the New Synagogue opened on Oranienburgerstrasse with the chancellor, Prince Otto von Bismarck, and other court figures in attendance.

Five years later, Bismarck's policy of "blood and iron" brought the German states together for the first time. Wilhelm, king of Prussia, became the first kaiser, or emperor, of Germany. As the new imperial city, Berlin embarked on a building boom that more than tripled the size of the city in the next forty years. At this time almost all of what later became West Berlin was built. The Rotes Rathaus (Red Town Hall) built in the 1860s was supplemented with a second municipal pile at the turn of the century; Parliament was given a new home with the Reichstag, and Frederick the Great's Protestant cathedral was replaced with an enormous edifice, the Berliner Dom, which rivaled St. Peter's in Rome.

After the catastrophe of World War I, Berlin experienced civil war, a putsch attempt, and finally hyperinflation before something like stability returned in 1924. But the "Golden Twenties" lasted all of five years before the cold reality of the Depression set in and the unemployment lines grew once again. Hitler's promises of national greatness ended ultimately with the center of Berlin being 90 percent destroyed and Germany not only being divided but also losing East Prussia, Silesia, and other sizable tracts of land to the Soviets and Poland.

Tension between the wartime allies quickly came to the surface after the defeat of Nazi Germany; within three years, the Soviet Union was blockading West Berlin, and a year later, Germany was being formally divided into two sovereign states. It was not until the passing of the Two-Plus-Four Treaty in 1990, which allowed Germany to reunite, that Berlin and Germany's Cold War predicament was finally resolved.

It has not been an easy task to stitch the city back together again and it has led to a massive rise in the city's debt. But there is no doubt that, since the movement of the government from Bonn to Berlin in 1999, the city has witnessed a huge boost in its status and self-assurance. With the recent enlargement of the European Union to include such neighbors as Poland and the Czech Republic, there is also no doubt that Berlin is well placed to benefit from the trade that this generates, mirroring its roots as a trading post in the Middle Ages.

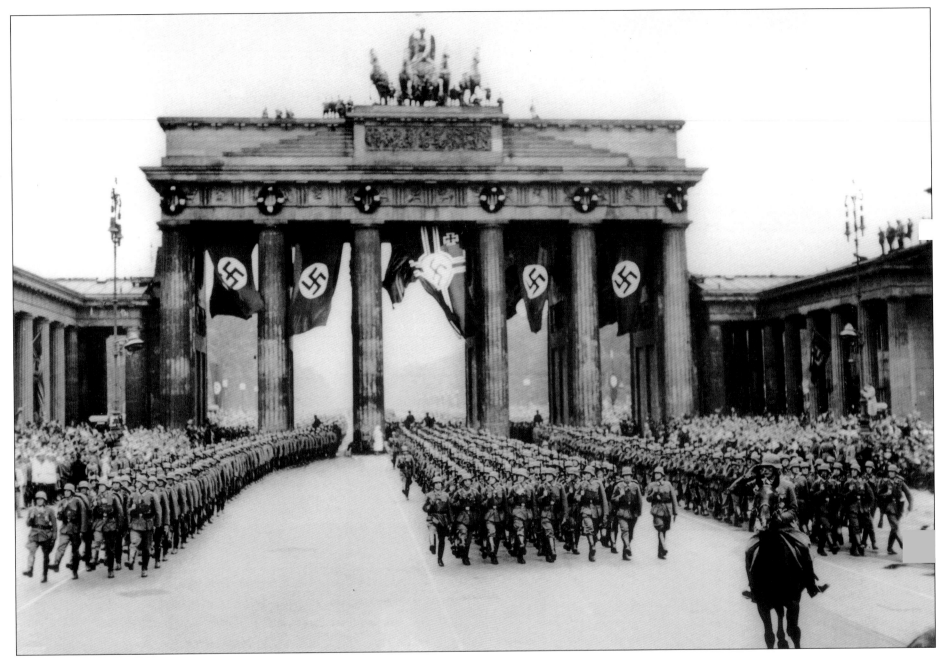

The Brandenburg Gate has been the focal point of many parades. This shot shows the Wehrmacht troops celebrating the fall of France in the summer of 1940. Designed as the royal entrance to the city in the 1780s by Carl Langhans, it was part of the outermost city walls and built to raise taxes from people leaving or entering the city; hence it was a rather elaborate toll gate. Built on the old Brandenburg road, it connected the royal palace in the center of town with the out-of-town summer palace of Charlottenburg. On top of the gate, Gottfried Schadow created the sculpture of Eirene, the goddess of peace in her four-horsed chariot, or quadriga. After the city was occupied by the French in 1806, the entire sculpture was taken back to Paris on Napoleon's orders as war booty. It was duly returned after the defeat of France, and the goddess given a new identity, Victoria, the goddess of Victory.

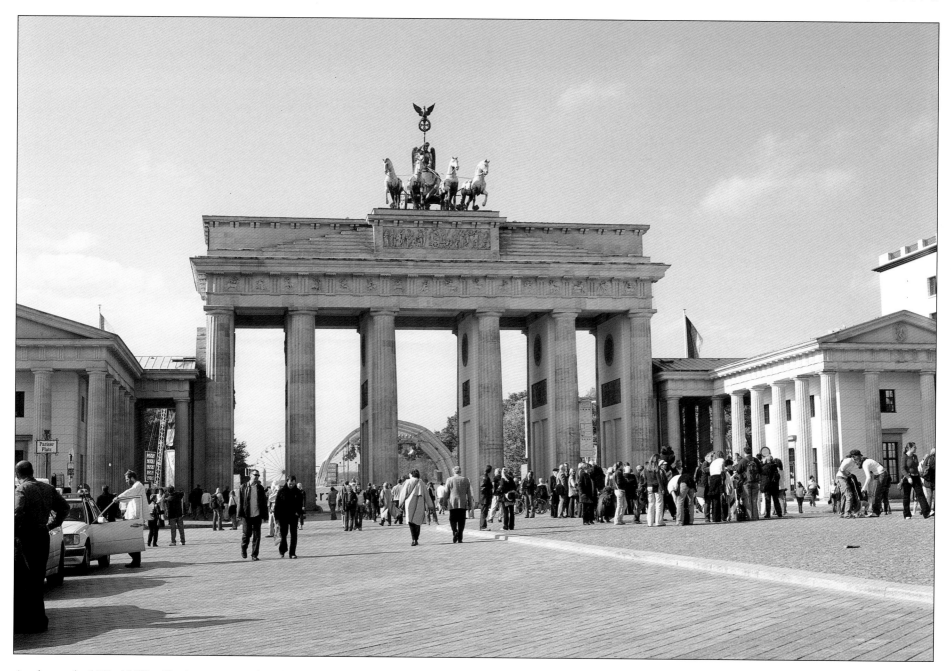

At the end of World War II, the gate was barely standing. It lay just inside the Soviet district of Mitte; the East Germans were therefore responsible for the first postwar restoration of the gate in the 1950s, although the quadriga was restored in West Berlin. By the time the sculpture was rebuilt, relations had broken down so completely between East and West that there was no formal handover; it was simply loaded onto the back of a large truck and left in Pariser Platz for collection by the East Berlin authorities. Soon after reunification in 1990, the quadriga was given another overhaul. Both the iron cross and the eagle on top of the goddess's staff were replaced. They had been taken away by the East German authorities on the grounds that they smacked too much of Prussian militarism. The gate was extensively restored and was reopened on October 3, 2002, the twelfth anniversary of reunification.

This photo was taken during the official reception of Queen Wilhelmina of the Netherlands during her state visit to Berlin in May 1901; the carriages and royal cavalry have just passed through the Brandenburg Gate, part of which is on the far left. Less than twenty years after this reception, it was Wilhelmina who played host to the last kaiser in Holland, allowing him refuge after he was forced to abdicate in November 1918. She herself had to flee in 1940 with the Nazi invasion of Holland but returned to help rebuild her country after the war. Immediately to the right of the Brandenburg Gate stands the three-story villa in which the painter Max Liebermann lived. He came from a long-established Jewish Berlin family and famously remarked on the night that Hitler came to power, while watching the torchlit parade, "It is a pity one can't eat as much as one would like to vomit!"

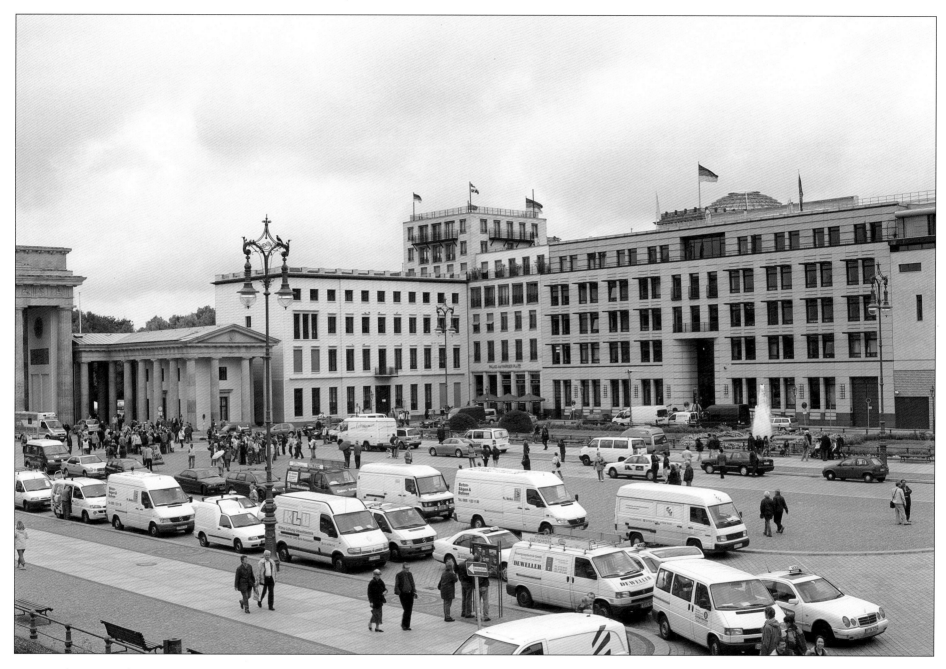

Pariser Platz, named after the defeat of France in 1815, has now firmly reasserted itself as the premier square in central Berlin. With the division of the city, the square lay in a barren strip on the edge of the Soviet sector, with almost all the buildings heavily damaged or destroyed. After the wall was built, the square was in a no-go area called the "Death Strip" (seen on page 14). Since the fall of the wall, the square has been transformed—not only in the physical sense with contributions from world-renowned architects, but it can now also be considered the new central point in the city. To the right of the gate, the new rebuilt Haus Liebermann can be seen, now four stories high. The green-roofed office building was designed by GMP for Dresdner Bank; in the distance behind it, the top of the new dome on the roof of the Reichstag is just visible.

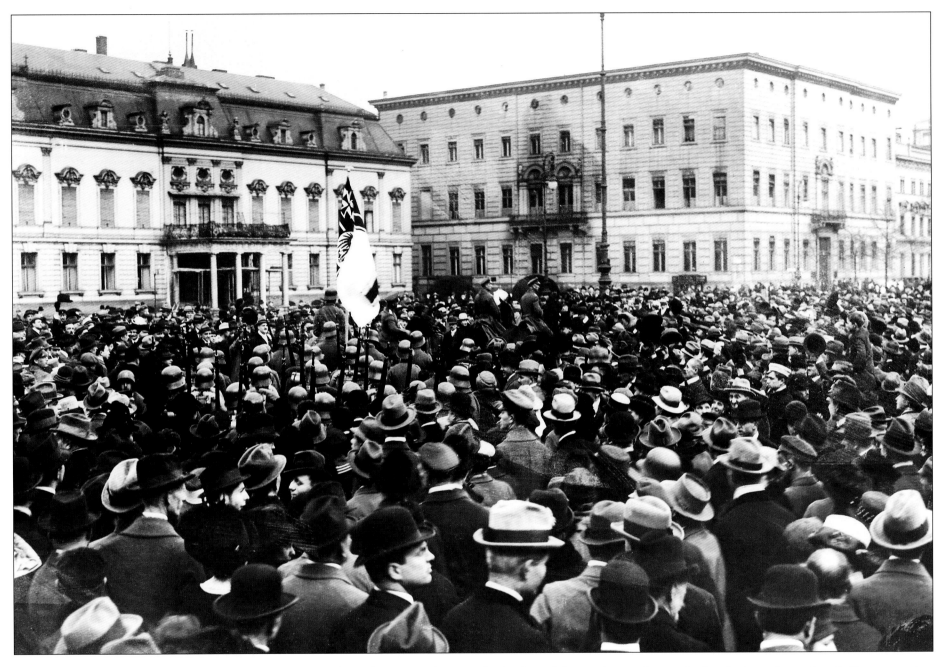

In this photo, a large crowd watches soldiers processing through Pariser Platz during the Kapp putsch in 1920. This putsch was an attempt by disaffected right-wing Freikorps soldiers to overthrow the republic, but it failed spectacularly. The putschists lacked leadership and could not cope with the paralyzing General Strike, giving up within four days. Sadly for the republic, little was learned from this incident, which should have shown them that the leadership of the professional army had to be brought under civilian control. Indeed, regular and Freikorps troops continued to be used by the republic in the suppression of left-wing insurgencies in other parts of Germany only weeks after the failure of the putsch. In the background on the left of this picture stands the French Embassy, which was acquired by the French government in 1860 during the reign of Napoléon III.

In the center-left of this photo, the new French Embassy presents its unusual facade to Pariser Platz. Designed by the avant-garde French architect, Christian de Portzamparc, it was completed in 2002 and officially opened by President Chirac in January 2003. The most dominant features of the facade are the slanting window openings, which orient the building toward the Brandenburg Gate. After the signing of the reunification treaty in 1990, the German government offered the site back to the French. However, because the government was planning new buildings for the Bundestag between the square and the river, the French agreed to trade the back of their site in return for a site on Wilhelmstrasse. This means that the new embassy site is L-shaped but the back entrance is more prominent.

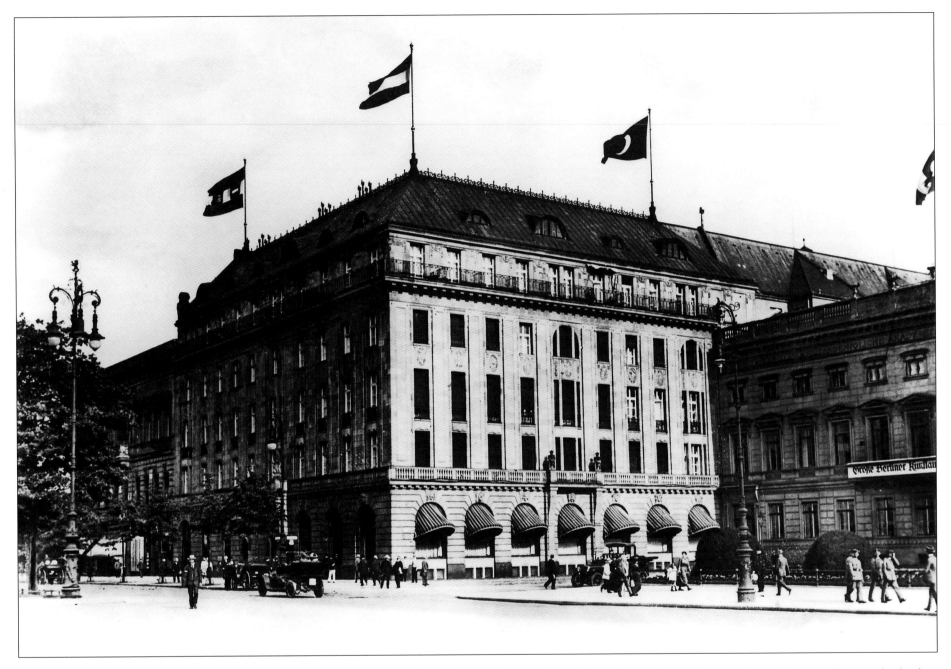

Where Unter den Linden meets Pariser Platz, the wine merchant and hotelier Lorenz Adlon opened his new luxury hotel in 1907, seen in the center of this 1914 photo. His most important sponsor was the kaiser, who assisted him in the acquisition of the site and the removal of the existing building, a palace supposedly protected as a monument. Between the wars, this was Berlin's grandest hotel; guests included Einstein, Charlie Chaplin, and John D.

Rockefeller. On the right can be seen the Royal Academy of Arts, which also moved into this former palace in 1907. In 1937, they were ejected by Albert Speer, who set up his office there as the chief inspector of buildings. Hitler could visit him from the chancellery gardens and admire the models of the grandiose buildings he planned for Berlin.

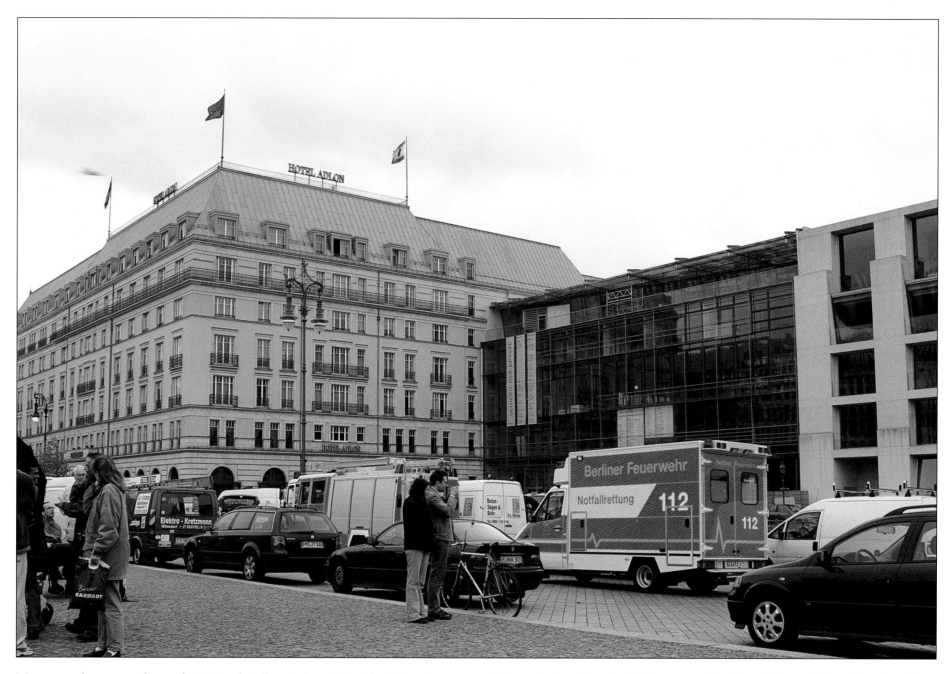

Many people assume that today's Hotel Adlon is the original building, but a comparison of the number of stories is one indicator that this is a completely new structure. Remarkably, the old hotel survived the bombing and the shelling of the war, but on the day the fighting ended in May 1945, a serious fire destroyed most of it. The East German regime carried out a limited rebuilding in the 1960s, but it was demolished in the 1970s. The all-new

Adlon, designed by the Berlin partnership Patzschke and Klotz, has played host to guests such as President George W. Bush and Queen Elizabeth II. Behind the ambulance stands the new glass facade of the rebuilt Academy of Arts, incorporating surviving parts of the prewar building. On the far right is the low-key facade of Frank Gehry's DZ bank building.

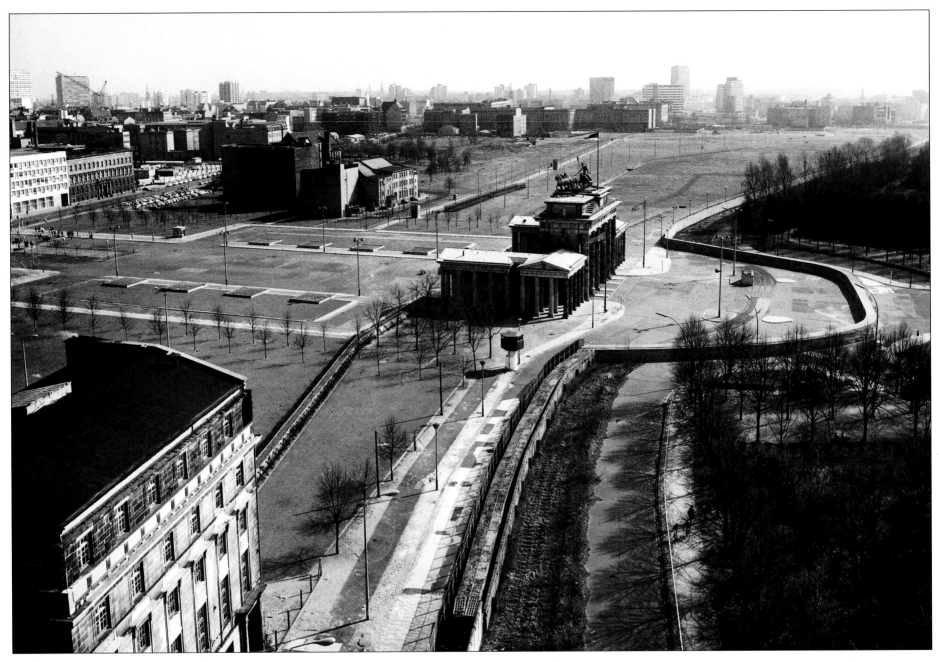

This photo, taken in the 1960s from the roof of the Reichstag, shows the isolated Brandenburg Gate (viewed from the side) in what was known as the Death Strip. The Berlin Wall can clearly be seen bowing out in front of the Gate and then continuing in the direction of Potsdamer Platz. It was no accident that the Wall, built in 1961, happened to follow the line of the old eighteenth-century city wall. After it had been decided to parcel out Berlin among the victorious Allies, it made sense to use existing district boundaries in the city; the boundaries of the old central city district of Mitte followed the lines of the eighteenth-century city walls, and Mitte became a Soviet district. It therefore follows that the line of the Communist wall, where Mitte shared its boundary with Western districts such as Tiergarten or Kreuzberg, should also be where the eighteenth-century walls once stood.

Today, a line of bricks in the tarmac, just visible on the extreme left, marks where the Wall used to run. Behind the trees on the right, white crosses were erected as a memorial to some of the approximately 250 victims of the "shoot to kill" policy pursued by the East German government in the policing of the Berlin Wall. This memorial was first erected on the river side of the Reichstag, but before rebuilding started in the 1990s, it was decided to move the memorial to this corner of the Tiergarten park. The street name is a reminder of the fact that the republic was first proclaimed by the Social Democrat Philipp Scheidemann from a window of the Reichstag on the day the kaiser abdicated in November 1918. However, the actual window was on the west front of the building (as seen on page 143), not on the Scheidemannstrasse side.

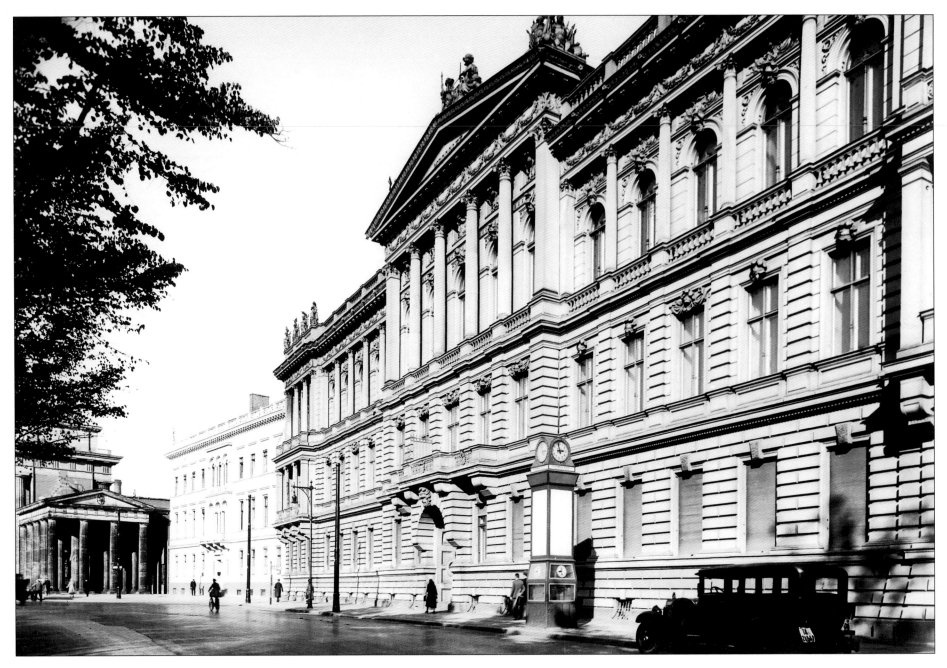

This grandiose structure on Ebertstrasse was built for the Blucher family in the 1870s. In 1931, it was acquired by the American government as a new embassy, but shortly after contracts were signed, a major fire gutted most of the building. The uncertainty created by the Nazi seizure of power in 1933 and apparent financing problems delayed the necessary repairs to the fire-damaged building until the late 1930s. By 1945, the building had been once again gutted by fire, although most of the Ebertstrasse facade pictured here was still standing. Between the Blucher Palace and the Brandenburg Gate (to the left of the palace) can be seen the three-story Haus Sommer, similar in appearance to Haus Liebermann on the other side of the gate. First built in the 1730s, it was purchased by a major German bank for use as their Berlin headquarters in 1936, the year this photo was taken.

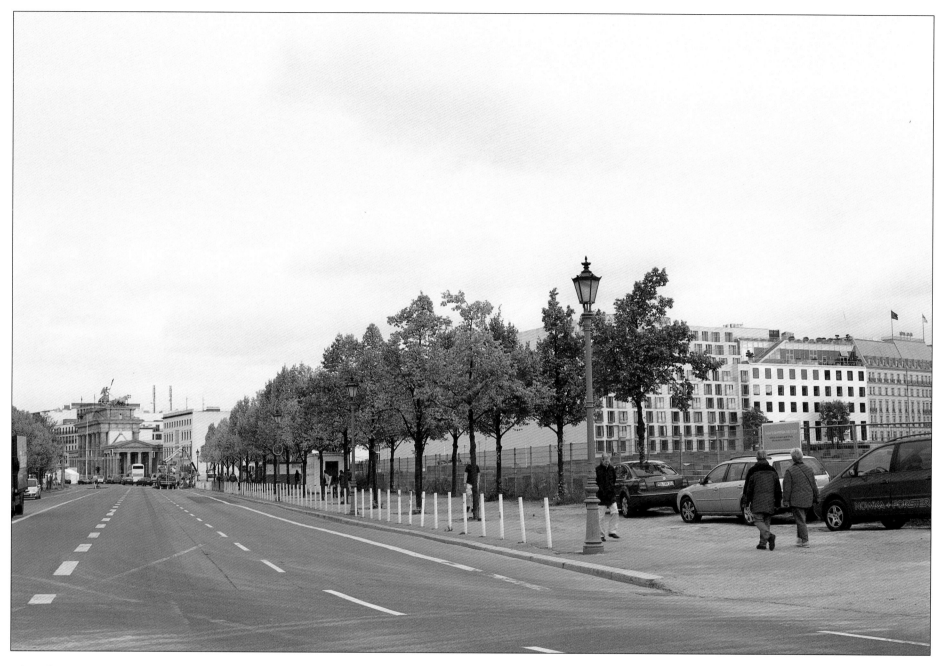

This photo was taken a little further down the Ebertstrasse, showing the beginnings of the Memorial to the Murdered Jews of Europe—a low, curved mass of gray-blue stones, which can be seen behind the wire fence on the right. On schedule for completion in May 2005, it will comprise 2,700 stelae, or concrete slabs, of varying heights, in a grid, undulating over an enormous four-acre field. In the southeast corner (to the right of the photo), an underground documentation center will complement the memorial. Between the memorial and the rebuilt Haus Sommer, an empty site waits for the new American Embassy; never an easy site to build on from a security point of view, progress was also delayed by strained relations between Washington and Berlin. The new embassy, designed by Moore Ruble Yudell, is planned for completion in 2008.

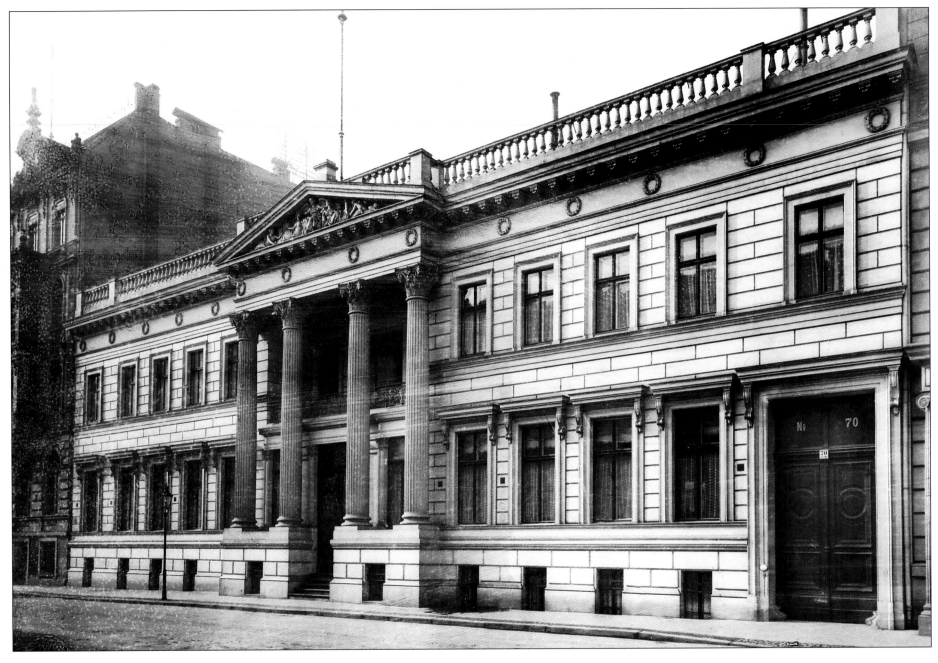

This palace (photographed in 1900) was first built as the private residence of the entrepreneur Bethel Henry Strousberg, the "Railway King," in 1871. Soon after, Strousberg went spectacularly bankrupt and the British government leased the newly completed building to serve as its embassy. Its location on the Wilhelmstrasse was very advantageous; after 1882, the Foreign Ministry was only a few doors away in the same street and the French and Russian embassies were also in the vicinity. In the early 1900s, the kaiser sent a direct request to the British ambassador to sell part of the large garden to Lorenz Adlon, who was in the process of putting the site together for his hotel. The ambassador felt he had no choice but to agree. The British always regretted this decision; in 1939, attempts were made to find a larger site, but the outbreak of war soon ended this.

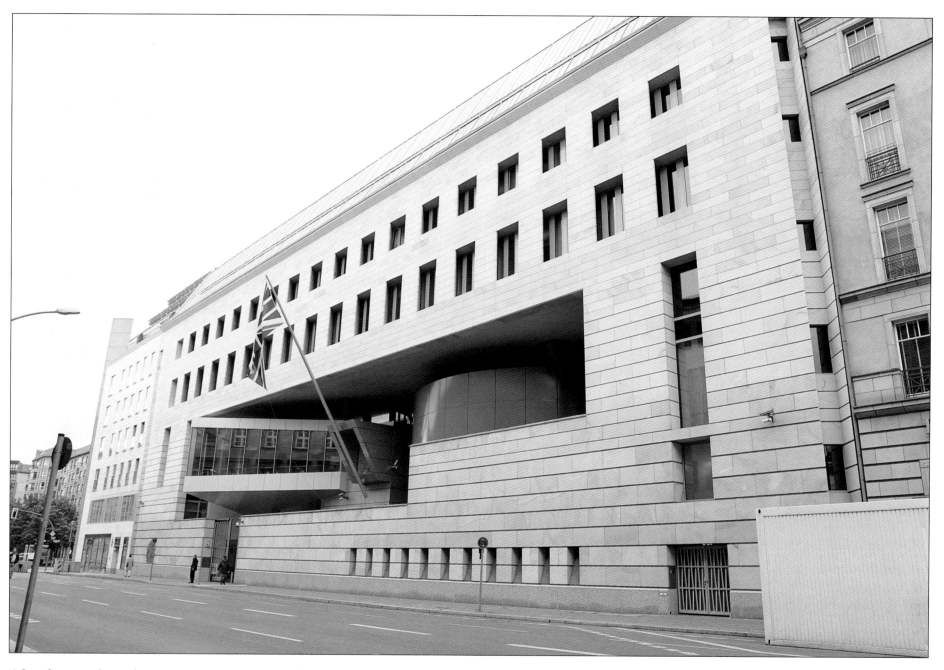

After the war, the embassy was in a very poor condition, and in the 1960s the East German government pulled it down. With the collapse of the wall and the return of the site to the British government after 1990, an all-new building was constructed by Michael Wilford on the same site. Queen Elizabeth II opened the new embassy in 2000, although it was not fully operational until 2001. Wilford's design uses a broken facade to emphasize the openness of the embassy to the outside world; projecting through the facade is the blue information center. Inside, the old wrought-iron gates from the original building have been turned into a feature, alongside works of contemporary British sculptors. The absence of traffic is thanks to the addition of a line of steel posts, placed at either end of this block for security reasons, which keep the street free of vehicles.

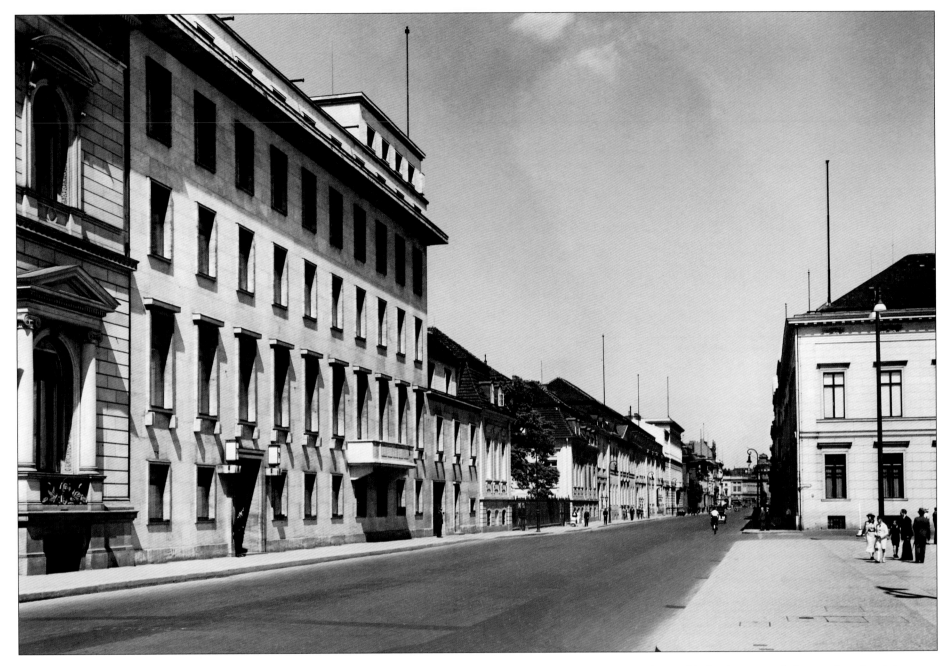

This late 1930s view was taken from a square called Wilhelmplatz, looking northward up the Wilhelmstrasse. On the left are the Reichschancellery buildings, first turned into the residence and home of the chancellor in the 1860s and extended with the white stone building in the 1920s. After 1933, the Wilhelmplatz became the nerve center of the Third Reich; as well as the chancellery buildings, the newly formed Ministry of Propaganda and Public Enlightenment, run by Joseph Goebbels, dominated the north side of the square. The old government press office, housed in an eighteenth-century palace (visible on the right side of the photo) was taken over for this ministry. The Foreign Office and Presidential Palace were also located further north up the Wilhelmstrasse. In 1939, the Presidential Palace was taken over by Joachim von Ribbentrop, Hitler's foreign minister.

These blocks are typical Communist-built apartment buildings, constructed using prefabricated panels (*Plattenbau*) in the late 1980s. For decades after the war, the Wilhelmstrasse was an empty wilderness for East Berliners. Even the name changed—it was replaced with Otto-Grotowohl-Strasse, named after a senior Social Democrat who sided with the Communists in the forced marriage of the SPD and the Communist party in the late 1940s. There were also good logistical reasons for not rebuilding the street, given its proximity to the border. Another reason for not building here was the long shadow of Nazism; the site of Hitler's bunker lies just behind the buildings on the left of the photo, and even in the Communist East, it was feared that drawing any attention to this could encourage neo-Nazism. After reunification, the street name was changed back to Wilhelmstrasse.

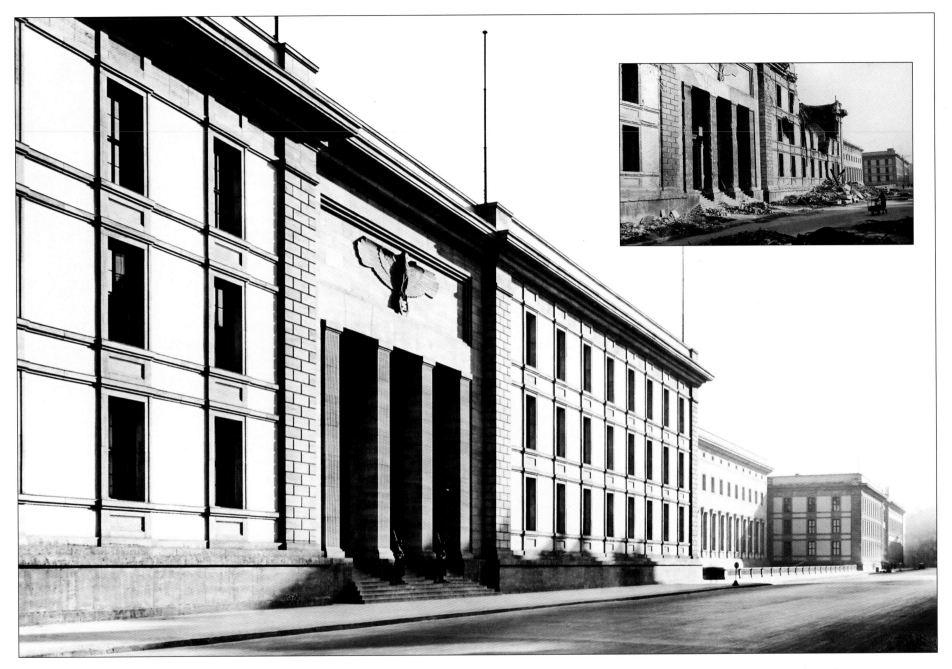

In 1938, work started on a new extension to the Reichschancellery buildings westward along the Voss Strasse, stretching all the way to Ebertstrasse (then called Hermann Goering Strasse). Designed by Albert Speer, the frame was completed in four months and the interiors in seven months; the whole building was finished in January 1939. This photo shows the Voss Strasse facade from the west end; SS sentries can be seen guarding the entrance in the foreground, which is in fact the back entrance. The same view is shown inset, taken in the summer of 1945—remarkably, the central part of the building containing Hitler's office was still standing at the end of the war.

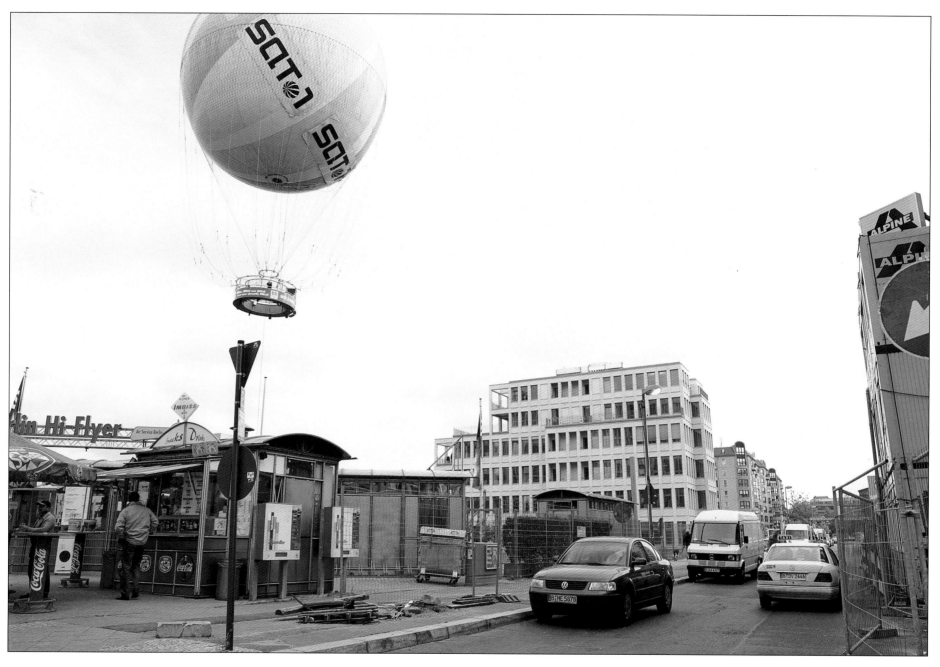

No signs of the Reichschancellery can be seen on Voss Strasse today; the Soviets made short work of Hitler's building in the late 1940s—after they removed the large quantities of marble from inside the building, which they used for a Soviet war memorial (see page 100), they demolished it. Today, the western end of the Voss Strasse remains an empty site. Visitors to Berlin can take rides in the Sat 1 balloon to see the enormous amounts of construction taking place in the former Death Strip. Close to the base of the balloon is the site of Hitler's drivers' shelter, the Fahrerbunker, which still exists belowground, its future a controversial subject. At the far end of Voss Strasse can be seen both the Communist-built apartment blocks on the Wilhelmstrasse and the Czech Embassy, filling in the former Wilhelmplatz.

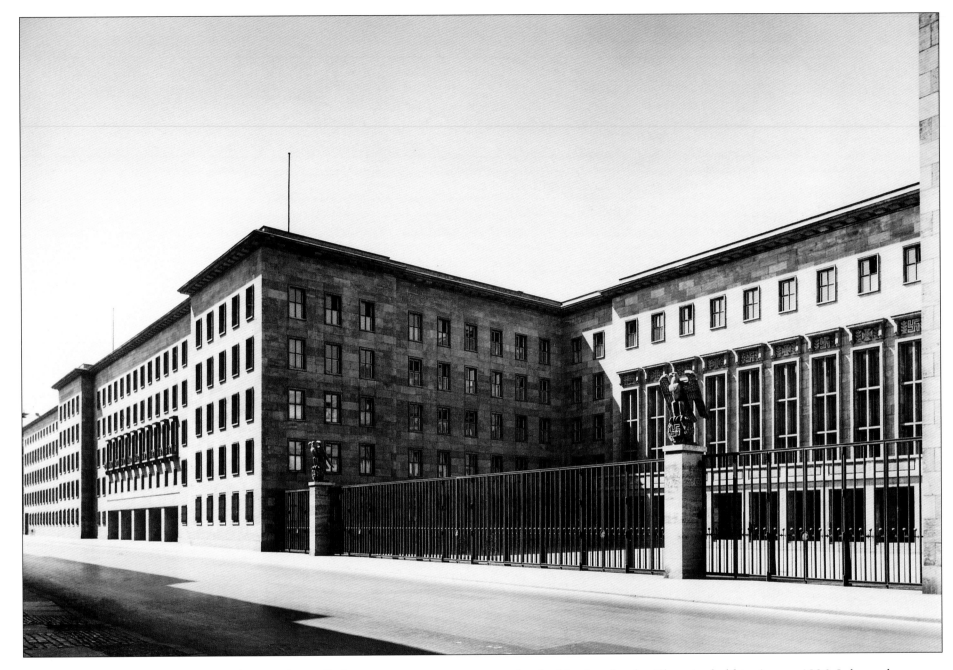

Pictured here is the Air Ministry building on the Wilhelmstrasse. Commissioned by Herman Goering and built by Ernst Sagebiel, a former partner of the famous modernist architect Erich Mendelsohn, its stark lines are authoritarian but not as pompous as some of the designs for later Nazi buildings, which were never built. It was constructed extremely quickly and was finished in time for the Olympics held in August 1936. It housed not only the Luftwaffe headquarters but also civilian air administration, another department in Goering's extensive portfolio. After 1939, the bombing campaigns against cities such as Warsaw, Rotterdam, and London were planned in this building.

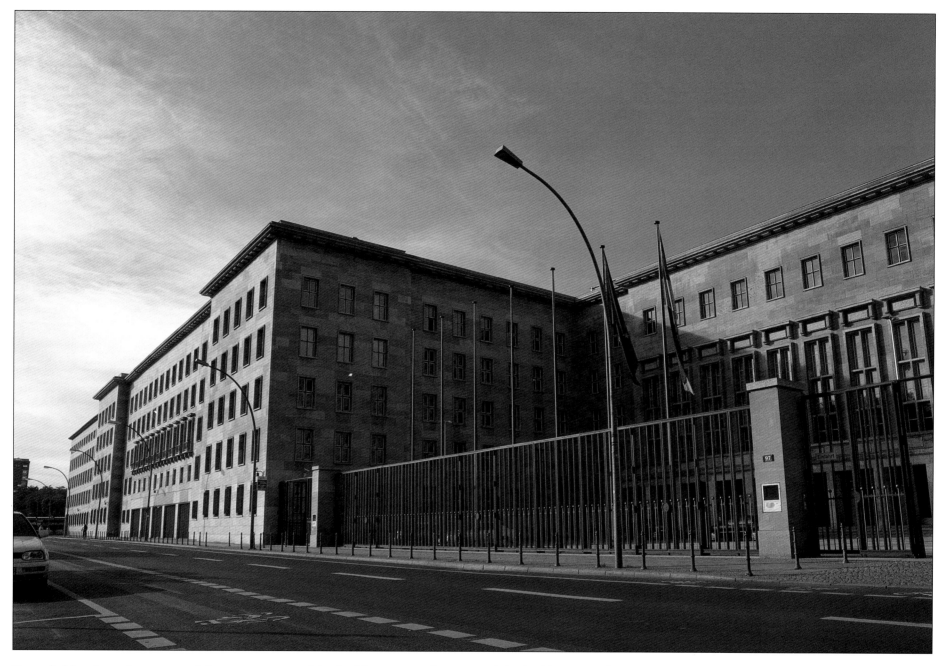

Remarkably, given the nature of this target, most of the building survived the war intact. Gone are the eagles and swastikas from the columns in the forecourt, but the ironwork in the front is original and some of the facing stone has survived. The first Communist East German government was inaugurated here in October 1949. Later the government moved to a more central building, and various ministries used it prior to 1990. In 1965, the roof of the building served as the jumping-off point for a spectacular escape by a family of three, using a cable and harnesses to slide to freedom. Today the building has been totally refurbished for the Federal Ministry of Finance. This refurbishment was more extensive and expensive than planned and there was a considerable cost overrun on the whole project.

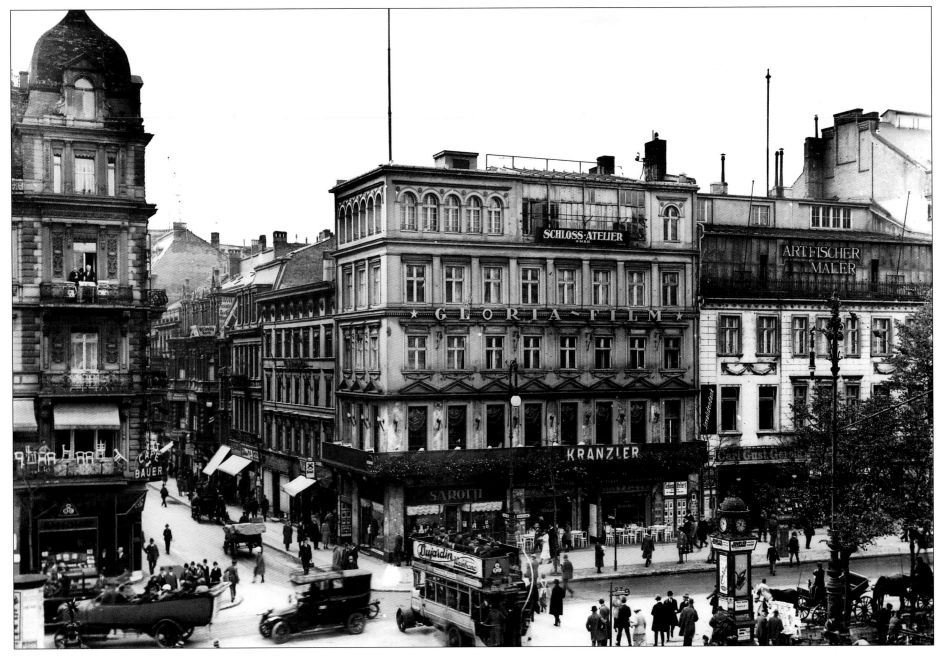

In the center of this picture stands the famous café Kranzler, on the corner of Unter den Linden and Friedrichstrasse (named after Frederick I in the early 1700s). The Viennese master baker Johann Georg Kranzler opened this shop, designed by Stuler, in 1834. Although Kranzler became the fashionable place to be seen, he ruffled feathers at first by opening the first public smoking room and by putting seats out on the street, both in contravention of existing regulations. Unter den Linden can be seen on the right side of the photo. This magnificent boulevard was first laid out in 1648 as a tree-lined avenue outside the city walls. The rapid expansion of the city led to the Dorotheenstadt being created to the north and the Friedrichstadt to the south. As the royal road out of the city, the kings and, later, kaisers limited the encroachment of public rights of way, preventing streetcars from using the street.

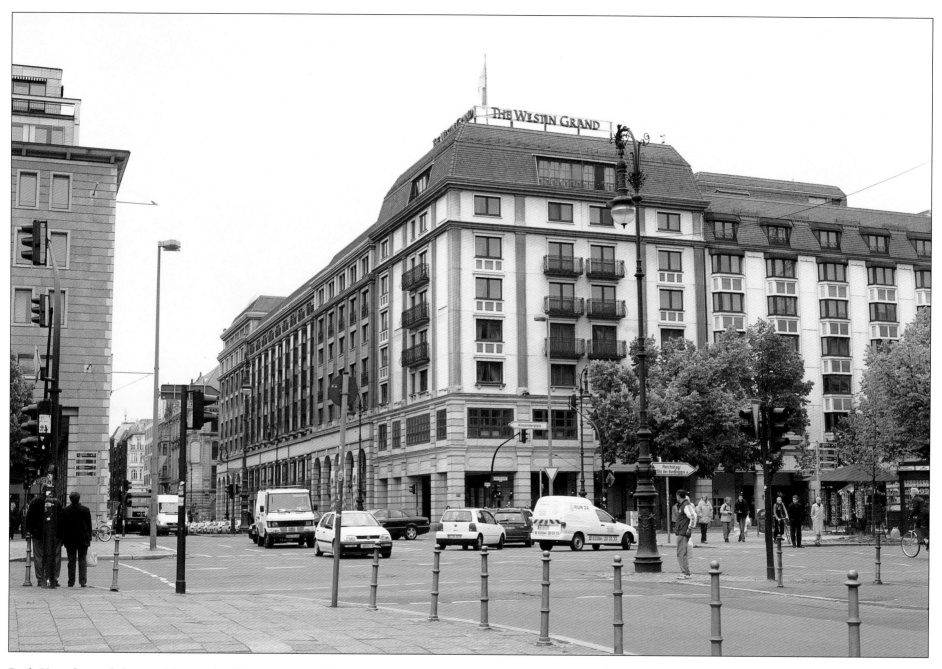

Both Kranzler and the neighboring building on Unter den Linden were destroyed in the same air raid in 1944. The Westin Grand hotel was built on the site in the 1980s by a Japanese company contracted by the East German government. Visible on the left of the photo is the 1990s-built Linden Corso, bought by the Volkswagen company and used on the ground floor as a showroom for VW, Bentley, and other marques owned by the organization.

Heading further along Friedrichstrasse, the entire stretch of the street, all the way to Leipzigerstrasse, has been transformed since 1990, becoming the new upmarket shopping street to rival the Ku'damm on the west side of town. The most famous of the new arrivals is the French department store Galeries Lafayette, which was designed by Jean Nouvel and contains an extraordinary atrium in the shape of a funnel.

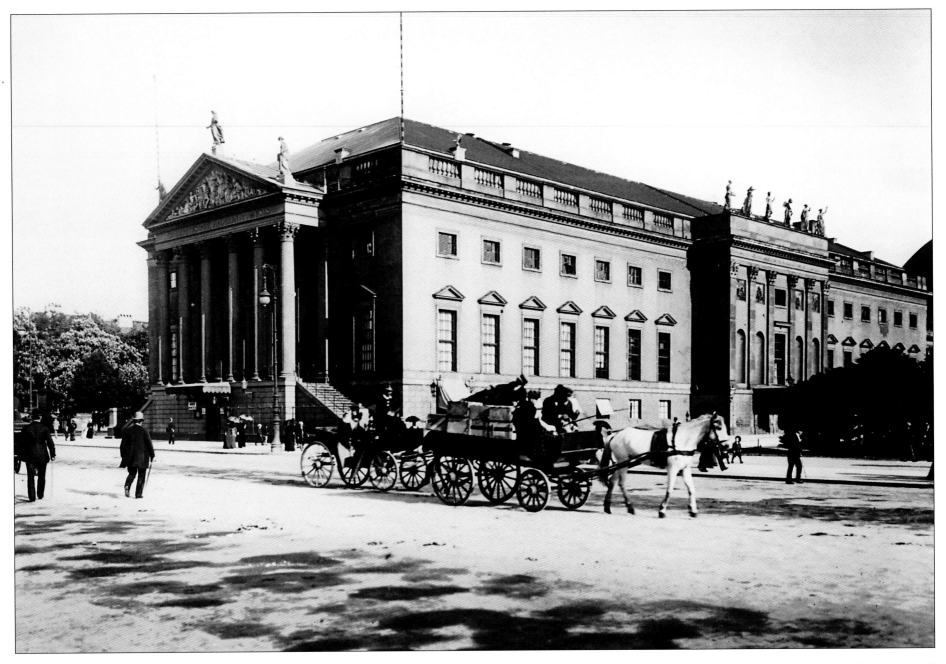

Originally built in 1743 as the Royal Opera House, this was the first new building commissioned by Frederick the Great. During the reign of Frederick, the audience was limited to the nobility, but in the late 1780s, ticket sales were opened to the general public. Exactly one hundred years after it was finished, the entire structure was destroyed by a fire; although the outside was rebuilt in keeping with the original, the interiors were modernized in late-classical style and an extra level was added to the seating area. This picture of the reconstructed building was taken in 1895. From the time of its opening, it has attracted considerable musical talent to direct its productions, including Giacomo Meyerbeer, Felix Mendelsohn-Bartholdy, and Richard Strauss. After 1933, all Jewish members of the orchestra were dismissed, and many, including Otto Klemperer, went into exile.

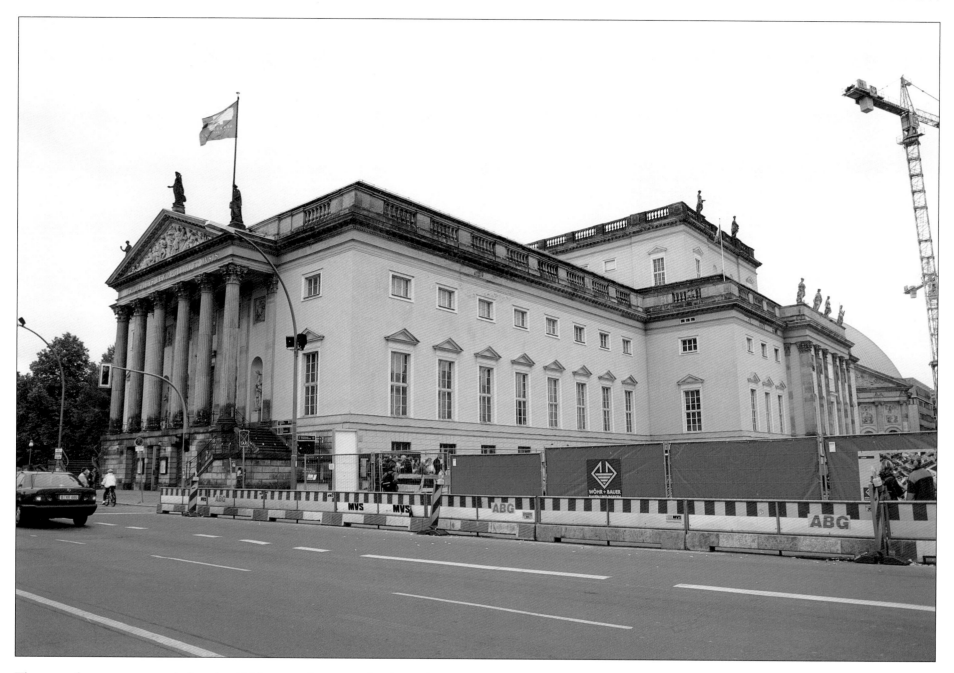

The opera house was extended in the 1920s to modernize and enlarge the production areas. However, the building we see today, now called the Staatsoper Unter den Linden (State Opera), is in fact almost entirely new. In World War II, the building suffered the strange fate of being bombed twice. Rebuilt in the 1950s, it has also been reinvigorated since reunification with new musical talent; Daniel Barenboim became musical director in 1992 and was awarded the title of lifetime chief conductor in 2000. To the right of the opera house, the green domed roof of St. Hedwig's Cathedral can be seen. Built for the Catholic community according to designs by Knobelsdorff, it was also damaged in World War II and was rebuilt from 1952 to 1963 to designs by Hans Schwippert.

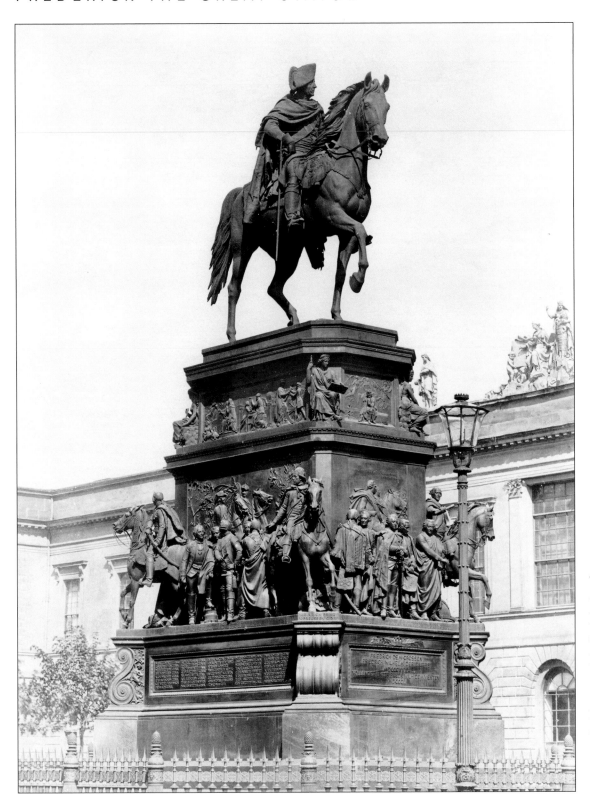

The equestrian statue of Frederick the Great was first unveiled in 1851. It had taken its creator, Christian Daniel Rauch, over ten years to complete. Frederick is shown striding down Unter den Linden in a deliberately relaxed pose. On the throne for forty-six years, he turned Prussia into a European power for the first time. He preferred to live in Potsdam, but he left his mark on Berlin, in particular with the new buildings on Unter den Linden, close to where this statue now stands. In the background, the two-story building housed the Academy of Sciences and the Arts; this was pulled down at the end of the nineteenth century to make way for the new State Library of Berlin.

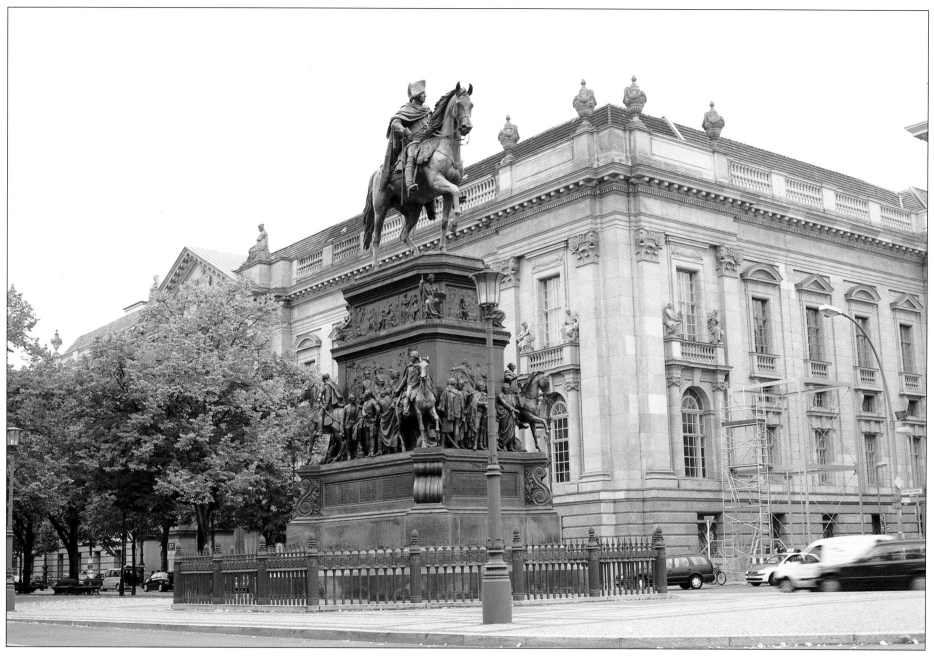

Today the statue is in excellent condition thanks to a recent overhaul. Despite being moved twice in the twentieth century, it is now back in its original 1851 position, surrounded by a copy of the original railings. It was damaged in the civil war that followed the collapse of the kaiser's regime in November 1918 and was repaired in the 1920s. It then survived World War II, thanks to a protective sand-filled "house" constructed solely to deflect the bombs. In 1950, the East German regime decided that Frederick was not worthy enough to be represented in such a prominent part of Berlin and the statue was moved to the gardens of Sans Souci in Potsdam. Following a reassessment of Frederick's greatness, the statue was allowed to return in 1980, but for traffic reasons, it ended up a few feet farther east. Following the latest restoration, it is now finally back in its original position.

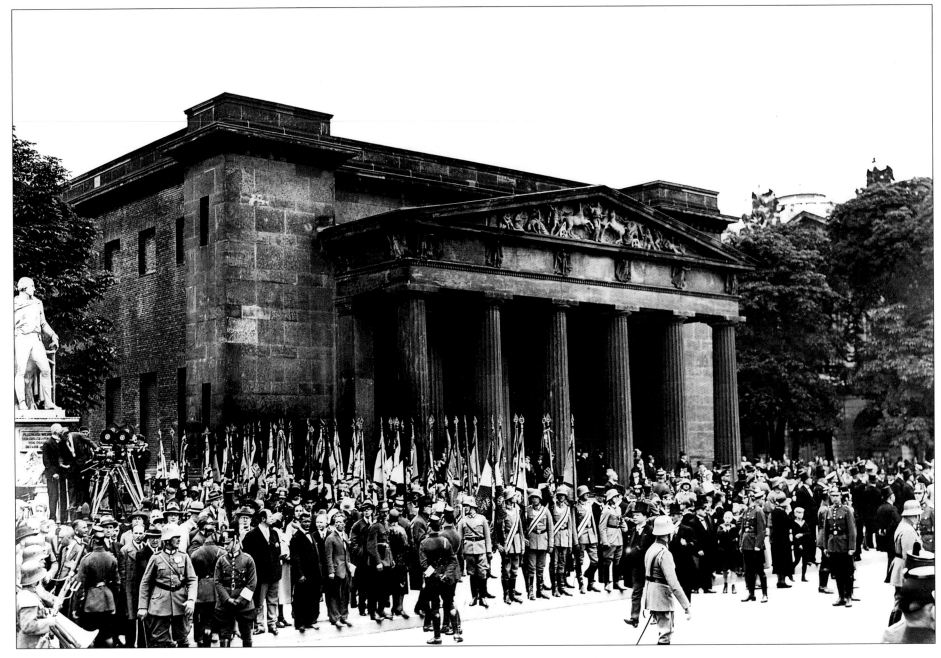

The soldiers, police, and spectators shown here in front of the Neue Wache (New Guard House) are waiting for the arrival of President Hindenburg on June 2, 1931, the day the Neue Wache was first inaugurated as the War Memorial to the fallen in the Great War. The Neue Wache was built immediately after the defeat of Napoléon, providing a monument to the war of liberation and a ceremonial home for the Palace Guard. Designed by Karl Friedrich Schinkel, it had a square ground plan reminiscent of a Roman fort. The original building also provided a guard room for officers, a prison cell, and offices. In the 1920s, the building continued to be used by the German army but was substantially rebuilt in 1931 as the national war memorial to designs by Heinrich Tessenow. The interior was opened up and the offices and cell removed (the side wall windows can be seen bricked up in this photo).

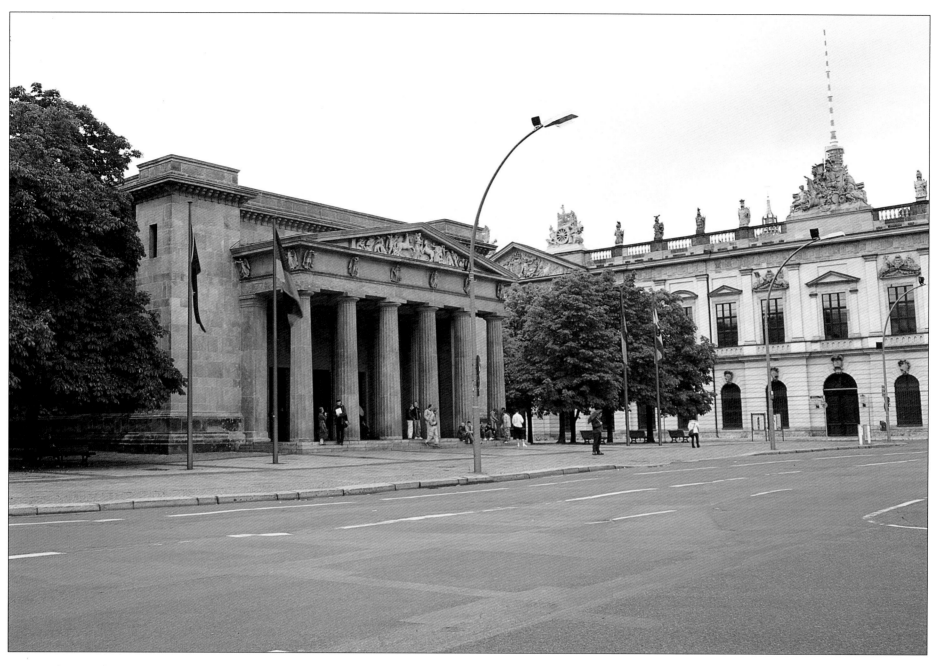

Following serious damage in World War II, the memorial was rebuilt in the 1950s and opened in May 1960 as the Memorial to the Victims of Fascism and Militarism. This was the official name of the memorial until reunification. In the early 1990s, the Neue Wache was completely restored inside and out. In November 1993, it was newly inaugurated after much debate as the Central Memorial to the Victims of War and Tyranny. On the right can be seen the pink walls of the Zeughaus, the royal armory, now home to the Deutsches Historisches Museum (German Historical Museum). Originally the Zeughaus was built for storing the royal weapons but the first kaiser had the structure rebuilt as a military museum. In East German times, it was converted into a historical museum.

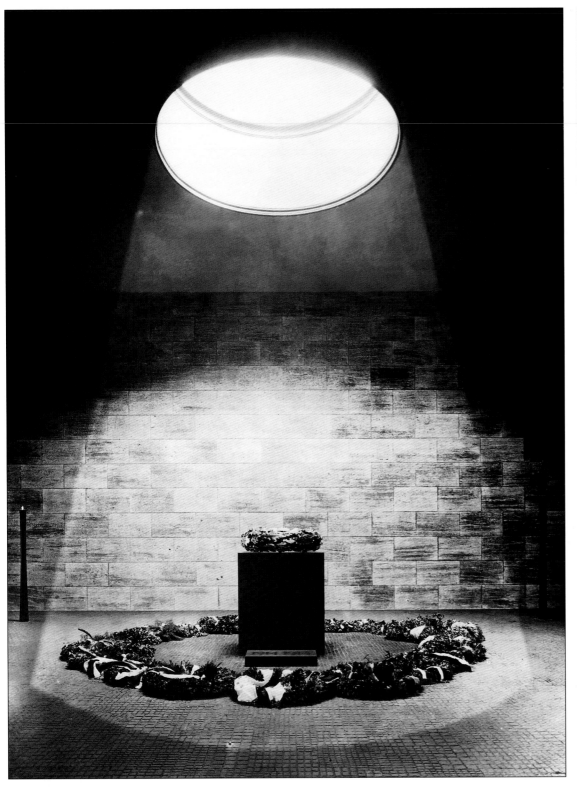

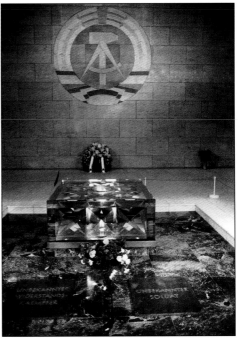

*Left:* A granite monolith draped in sunlight and topped with a wreath formed the centerpiece of the war memorial as unveiled in 1931. The Neue Wache was closed to the elements; by opening the roof, the memorial became exposed to sun, rain, and snow. After World War II, the East Germans retained the monolith but changed the dedication; rather than explicitly remembering the dead of the world wars, onlookers were encouraged to remember the victims of Fascism (in effect, Nazism) and Militarism. In the late 1960s, a more confident East Germany decided to remodel the interior completely (*above*), enclosing the roof and installing the state flag firmly on the back wall. An eternal flame became the new centerpiece of the memorial, mounted on a fire-resistant glass slab in front of which was buried an unknown resistance fighter and an unknown soldier. To complete the effect, the National People's Army conducted elaborate changing of the guard ceremonies outside the memorial every Wednesday.

Today the roof is again opened up, and in place of the monolith is an enlarged replica of *Pieta* by Käthe Kollwitz; the original was only 15 inches high and was created in the late 1930s as an antiwar gesture. Considered a dangerous influence by the kaiser, Kollwitz was only briefly given the status that she deserved in the time of the republic, only to be ostracized once again by the Nazis. The decision to remodel the Neue Wache after 1990 was taken by the government of Chancellor Helmut Kohl. Perhaps most controversial was the inscription: "Den Opfern vom Krieg und Gewaltherrschaft" ("To/For the Victims of War and Tyranny"), placed in front of the *Pieta*. For some, this was considered to be too vague and all-embracing; responding to this criticism, two more-detailed bronze plaques were placed on the front of the Neue Wache itself.

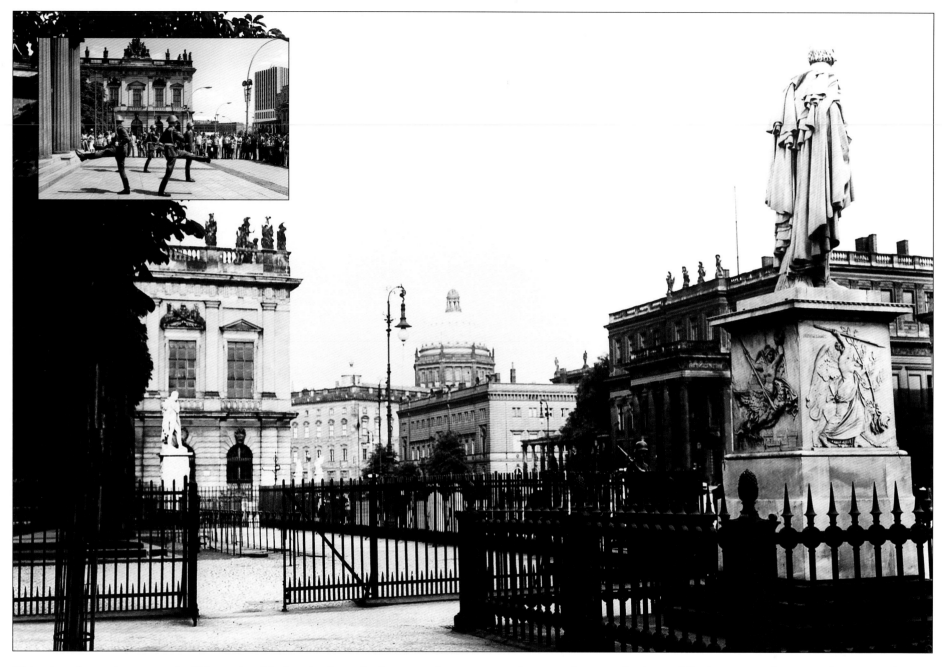

This view shows the east end of Unter den Linden: in the right foreground surrounded by railings is a statue of Friedrich Wilhelm von Bülow, who led the Third Prussian Corps in the Battle of the Nations against Napoléon Bonaparte. A matching statue of Gerhard Scharnhorst is seen in the distance with the Zeughaus behind it. Both statues were designed by Schinkel and then built by Rauch in 1822. In the center, the dome of the Stadtschloss, or city palace, can be seen. In the middle distance is the original Kommandantur, the Berlin military governors' seat. Behind the statue of von Bülow is the Crown Prince's Palace. All three of these buildings were severely damaged in World War II, and only the Crown Prince's Palace was rebuilt. The inset photo shows the East German changing of the guard. The soldiers, perfectly choreographed, were something of a tourist attraction in East Berlin.

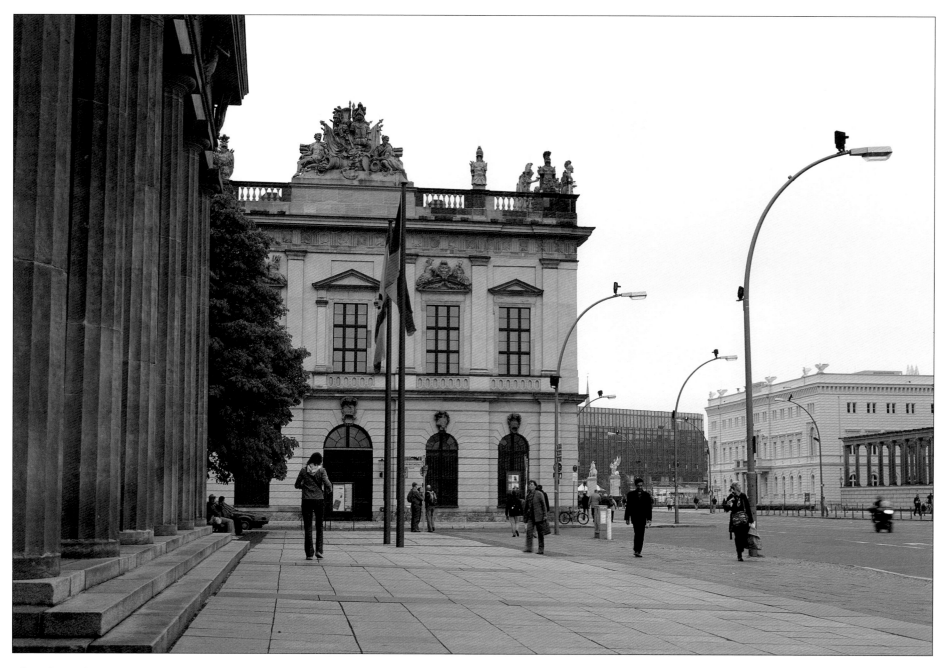

This photo shows the pink-walled Zeughaus with its intricate stone carvings—suits of armor, cannons, spears, and other trappings of war—on the parapet. Inside the courtyard of the Zeughaus, Andreas Schlüter, the most talented baroque sculptor to work in Berlin, carved the famous heads of dying warriors. Today the Zeughaus plays host to the Deutsches Historisches Museum. Beyond the Zeughaus, in the distance, is the gold reflective glass of the Palace of the Republic. To the right, on the other side of Unter den Linden, stands the all-new Kommandantur. The war-damaged Kommandantur was replaced with the East German Foreign Ministry, which was in turn pulled down in 1995. The new Kommandantur houses the Berlin headquarters of media concern, Bertelsmann. Opened in November 2003, the facade is a copy of the original building from 1874.

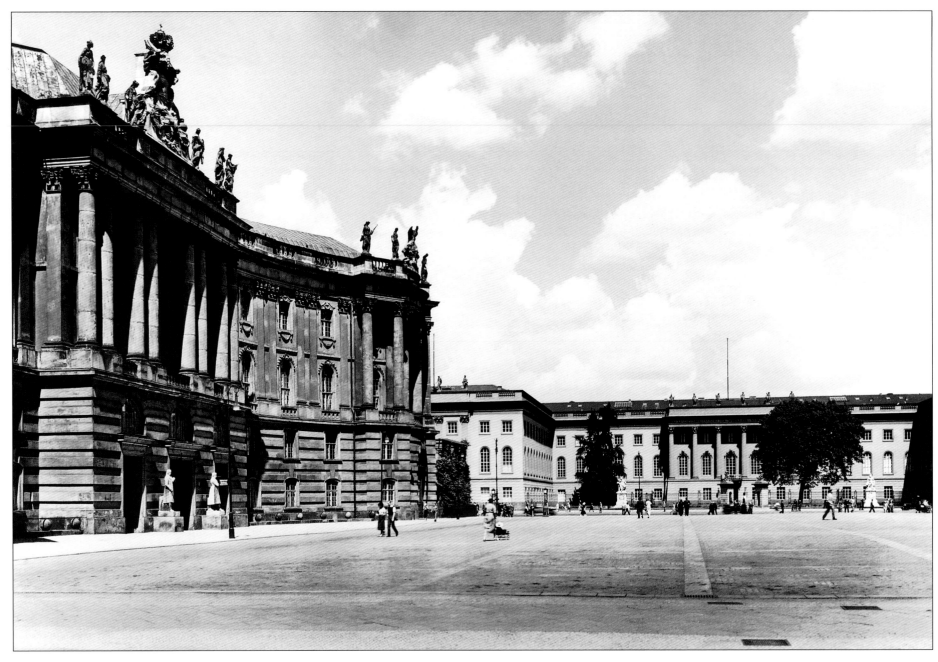

The imposing building with the curved facade on the left is the Old Royal Library of Frederick the Great, completed in 1780. To the right stands Berlin University. The library started life not only as the home of the royal library; the army used the basement of the building as a magazine until 1814. Above the main door is the Reading Room in which Lenin whiled away some time in 1895, remembered with plaques installed in the 1960s. In 1914, the books were transferred to the new State Library and the building was taken over by the university. Berlin University was founded in 1810 and took over the palace originally built for Frederick's young brother, Prince Henry. In 1828, the university was renamed the Friedrich Wilhelm University and its list of alumni includes Karl Marx, the brothers Grimm, and no less than twenty-nine Nobel prize winners. It is now known as Humboldt University.

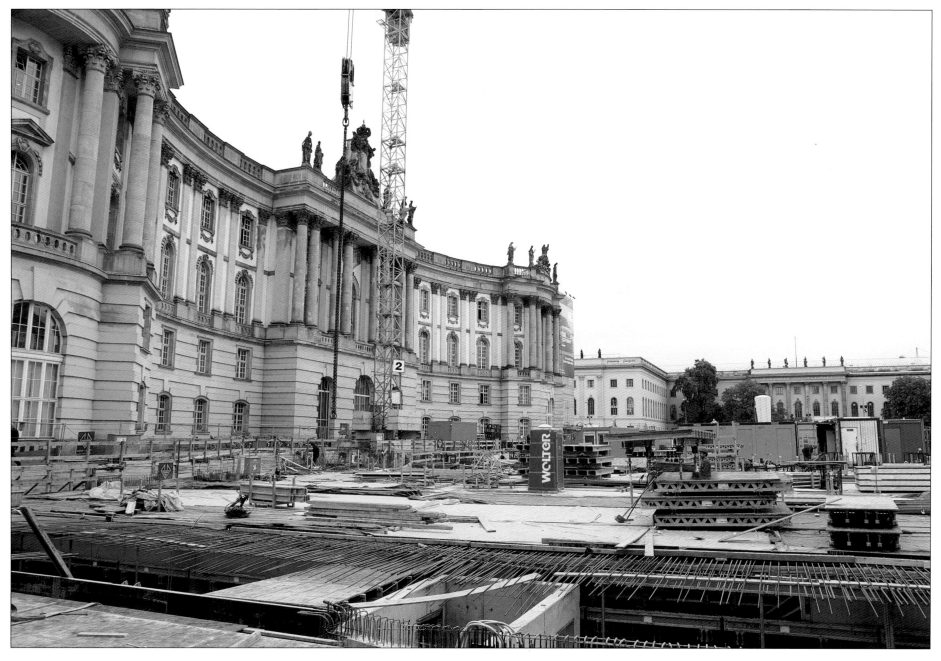

Dominating the square today is the construction site of what is now called Bebelplatz (after one of the founding fathers of the Social Democratic party of the nineteenth century, August Bebel). A two-story underground parking garage nears completion. In the middle of this square, on May 10, 1933, the Propaganda Ministry of the newly formed Nazi dictatorship organized students of the university to burn books by non-Germanic writers. Anyone who fell afoul of the long list of Nazi prejudices—racial, political, and social—found their works committed to the flames. In 1995, a wonderfully subtle memorial, designed by Israeli artist Micha Ullmann, was opened in the middle of the square. A three-foot square glass panel gives a view into a large underground room: the Empty Library contains illuminated white shelving, large enough to hold 20,000 books, the number of books burned in 1933.

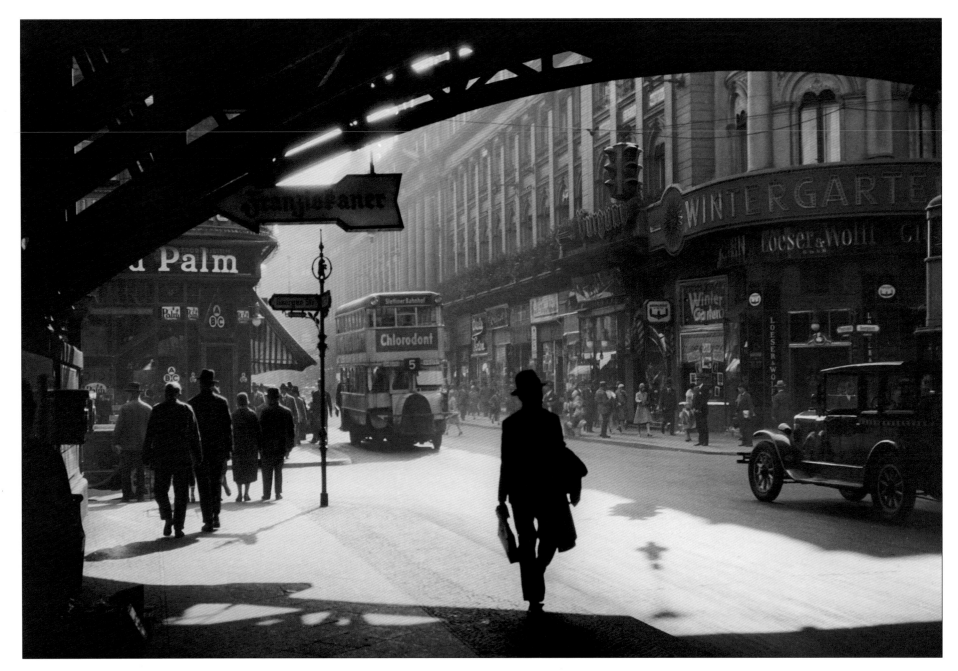

This picture is framed by the archway of Friedrichstrasse station and looks south in the direction of Unter den Linden. In 1888, the Wintergarten variety theater opened—its entrance can be seen on the right. A year after this photo was taken, the 1931 census showed that Berlin had a population of 4.3 million and was the third largest city in the world after London and New York. The numbers of visitors to the city steadily grew and the Friedrichstrasse catered to all tastes: by the time the Nazis started to close venues down in 1933, there were about 250 places serving the public on this street alone, from simple bars to variety venues and night clubs. For family entertainment, the Wintergarten offered variety shows and tea dances. At the other extreme, the Black Cat Cabaret, on the other side of Unter den Linden, was not somewhere you took your grandmother!

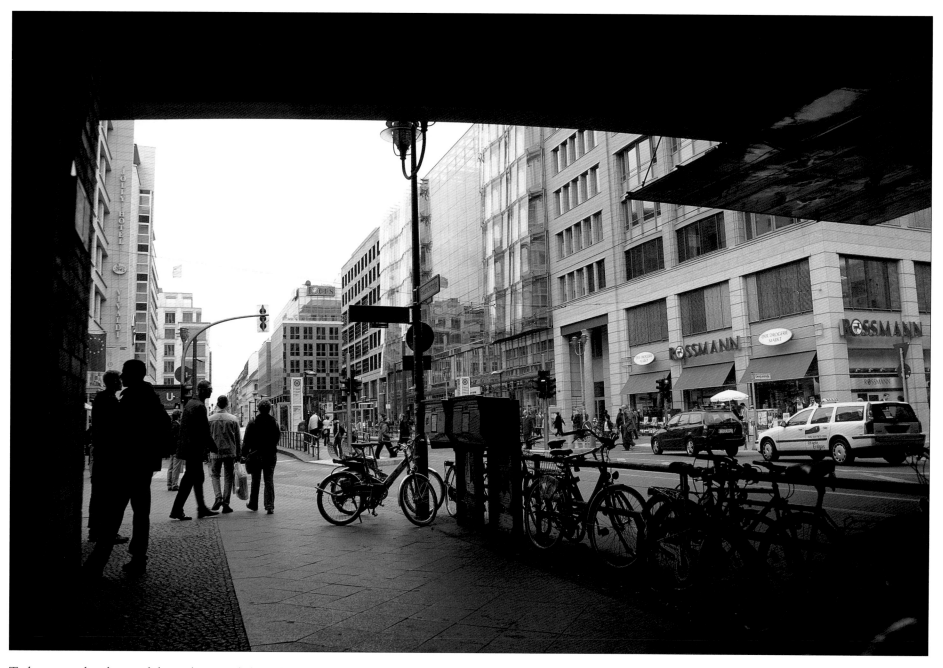

Today even the shape of the railway arch has changed, reflecting the fact that in the mid-1990s, the entire four-line elevated railroad between Zoo station and Ostbahnhof was renewed, including all bridges. Locked-up bicycles are in abundance, an indication of how Berliners often use a combination of bike and train to get to their destination. During the years of division, the S-Bahn plied between Zoo Station and Friedrichstrasse, allowing visitors and commuters to access East Berlin from the West. The visitor processing building still stands to the north of the station, seemingly isolated but connected by tunnel to the main station building. Known poignantly as the Tränenpalast (Palace of Tears) by the Berliners, this was where West Berliners had to bid farewell to their family and friends in East Berlin. Today the building is used as a live music venue, bearing the same name but in neon.

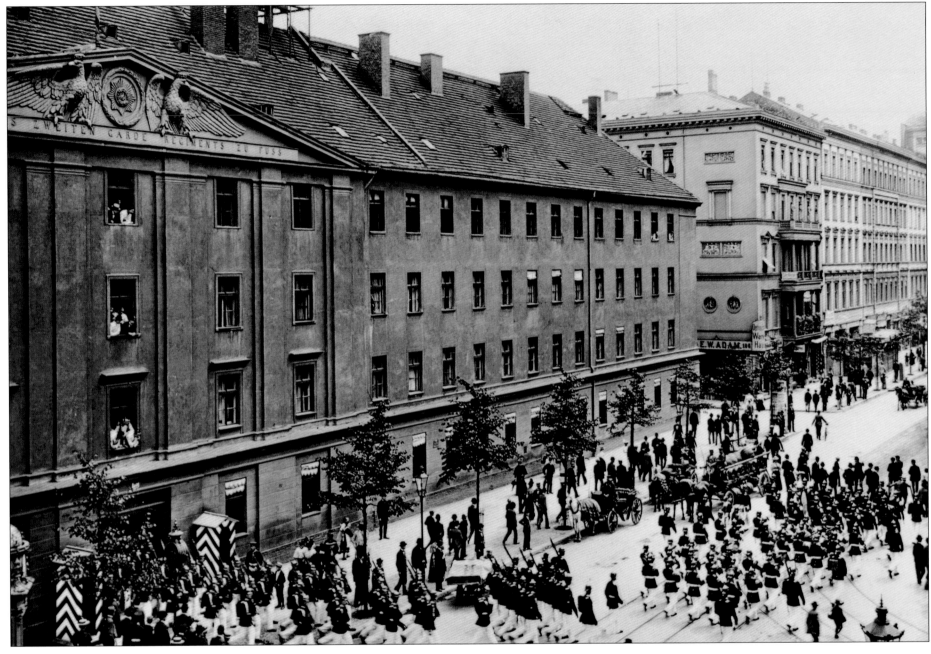

This photo dates from the 1890s and shows infantry leaving their barracks at the north end of the Friedrichstrasse. The barrack building dates from the 1760s and was first built for an artillery regiment. When this building was built, the population of Berlin was over 100,000, but more than a quarter (26,000) were soldiers. Many were press-ganged into service against their will and desertion was commonplace; indeed, one of the functions of the last set of city walls in both Berlin and Potsdam was to reduce the flow of deserters. Many regiments were garrisoned in the north part of the old city, and a prewar map reveals many military connections: Artilleriestrasse, Dragonerstrasse, Grenadierstrasse. True to the anti-Prussian militarism doctrine of the East Germans, these street names were purged and usually replaced with the names of worthy left-wingers.

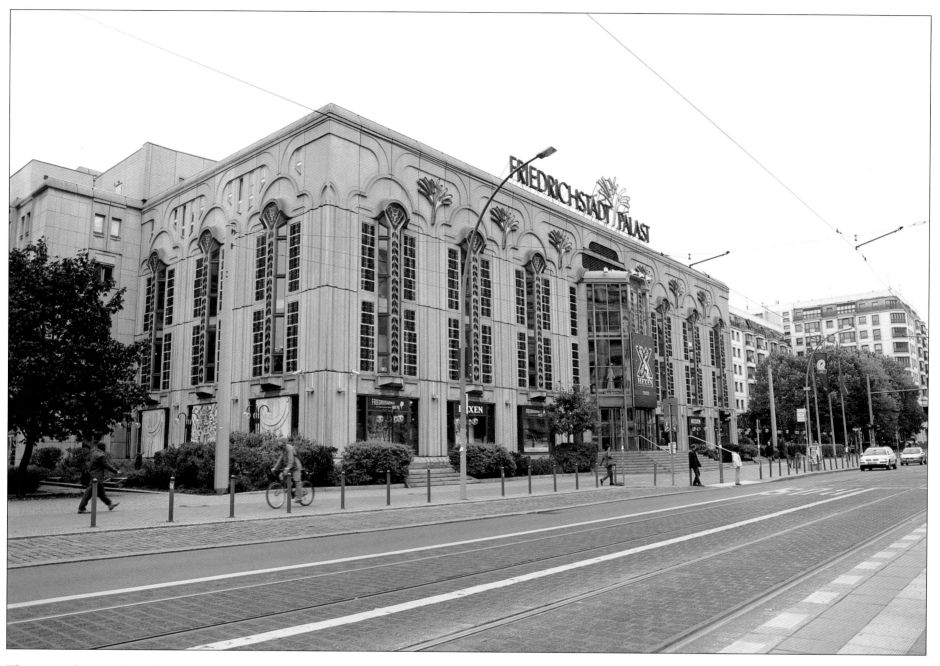

The revue theater shown here is perhaps the most interesting example of late-Plattenbau architecture in the city; Plattenbau describes the prefabricated nature of this type of building, used by East Germany until 1989. Here the facade has been relieved by Jugendstil (Art Nouveau) ornamentation. Described as the largest revue venue in Europe, the main theater opened in 1984 and accommodates 1,900 people. There is also a smaller stage for more intimate shows. The previous Friedrichstadtpalast was forced to close in 1980 because of the deteriorating condition of the building. It was not in this location but on the other side of the Friedrichstrasse, close to the river. In its heyday in the 1920s, it was called the Grosses Schauspielhaus and was the creation of Max Reinhardt, a famous Austrian-born impresario. The crumbling building was finally pulled down in 1986.

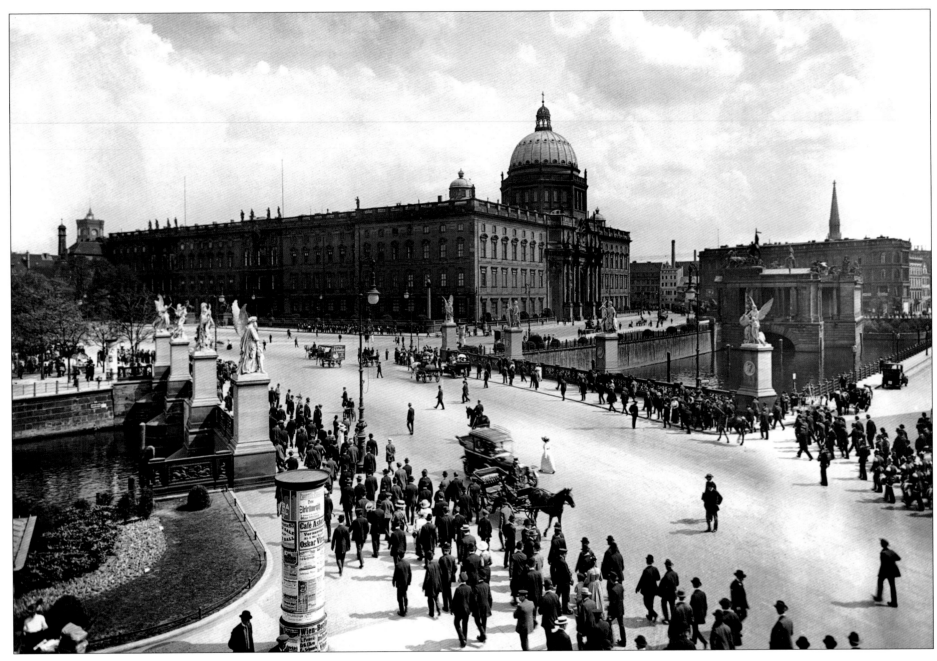

This photo is taken from a window of the Zeughaus and is dominated by the massive form of the Stadtschloss, the city palace. On this site, the Hohenzollerns had first imposed a fortress on the Berliners soon after they arrived in the fifteenth century. The appearance of the city palace, including the cupola on the southwest facade, dates from the late seventeenth and early eighteenth century, when the previous Renaissance-style palace was almost entirely remodeled. In the foreground, people cross the Palace Bridge, which traverses the Spree at the end of Unter den Linden. Adorned with eight marble statues showing the life and death of a Greek warrior, they were designed by Schinkel in the 1820s when the whole bridge was replaced. However, lack of public funds meant that the marble figures weren't created until after his death in the mid-nineteenth century.

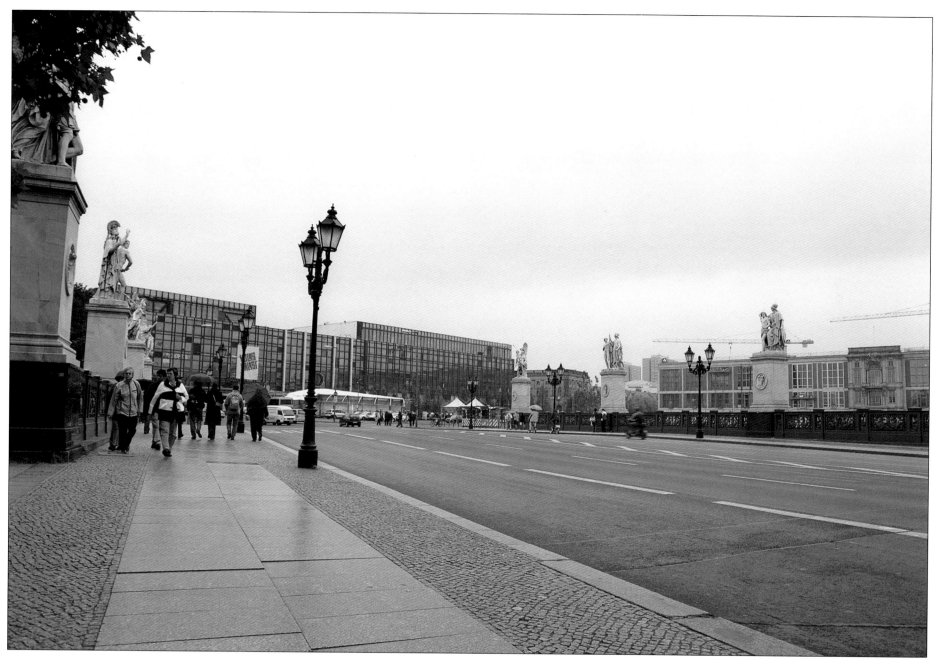

At street level, the size of the Schlossplatz is not so apparent and only the back of the site is now built on, with the Palast der Republik (Palace of the Republic) at center left. The kaiser's palace could have been rebuilt after the war—most of the roof was lost to firebombing but the outside walls survived. But in 1950, the ruins were dynamited by the East German government on the grounds that the site was needed for large public rallies. In 1976, the Palast der Republik first opened its doors. In the drab center of East Berlin, this was one place where people came to enjoy parties, concerts, and even bowling. Parliament played only a secondary role in the significance of the building for the East Berliners.

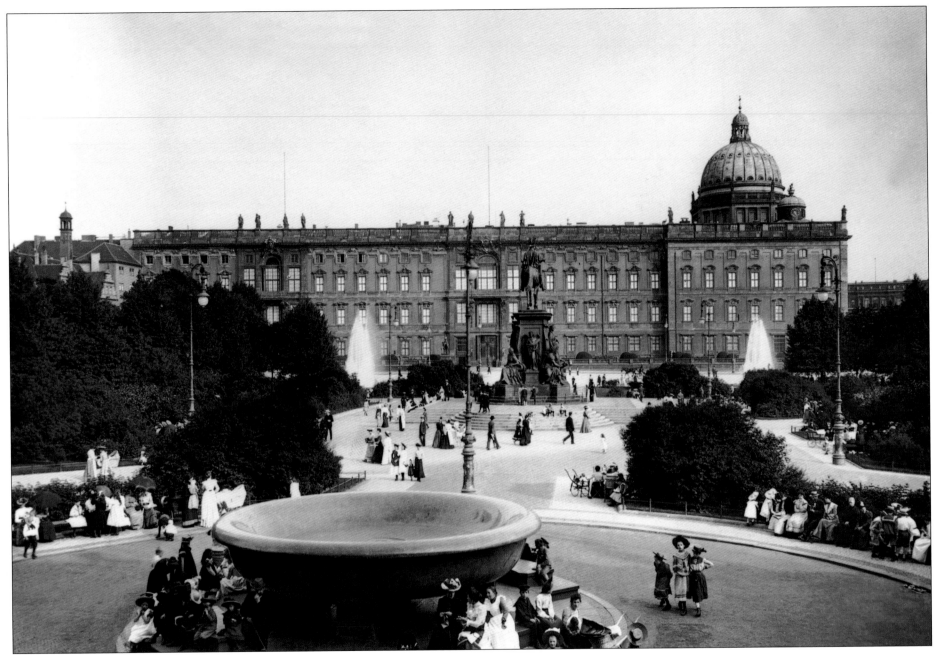

This lively picture of the Lustgarten (Pleasure Garden) was taken in 1913, from the steps of the Altes Museum (Old Museum). In the foreground is a granite bowl, with a diameter of over twenty feet, created out of a single glacial boulder by Christian Gottlieb Cantian in the late 1820s. Originally it had been commissioned to grace the interior courtyard of the Altes Museum. On completion, however, it was so large that it would not fit inside the museum and Schinkel created a base for it so that it could stand permanently in the Lustgarten. The Lustgarten was created as a public garden by the Great Elector in the late seventeenth century. However, his grandson, Friedrich Wilhelm I, the "Soldier King" ripped out the gardens and installed a military parade ground. In the nineteenth century, the gardens were reinstated, and the statue of Friedrich Wilhelm III (center) was unveiled in 1871.

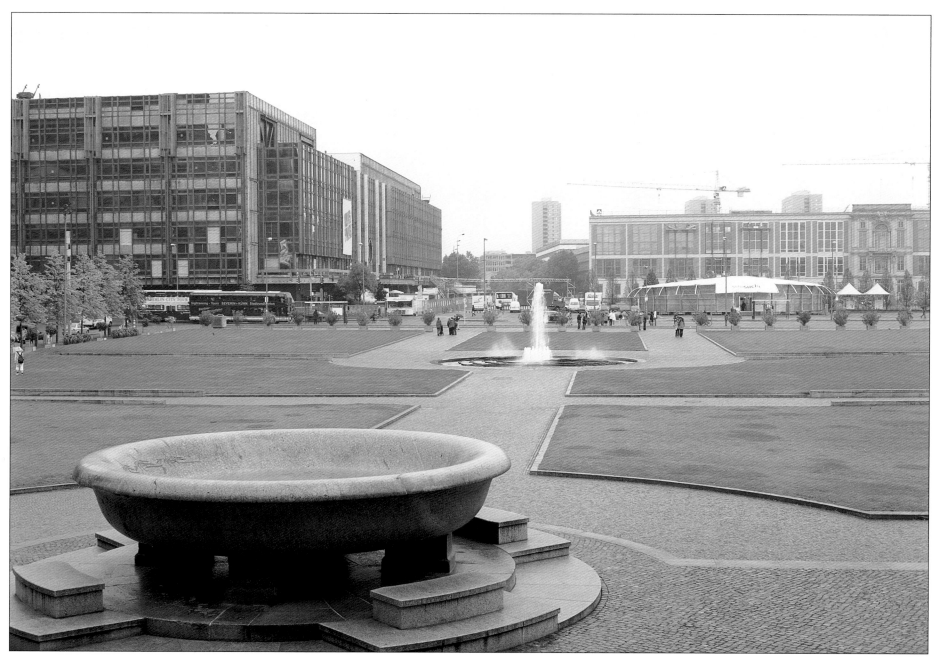

On the far right, the Eosander portal (partially hidden behind trees at the left in the photo opposite) has reappeared in a new position. It is now part of the Stadtratsgebäude (State Council Building), constructed by the East Germans in the early 1960s. When the ruins of the city palace were cleared away in 1950, this portal was dismantled and saved because of its connection with Karl Liebknecht, co-founder of the German Communist Party, and the events of November 9, 1918. On this day, the kaiser abdicated and there was a scramble for power. Liebknecht, representing the far left, proclaimed the founding of a Socialist republic from the balcony of this portal, but two hours earlier, the more moderate Social Democrats had done the same thing from the Reichstag. In the ensuing civil war, the Social Democratic republic prevailed, receiving the support of the army and the right-wing militia.

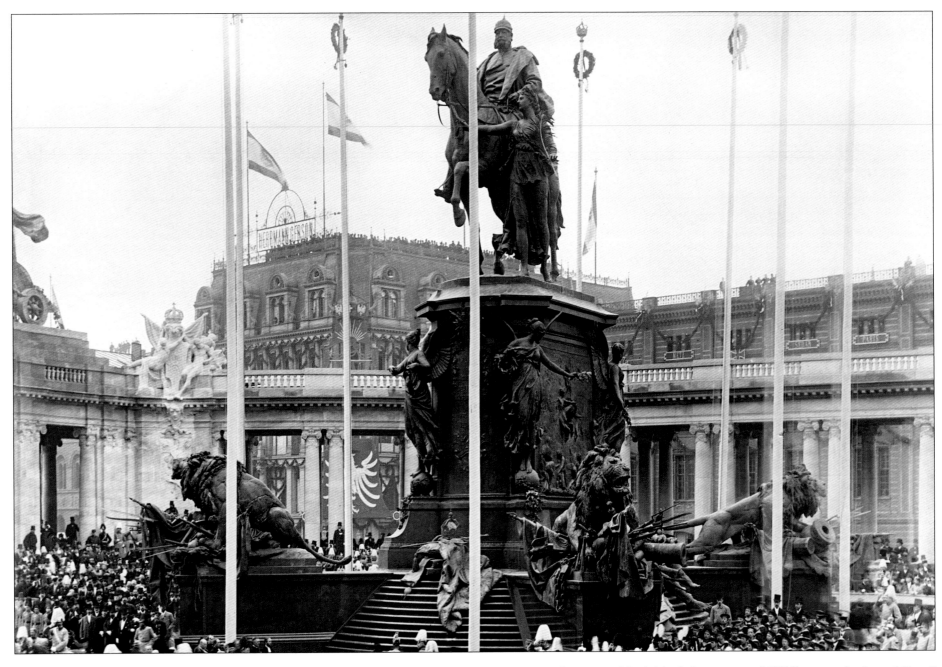

This photo was taken on the March 22, 1897, the hundredth anniversary of the birth of Kaiser Wilhelm I. This memorial was sponsored by his grandson, the last kaiser, and is one of the best examples of the pompous statuary he bequeathed to the nation. The whole design was carried out by Reinhold Begas, excepting the colonnades behind. The four lions are shown in attacking pose and symbolized the spoils of war from the defeat of France in

1870–71. Berliners quickly dubbed the memorial "William in the Lions' Den." Although most of the memorial was disposed of in 1950, two of the lions can still be found in the Tierpark, the zoo in eastern Berlin. In the distance, the garlanded building flying the flags carries advertising for the Hermann Gerson tailoring company. Gerson designed the coronation robes for Wilhelm when he ascended the Prussian throne in the 1860s.

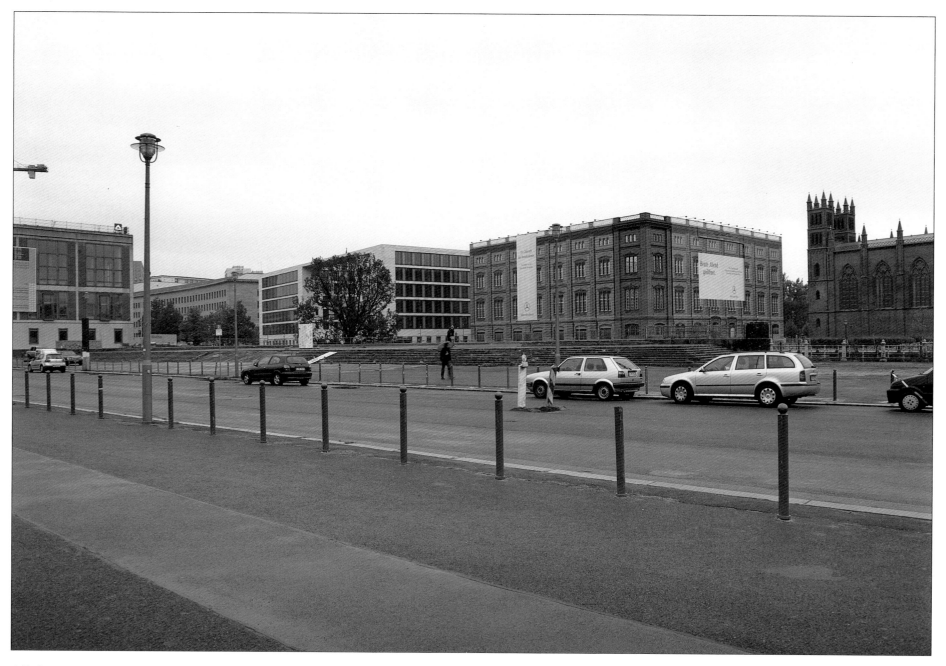

All that is recognizable of the memorial are the low, overgrown steps on the other side of the road. Behind these, the strange reddish-pink "building" is in fact a mock-up of Schinkel's building academy, made of canvas and scaffolding, to encourage public interest in this project. Damaged in the war, the building was pulled down in the 1960s to make way for East Germany's new foreign ministry (itself a casualty of bulldozers in 1995). On the far right, can be seen a real, surviving building by Schinkel, the Friedrichswerdescher Church in early-nineteenth-century Gothic style. This now houses the city museum of neoclassical sculpture by Schinkel and his school. On the left is the State Council Building, which was being rebuilt as Berlin's new business school. Used as a chancellery in the 1990s, it was previously used as the main office for Erich Honecker, party secretary of East Germany from 1970 to 1989.

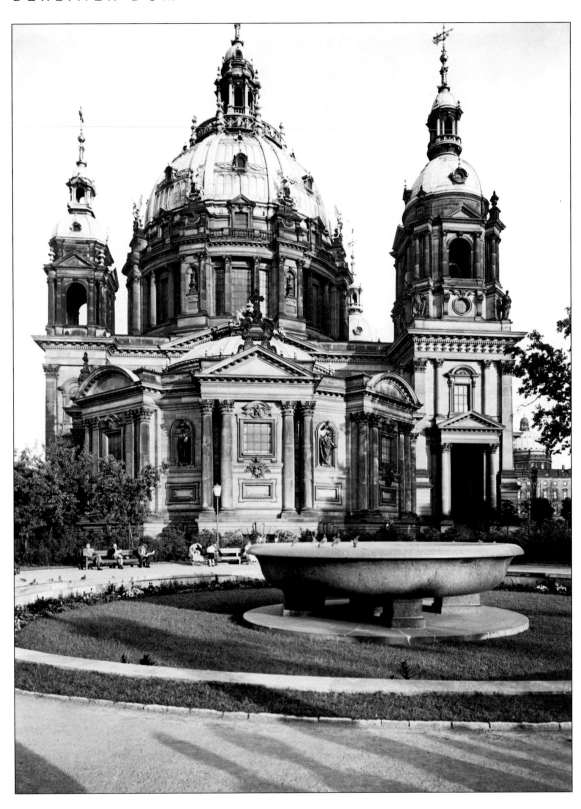

The Berliner Dom (Berlin Cathedral) was finished in 1905 and built in Renaissance style to designs by Julius Carl Raschdorff. It was built to replace the relatively small cathedral first built by Johann Boumann for Frederick the Great. The new building served two purposes: it continued to be the royal burial church and at the same time strived to be the Protestant equivalent of the Vatican. The reason for the corner cupola being larger on the right is that this side (the west front) was visually much more important than the left, or river, side of the building. The granite bowl from the Lustgarten, shown on page 46, can be seen here. In 1934 (the year before this photo was taken), it was moved here—allowing unrestricted space on the Lustgarten for Nazi mass parades.

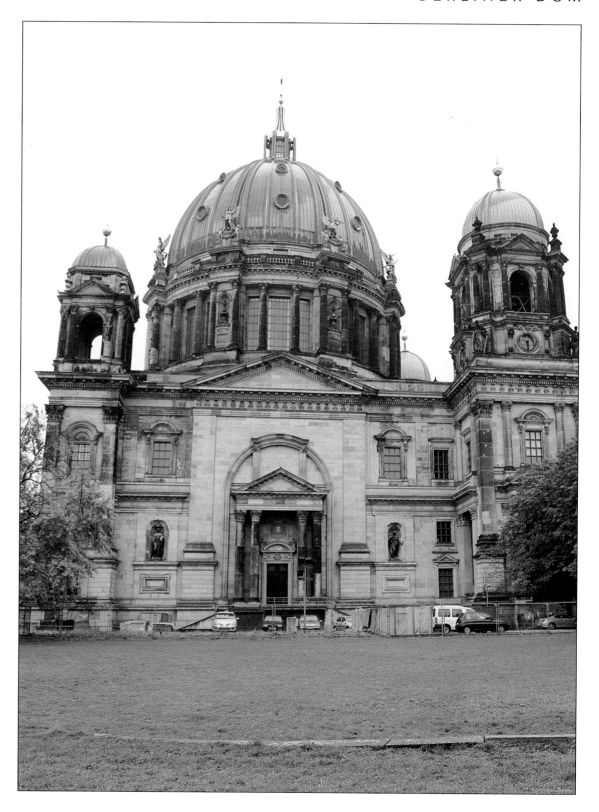

The bowl has been returned to its original position on the Lustgarten. The Dom seems to have shrunk, while the Burial Chapel, at the front, has disappeared. The Dom was seriously damaged in World War II, bringing the ground floor down into the crypt. The decision not to repair the Burial Chapel was a political one taken by the leaders of East Germany in the 1970s. It was only in 1993 that the interior work inside the Sermon Church was completed, and further work to the crypt was only finished in the late 1990s. In contrast to the rather crude appearance of the reduced domes on the roof, the interior ornamentation, including the altarpiece designed by Schinkel for the earlier church, has been faithfully restored.

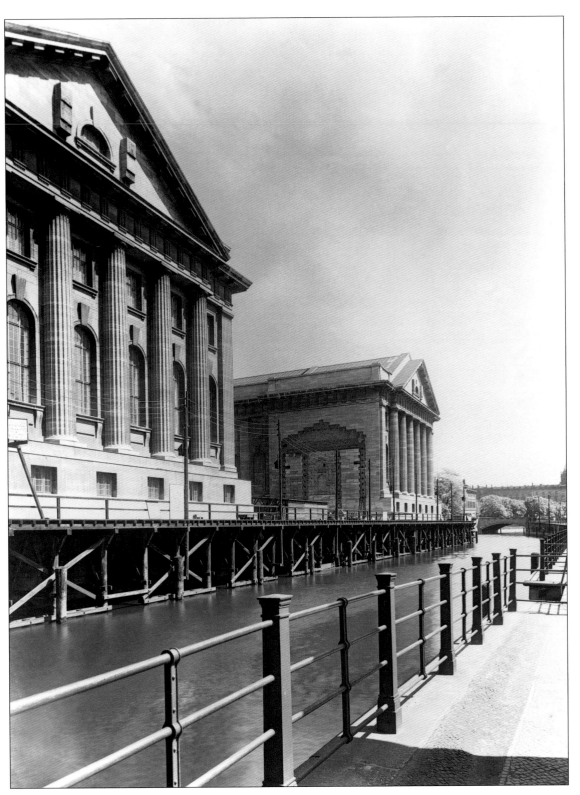

Seen from the west bank of the Spree, this view shows the two wings of the most famous museum on Museumsinsel (Museum Island) just before it was opened in 1930. Still to be built is the pedestrian bridge linking the west bank with the main entrance. The Pergamon was built to designs by Alfred Messel, who died shortly after work started. Delayed by the outbreak of World War I, the work was completed under the direction of Ludwig Hoffmann. With the building of this museum, the Pergamon altar from the temple of Zeus, the Roman market gate from Miletus, and the Ishtar Gate from Babylon could be displayed in a way that brought out the grandeur and scale of these ancient monuments. This museum was the last of five major buildings on Museum Island to be completed, allowing the main antiquities and art collections to be displayed together in one location and completing a project started with the Schinkel-built Altes Museum one hundred years before.

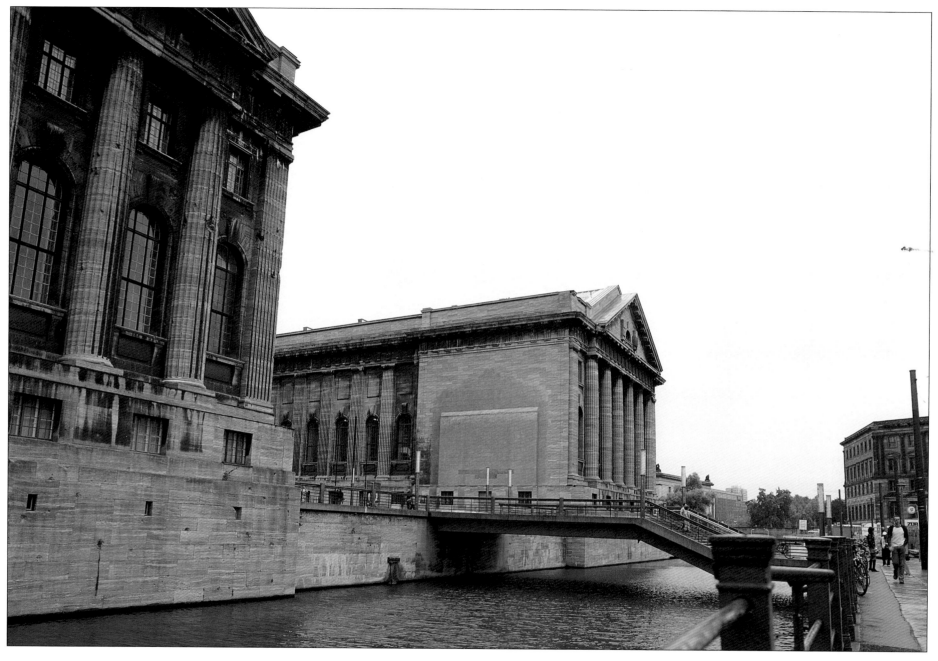

Despite the visible war damage on the columns and pilaster on the left side of the photo, the Pergamon was the only one of the museum buildings on Museum Island to survive with most of its roof intact. The decision to remove works of art and antiquities from other collections into the country for safekeeping during the war resulted in split collections; some ended up in the Soviet zone, some in the Western Allies' zone. As late as 2004, the main part of the Egyptian collection was still on display in its old West Berlin location in Charlottenburg. The legacy of the war still has an impact on Museum Island today; the Neues Museum (New Museum) is scheduled to be reconstructed and ready to display the Egyptian collection once again by 2009. Today the Pergamon continues to be the most popular state museum in the city, attracting at least 850,000 visitors a year.

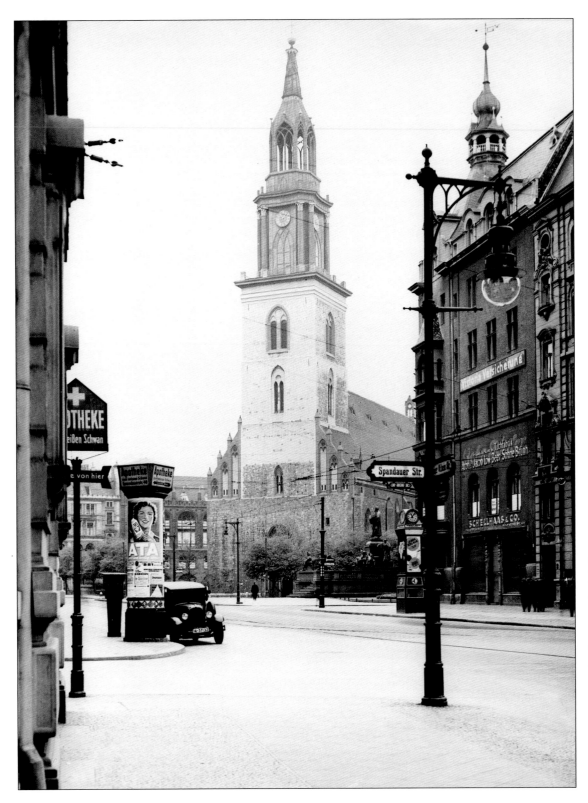

In the late thirteenth century, the new town of Berlin expanded northward from its origins around the Nikolaiviertel. On the junction of what is today Spandaustrasse and Karl-Liebknecht-Strasse, a new marketplace was set up, beside which was built a new church, the Marienkirche, named after the Virgin Mary. This was the third church to be established, the Petrikirche having already been built on the west bank of the Spree in Cölln. In time, the church expanded westward and a tower was added in the fifteenth century; this burned down several times, and in 1790, the architect of the Brandenburg Gate, Carl Gottfried Langhans, was commissioned to rebuild it, creating the copper-clad spire we know today.

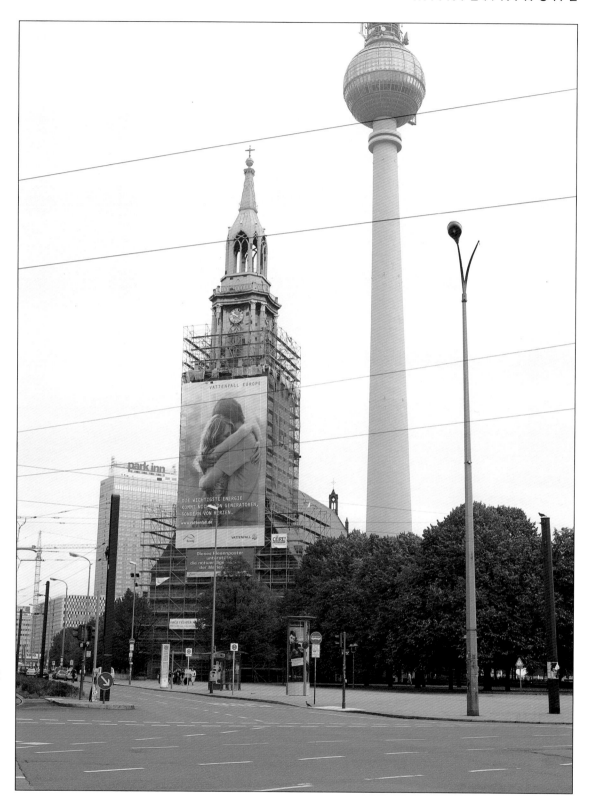

Today the Marienkirche is somewhat dwarfed by the structure of the Fernsehturm (TV Tower) on Alexanderplatz. Despite the scaffolding on the tower, the church weathered the inferno of World War II better than any other in the city. By 1950 the worst damage had been repaired. Today it is the only medieval church in the city still in use as a church. At present, the friends of the church are raising money to restore the most unusual aspect of the interior: the medieval mural painting called *The Dance of Death*. This fifteenth-century mural was painted in the vaults under the tower after an attack of the plague; it attests to the destruction of death and is nearly seventy feet long.

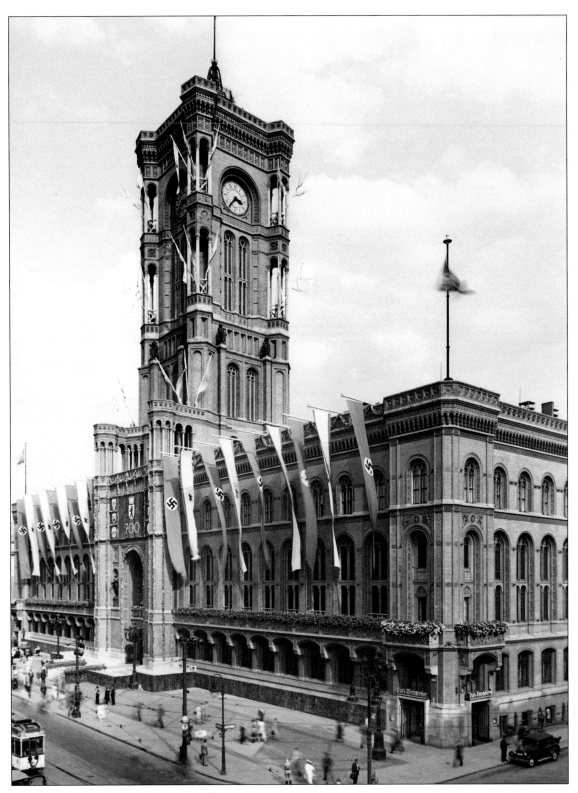

The Rotes Rathaus (Red Town Hall) was first opened in 1869 and is seen here in 1937, decked out with special pennants to celebrate the city's 700th anniversary. Designed by Hermann Friedrich Waesemann, it followed in the tradition started by Schinkel of building in red brick. This was married here to high-Renaissance-style monumentality: for decades, the tower was the highest nonsacred building in the city, easily eclipsing the dome of the city palace. The first forty years of the Rotes Rathaus' existence witnessed an explosion in the size of the city, with the population growing from less than a million in 1869 to over three million in the early 1900s. Despite the enormous size of the Rotes Rathaus, more space was needed for the city bureaucracy, and another huge structure, the Stadthaus, was built in the early 1900s to the south. At the time this picture was taken, any pretext of an independent city administration had disappeared; the city council, like all local administrations in Germany, had been subsumed to the power of the Gauleiters, the local Nazi party bosses.

Despite being 50 percent destroyed in World War II, the Rotes Rathaus was rebuilt in the 1950s, and from 1958, this was where the East Berlin city administration was based. Seeing the building in color brings out the richness of the redbrick and terra-cotta facades. Berliners often joke that it is because of the appearance of the building that it's called the Rotes Rathaus, not because of the politicians in the building. After the Berlin state elections in October 2001, the Social Democrats (red) swapped their existing coalition partners, the Christian Democrats (black) to rule with the reconstituted Communist party, the Party of Democratic Socialism (redder). The PDS polled almost half the votes cast in the districts of the former East Berlin. In recent years, this "red-redder" coalition has been forced to follow a difficult and unpopular path: cutting the budget to try and live within its means, brought about by the federal government reducing subsidies to the city.

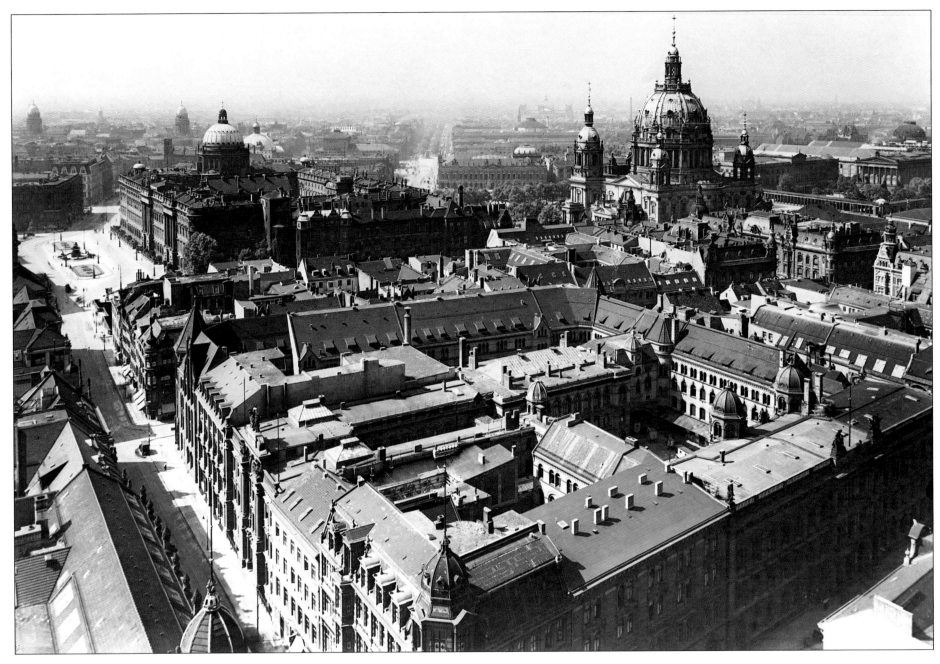

The block of buildings in the foreground of this 1922 photo is the Post Office Main Building. Behind and to the left is the city palace, and to the right of this is the Berliner Dom. Looking into the distance in the center, one can make out the avenue of Unter den Linden and the domed roof of the State Library. Just to the right of Unter den Linden, on the horizon, is the Reichstag. The two matching towers in the distance on the left belong to the German and French churches on Gendarmenmarkt. On the far right, one can make out four buildings on Museum Island: seemingly nearest the Berliner Dom and standing in the shade is the New Museum; to its right can be seen the glass roof of the Pergamon Museum. The building on the right edge, which looks like a Roman temple, is the National Gallery, and behind it is the dome on top of the Kaiser-Friedrich-Museum (today called the Bode).

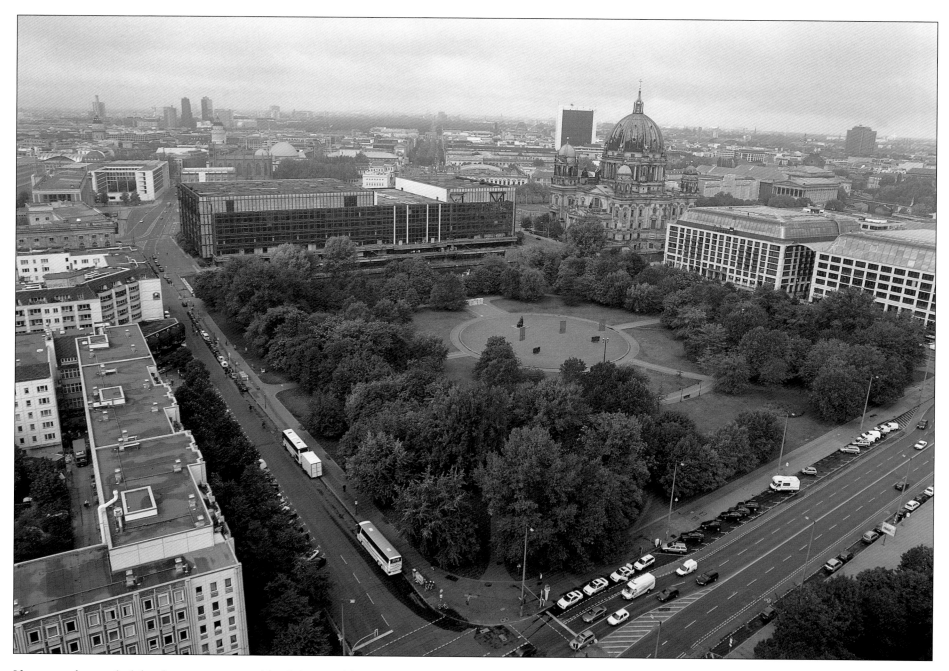

If one needs proof of the destruction caused both by World War II and the policies pursued by the East German government, it can be seen here. The Post Office and all the other buildings between the Red Town Hall and the Spree are gone, replaced by a park called Marx-Engels Forum. Behind the park is the forlorn shape of the Palace of the Republic, squatting where once the back of the city palace stood; this will almost certainly be demolished to make way for a rebuilding of the city palace in years to come. The lobby behind the rebuilding of the Stadtschloss (City Palace) has gained support over many years and succeeded in winning parliamentary approval in 2002. In reality, the new building would appear to be a palace but would be built for a mixture of public and private uses, including housing a library and convention center.

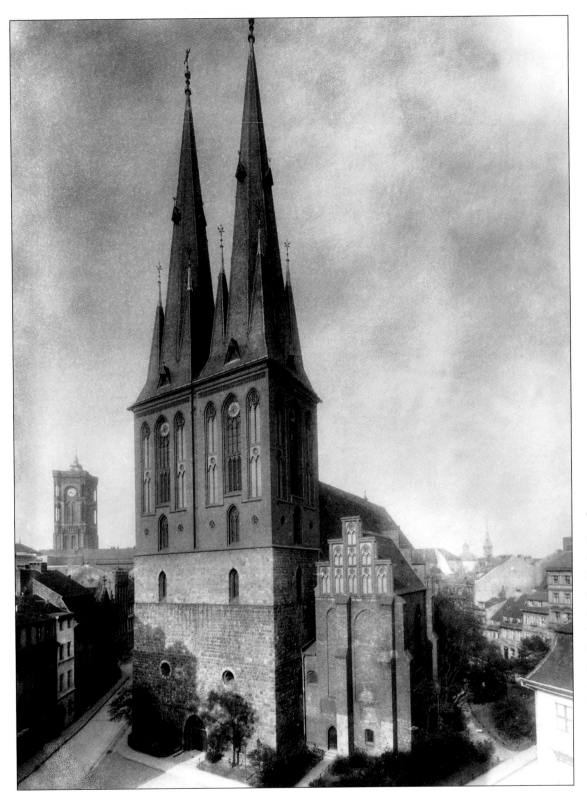

The Nikolaikirche is the oldest church in the city and the oldest stone-built structure that survives in the medieval center of town. Constructed on one of three sand dunes on the east bank of the Spree, it is named after the patron saint of shipping. It is believed that the oldest stone walls of the existing tower structure date from 1230. Later in the same century, the hall of the original stone church was remodeled with the first brick structure in early Gothic style. It was not until 1470 that it assumed its late-Gothic appearance. Over the following centuries, neither Renaissance nor baroque trends touched the church. In the 1870s, city builder Hermann Blankenstein decided, among other things, that the asymmetric tower was "unfinished"; it was removed and replaced with the twin tower construction we see in this 1903 photograph.

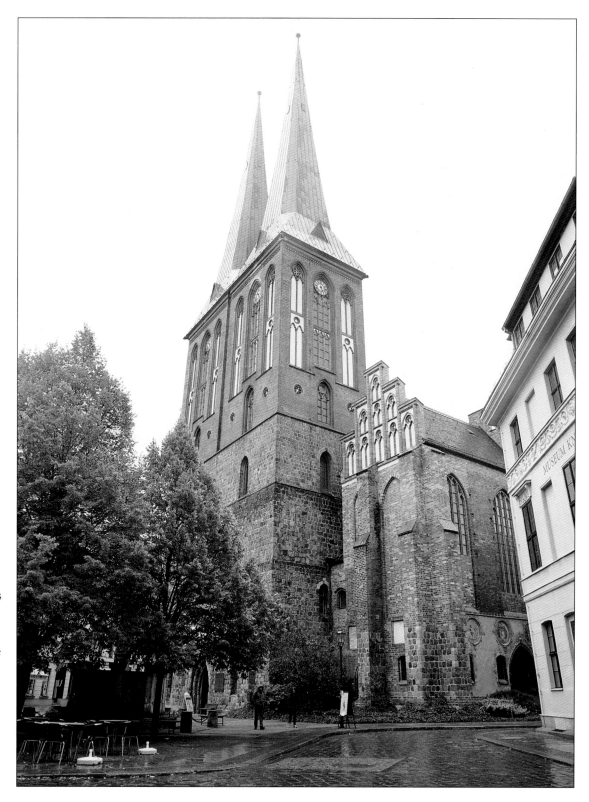

On first glance, the structure appears the same as it did in the 1903 picture. Close inspection of the towers shows that the covers are all new. In bombing raids in June 1944, the tower was burned out, and in May 1945, the hall of the church was destroyed. Nothing was done to secure the ruins after the war. Only in 1979 were the first measures taken to secure the ruins, but it was decided by the East German government to comprehensively restore the area around the church, the Nikolaiviertel, to tie in with the city's 750th anniversary celebrations in 1987. The restoration of the church was carried out as faithfully as possible, rebuilding the nineteenth-century matching towers.

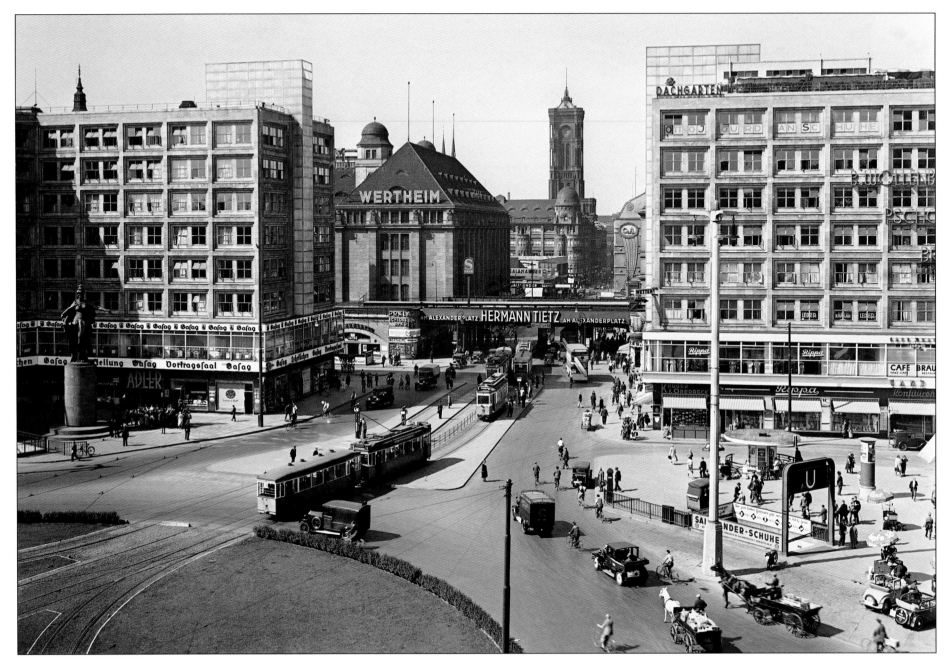

"Alex," (Alexanderplatz) as it is invariably called by Berliners, was named after Czar Alexander I of Russia, who visited Berlin in 1805. This view from 1934 looks southwest along the former Königstrasse, now Rathausstrasse, with the tower of the Rotes Rathaus (Red Town Hall) in the distance. Flanking the street and on the east side of the railway lines are the newly completed office buildings by Peter Behrens: the Alexander Haus on the left and the Berolina Haus on the right. In front of the Alexander Haus is the Berolina statue. This copper colossus dating from 1895 had been moved from its position in front of the Tietz department store on the northwest side of the square in 1933. Behind the railway lines stands the Wertheim department store; it had been constructed in 1911 on the site of the Königskolonnaden (pages 120–121), which was then moved to Kleistpark in Schöneberg.

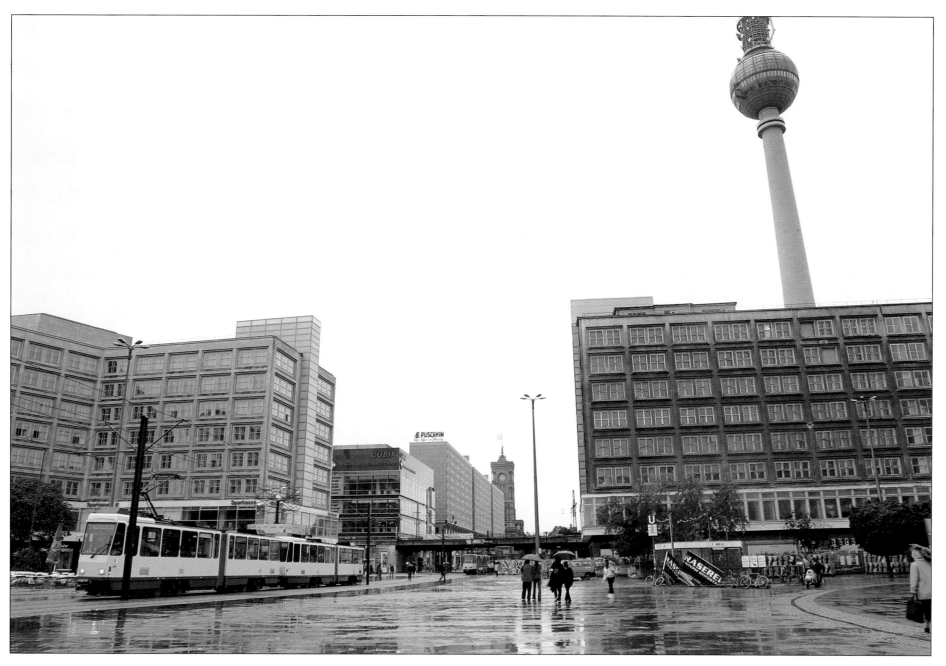

When this was a divided city, Alex was considered to be the center of East Berlin; it was rebuilt at least once in the late 1960s. On the site of the old Tietz store, a new department store and a thirty-nine-story high-rise hotel were built. The only prewar buildings salvaged from the ruins were the two Behrens-designed buildings. In the late 1960s, the 1,100-foot-high Fernsehturm (TV Tower), seen on the right, was constructed on the other side of the railway lines. As the second-highest structure of its kind in Europe (only the tower in Moscow is taller), it was the pride of Communist East Germany. At the same time, a world clock was constructed close to where the Berolina statue once stood (the top of it can be seen directly behind the middle part of the streetcar). A popular meeting point in Alex, the clock would tell you what time it was all over the world.

This street scene from 1912 shows life east of Alexanderplatz in the district of Friedrichshain. In this photo, one can see two curious features of the Berlin streetscape: first, the column, a Litfaß Säule, on the far right of the photo. These were introduced in the mid-nineteenth century to reduce the number of bills being illegally posted on buildings. The head of police, Karl von Hinckeldey, awarded an advertising monopoly to a certain Herr Litfaß, who duly installed 150 of these columns all over the city. The other curiosity is the small cast-iron structure immediately to the left of the tree in the center of the photo. This is a pissoir dating from the 1880s, built in an octagon shape. Paid for out of the public purse, some 140 of these structures were standing in the 1920s. Over the twentieth century, war and neglect destroyed most of them, but since 1990, there has been an effort to preserve them.

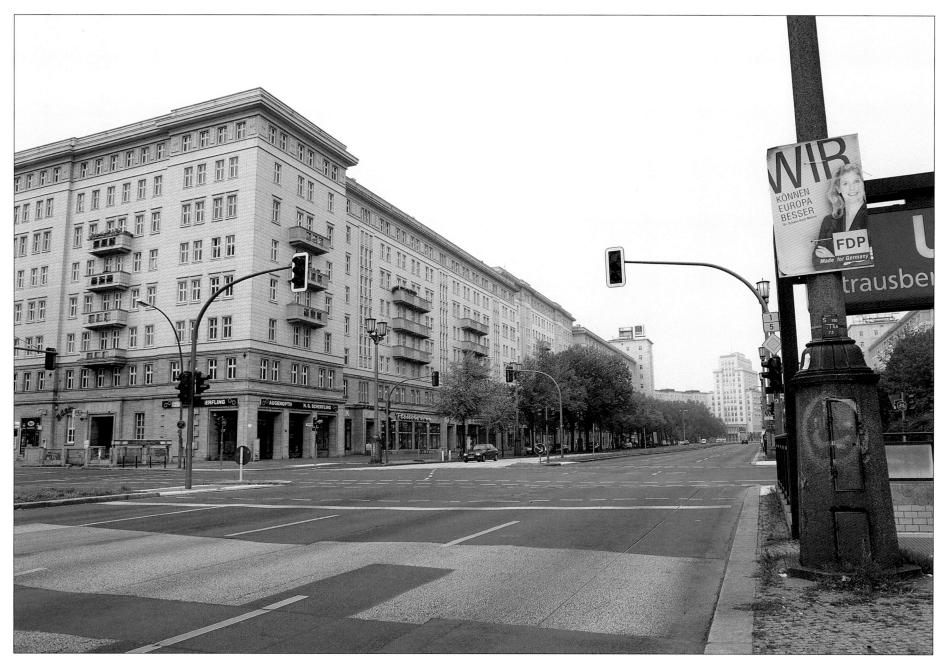

Today Strausberger Platz is a junction on the monumental Karl-Marx-Allee, constructed in the early 1950s as the showcase housing street in the former East Berlin. Its Soviet-influenced architecture was designed while Stalin still called the shots in Moscow, and on its completion, it was called Stalin Allee. In March 1953, the middle of its construction, Stalin died and most people expected that conditions would improve. However, in June 1953, East German construction workers were told that they had to work longer hours for less pay, unleashing a strike which rapidly turned into an uprising. In the ensuing chaos, the government lost control all over the country and was only rescued by the Red Army. On June 17, Soviet tanks cleared the streets, killing up to 200 people in the suppression of the uprising. In 1961, the street name was changed to Karl-Marx-Allee.

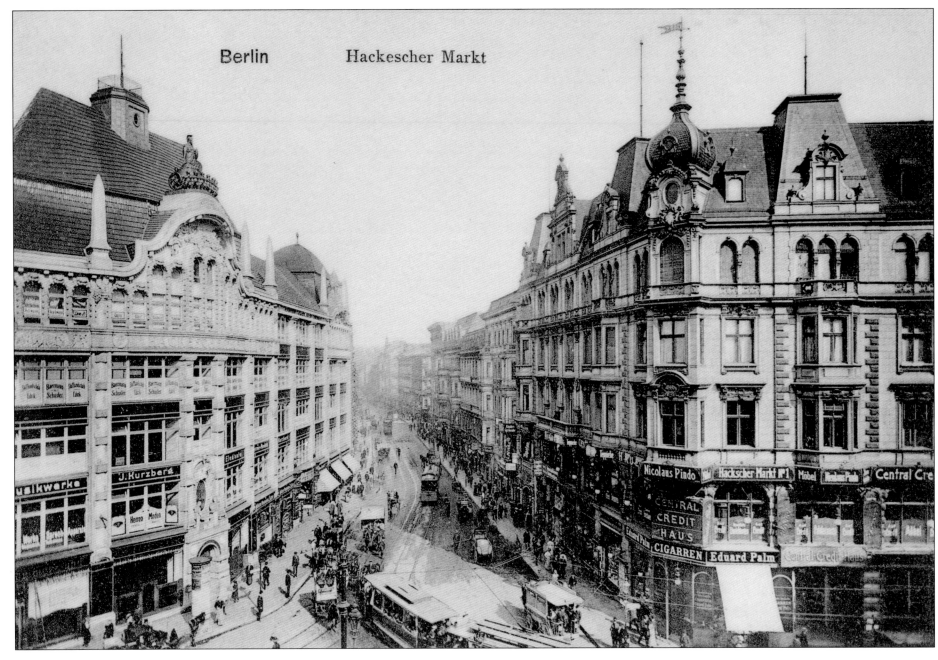

Berlin　　　　Hackescher Markt

This view from 1910 is looking up Rosenthalerstrasse, with Hackescher Markt on the right and Hackeschen Höfe on the left. Hackescher Markt was named after the eighteenth-century military commander General Hacke. The photo shows plenty of life in the street; Rosenthalerstrasse also contained a department store built in 1890s for the Wertheim family, one of the most successful Jewish retailers. Not far from here was one of the poorest neighborhoods of Berlin, the Scheunenviertel. Large numbers of immigrants moved here between the 1880s and 1920s, many of Jewish extraction, fleeing grinding poverty in eastern Europe. Speaking Yiddish and often religiously observant, the "Ostjuden," as they were pejoratively called, had little in common with the more assimilated and affluent German Jews who lived in Charlottenburg and Wilmersdorf.

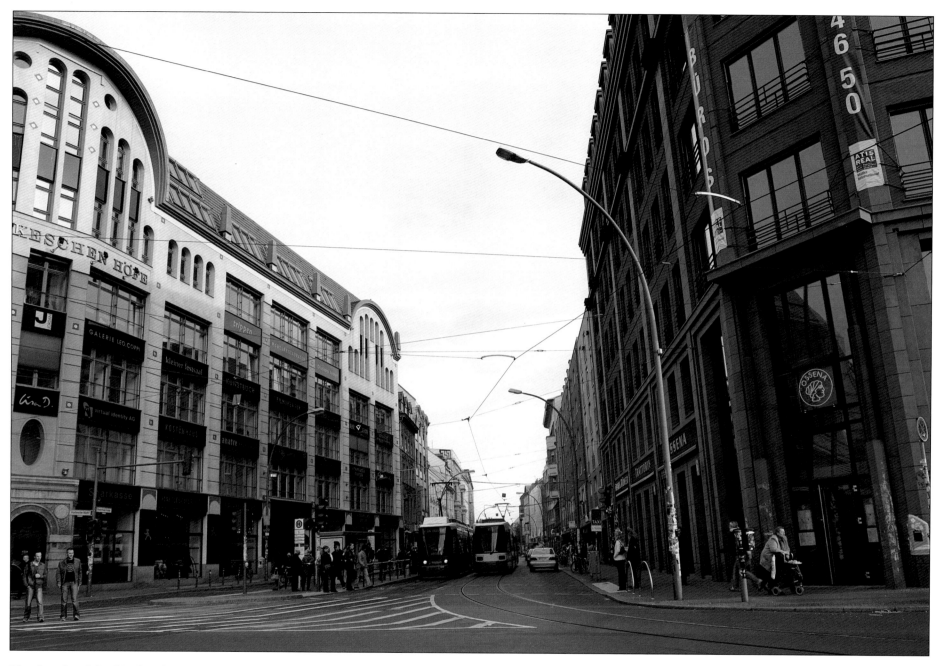

The facade of the Hackeschen Höfe is recognizably the same and the streetcars are still here, but the red building on the right corner is totally new, part of a large development, built in the late 1990s, that stretches all the way to the railway lines to the south. As in other parts of the former East Berlin, the changes here since 1990 have been enormous; this was the first district in the old center to come alive as far as nightlife is concerned, and at night the whole area is full of locals and visitors frequenting the new restaurants, bars, and clubs.

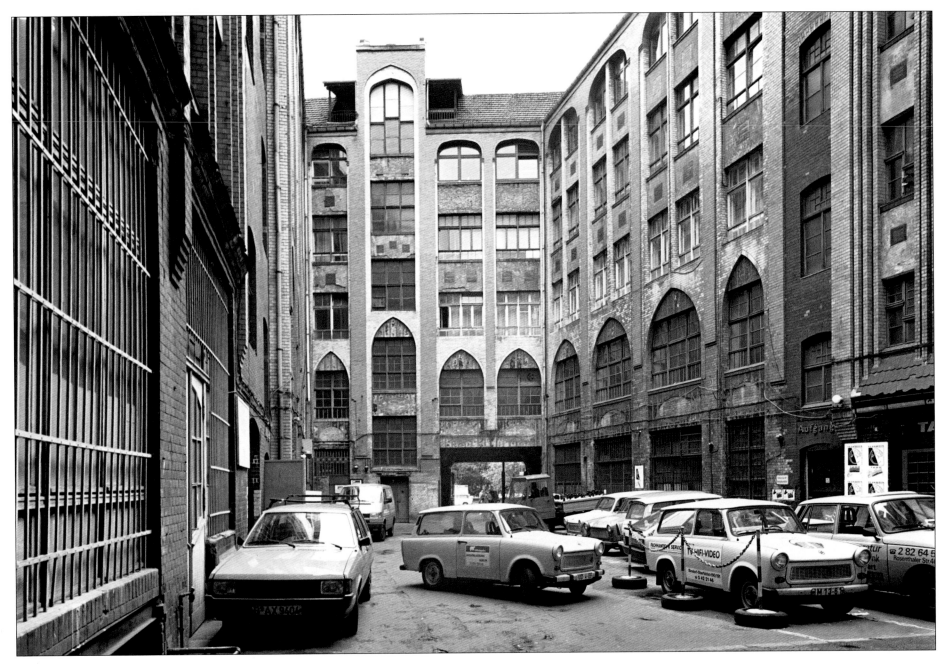

This courtyard is the first of eight interior courtyards developed in the early 1900s as a mixed-use development and called simply the Hackeschen Höfe; it connects Rosenthaler Strasse (seen through the driveway) with Sophienstrasse. In the center of this photo are two Trabant station wagons made by the East German state as their answer to the Volkswagen Beetle. In this shape or the grandly named "limousine," three million Trabis came off the production line between 1964 and 1990. The car acquired legendary status for many reasons: with only nine moving parts, it was surprisingly reliable and economical, and it didn't rust, thanks to the Duroplast bodywork. But, with the gas tank positioned above the engine, safety apparently wasn't high on the agenda for its passengers, and the two-stroke engine caused a lot of pollution.

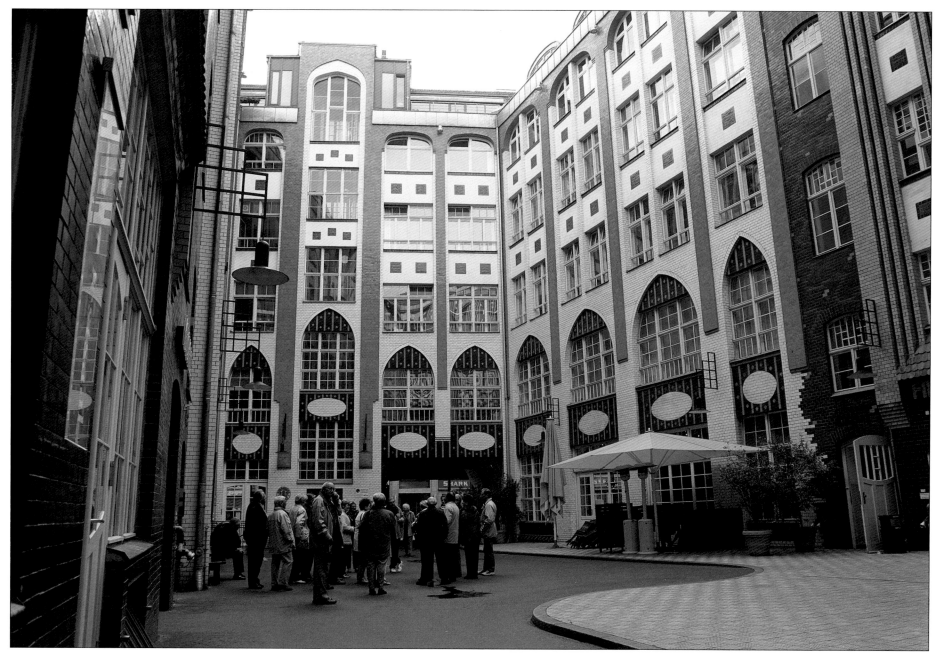

In this photo can be seen the wonderful Art Nouveau interior facades in their original color as designed by August Endell in the early 1900s. When it first opened in 1907, the Hackeschen Höfe contained restaurants, workshops, offices, and apartments. In 1924, the development was purchased by a Jewish investor, Jacob Michael; he left Germany before the Nazi takeover but in 1940 he was forced to sell the property by the state. However, the authorities were unaware that Michael had sold it to someone who held it on trust for him. After the war, the property (and all real estate in East Berlin) was nationalized by the East German government. The reunification agreement allowed former owners to reclaim their real estate and the property was returned to Michael's heirs. It was then sold to a developer who restored it in the mid-1990s.

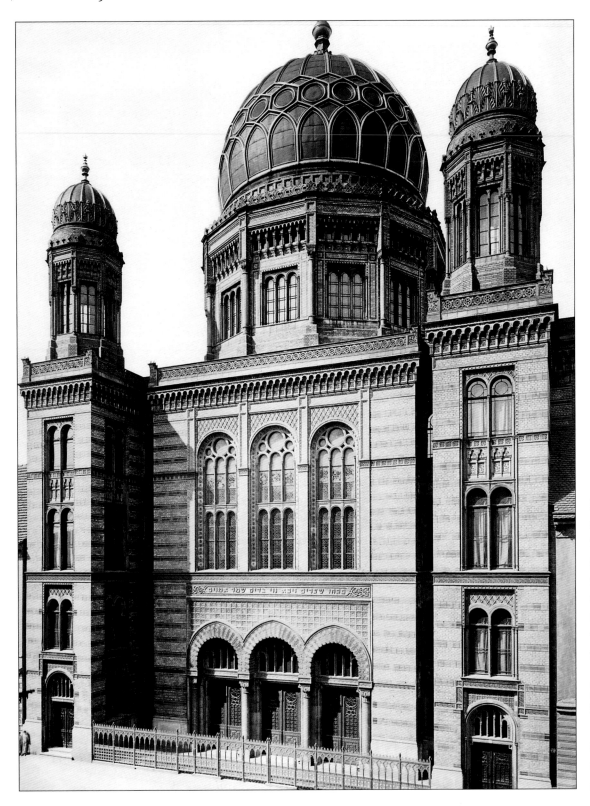

In the middle of the nineteenth century, Berlin's Jewish community had grown considerably, but there were only two synagogues in the city. In the 1850s, a site was purchased on Oranienburger Strasse, which was narrow and deep. When the architect, Eduard Knoblauch, proposed a large dome above the hall of the temple, the elders of the community had the plan modified so that the dome would be built on top of the entrance vestibule, making the dome visible from the street. Built between 1859 and 1866, several court figures, including Chancellor Otto von Bismarck, were in attendance for the opening ceremony. Over 3,000 could be accommodated in the main temple. By 1880, when this photo was taken, the Neue Synagoge (New Synagogue) had become a major tourist attraction, thanks to the exotic dome and the size of the building, which dwarfed the other buildings in the street.

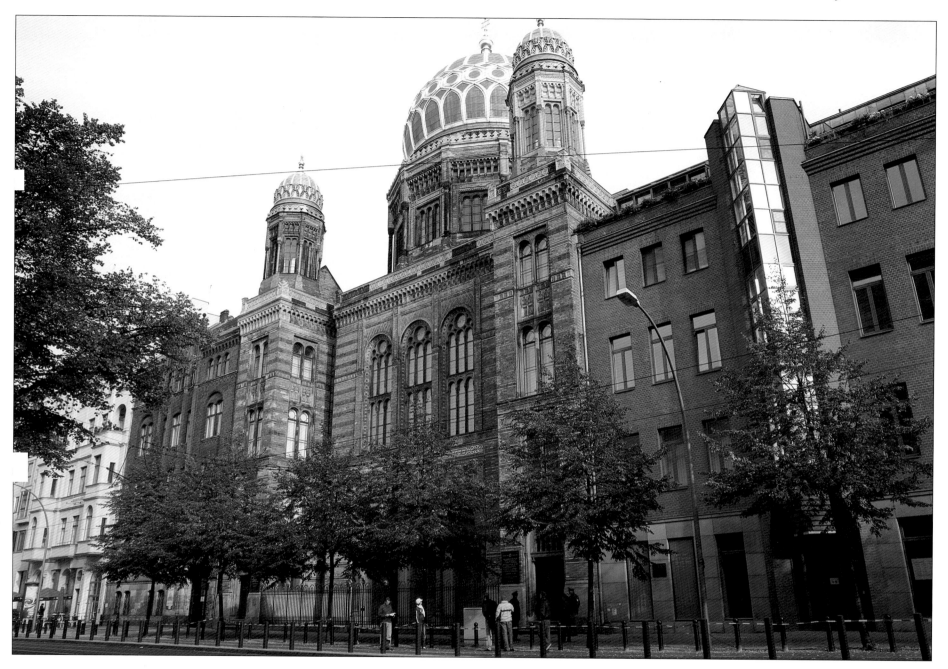

In 1995, the Centrum Judaicum opened as a museum for the synagogue and the prewar Jewish community. Only the front half of the building has been rebuilt, the site of the main temple lying empty behind. Targeted by the brown shirts on November 9, 1938—Reichskristallnacht, the "Night of Broken Glass"—the synagogue was only spared because of the personal intervention of the local police chief, who was, unusually for 1938, not a Nazi. However, the community lost the building to the government in 1940, and the main hall and dome were destroyed in bombing raids during the war. In 1988, construction started on the front section of the building. The reconstruction was carried out so that it is possible to make out what is new and what is original in the stonework—the lighter stone being new. Only the left-hand cupola of the three domes is original.

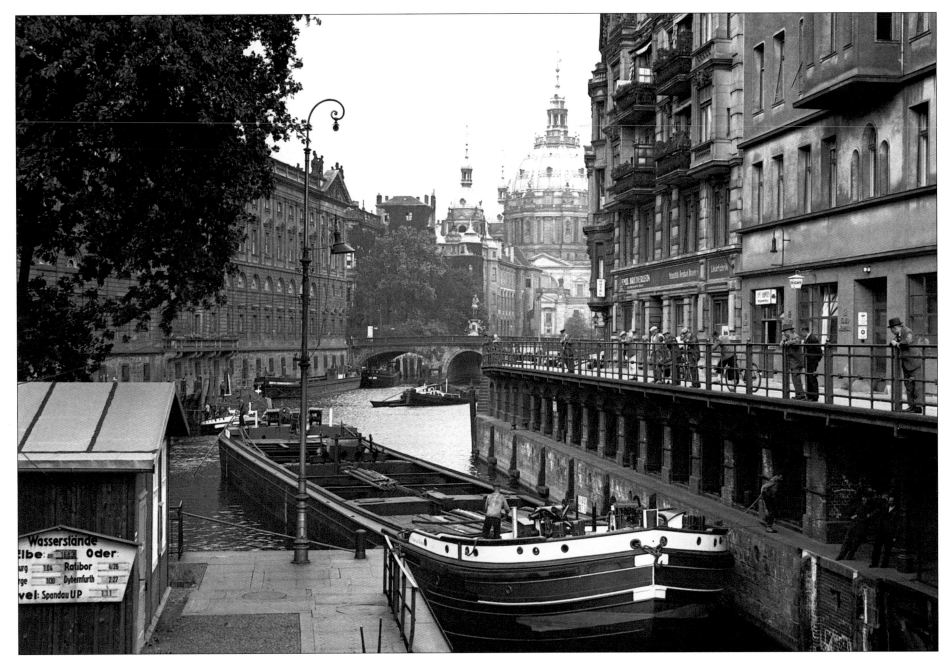

The name of this street, Mühlendamm, can best be translated as the "Mill Crossing." The relative ease of crossing the Spree here explains why the twelfth-century twin towns of Berlin and Cölln were founded at this location. Soon the river was closed to traffic here to allow a mill to function. Boats were diverted to the other arm of the Spree for the next 600 years. The number of mills grew to ten by the early nineteenth century, and in the 1830s, a new mill building was constructed. In the 1890s, the Spree became navigable again at this spot with the construction of the Mühlendamm lock. In the middle distance on the left bank of the Spree, are the Neue Marstall (New Stables), which were built in the 1890s for the royal palace and had sandstone-covered facades. Beyond the Neue Marstall can be seen the back of the city palace and the Berliner Dom.

Soon after the photo opposite was taken, the Mühlendamm was widened and the locks removed. The position of the bridge was also moved, necessitating the removal of the Ephraim Palace in the Nikolaiviertel. This photograph has been taken from a different point to achieve the same angle on the Marstall and the Dom. It is not surprising that the Spree side of the Nikolaiviertel should look so different, not only because of the realignment of the Mühlendamm but also because of the nature of the rebuilding in the 1980s—none of the buildings facing the river look very similar to their prewar precursors. The days of Berlin relying on boat and ship traffic for its existence may be over, but it is good to see that the river continues to be used and enjoyed in a different way: tour boats share the river here with two four-person rowing shells.

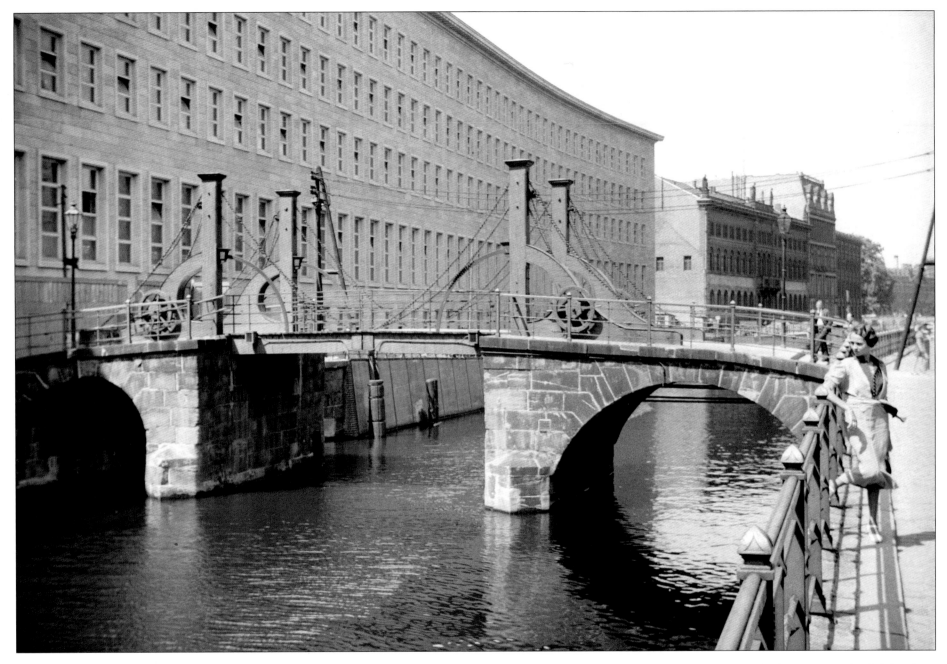

The first wooden bridge on this part of the Spree was built in the late 1600s and replaced with this iron drawbridge, the Jungfernbrücke, in 1798. By the time this photo was taken, in 1937, this arm of the Spree was closed to traffic after the new Mühlendamm lock had opened. It is no accident that a young lady is leaning on the railings for the photographer: Jungfernbrücke translates as the "Maiden's Bridge." In the early 1700s, lots of unmarried daughters of Huguenot families congregated here to chat and sell trinkets. The left bank seen in this photo was where many Huguenots first settled. The massive building to the left of the bridge is the new Reichsbank. Designed by Heinrich Wolff for the German national bank, it was the first major new public building completed in the center of town by the Nazi dictatorship. The low building further along the river was part of the Royal Mint.

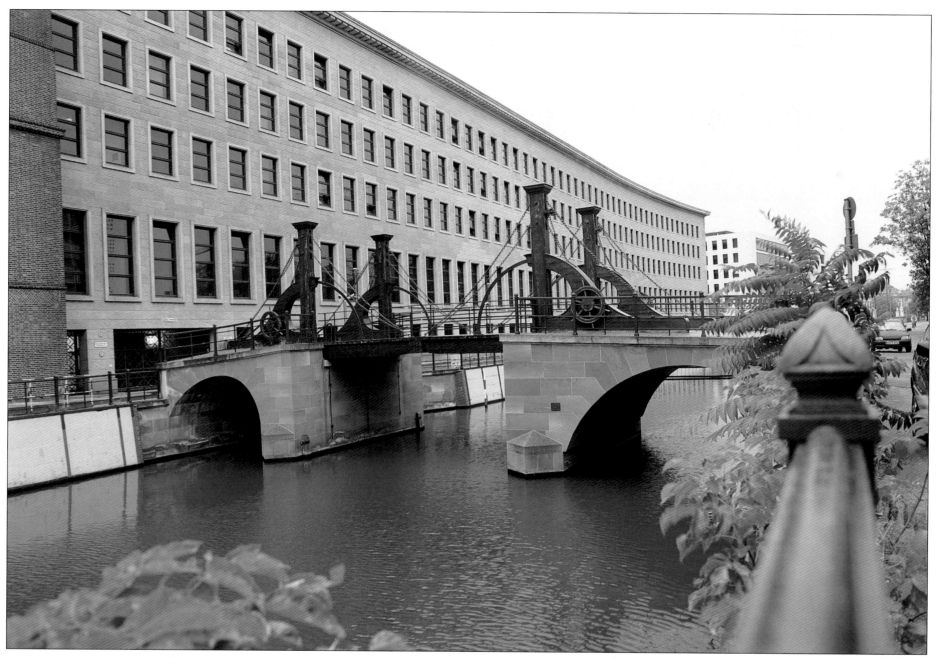

Surviving the destruction of World War II, the Jungfernbrücke is Berlin's oldest bridge, and it is now limited to foot traffic. Less surprising is the fact that the huge mass of the Reichsbank survived. At first it was controlled by the East German finance ministry, but after 1959, it effectively became the main administrative building for the dictatorship, housing the central committee of the ruling SED (Socialist Unity Party). In the same building, the local Berlin apparatus of the party was headquartered. Rebuilt in the 1990s by Hans Kollhoff for the foreign ministry, it has had a new addition built on the north side (where the mint used to stand). Since November 1999, when the foreign ministry moved from Bonn to Berlin, this is where Joschka Fischer, the foreign minister, works, using the same office formerly occupied by East German party secretary Erich Honecker.

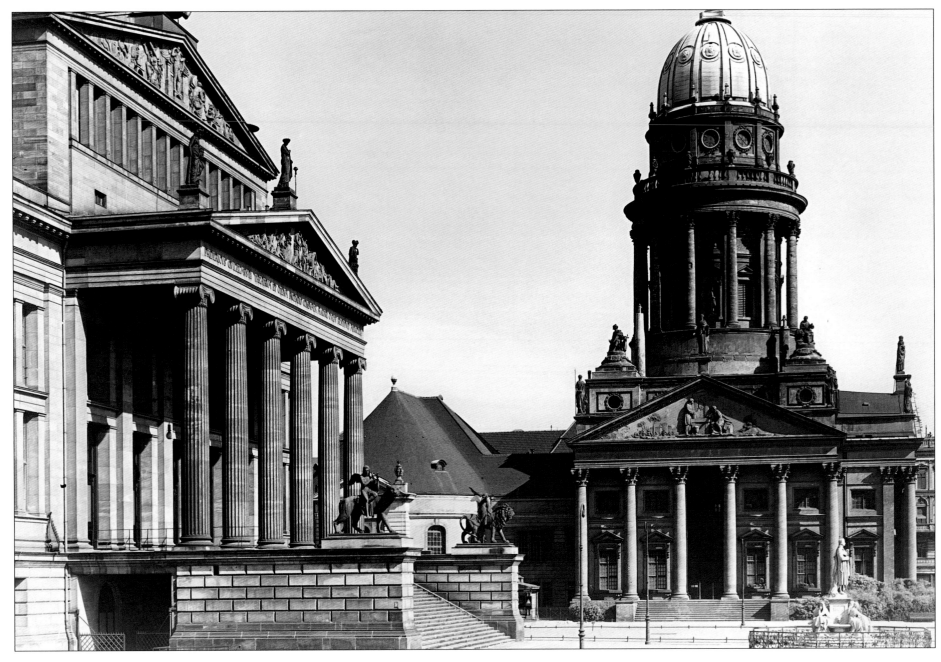

This view of Gendarmenmarkt shows Schinkel's Schauspielhaus on the left, with the French Church center and right, and is taken from the steps of the matching German Church. This area was first built out in the early 1700s, soon after large numbers of French Protestant refugees, the Huguenots, had arrived in Berlin on the invitation of the Great Elector. They had their own church built for them (the single-story building directly behind the steps of the Schauspielhaus) in this new part of town where many of them settled. In the late eighteenth century, Frederick the Great commissioned Gontard to build the grandiose towers for both churches, and in the 1790s, the first theater was built where the Schauspielhaus now stands. This was damaged by fire in the early 1800s, and Schinkel rebuilt it to a larger plan. On the lower right Reinhold Begas's Schiller memorial statue can be seen.

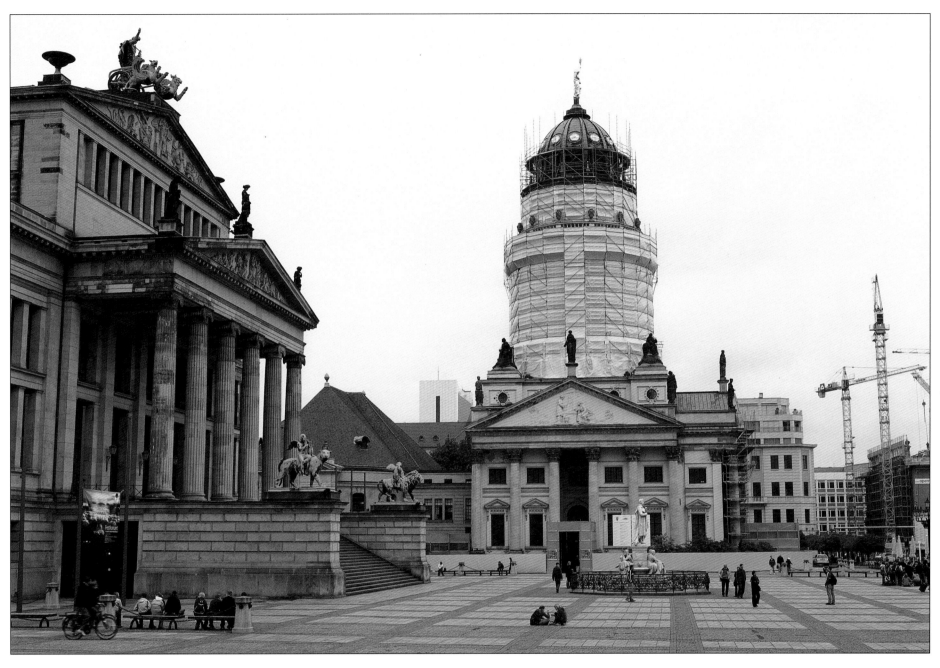

Both churches and the Schauspielhaus suffered serious damage in the war. Like the Hotel Adlon, the Schauspielhaus survived the bombing only to catch fire at the very end of the Battle of Berlin; it was allegedly set on fire by SS men. The French church was rebuilt in the late 1970s, and as before, there is a Huguenot museum in the tower section. The Schauspielhaus had to wait until 1978 before reconstruction started; in 1984, it was reopened with much pomp as the new auditorium for the Berlin Symphony Orchestra. The Schauspielhaus, now officially the Konzert Haus, has a rich musical past: this was the venue for the premiere of Weber's opera *Freischütz*, and Wagner conducted his own *Flying Dutchman* here.

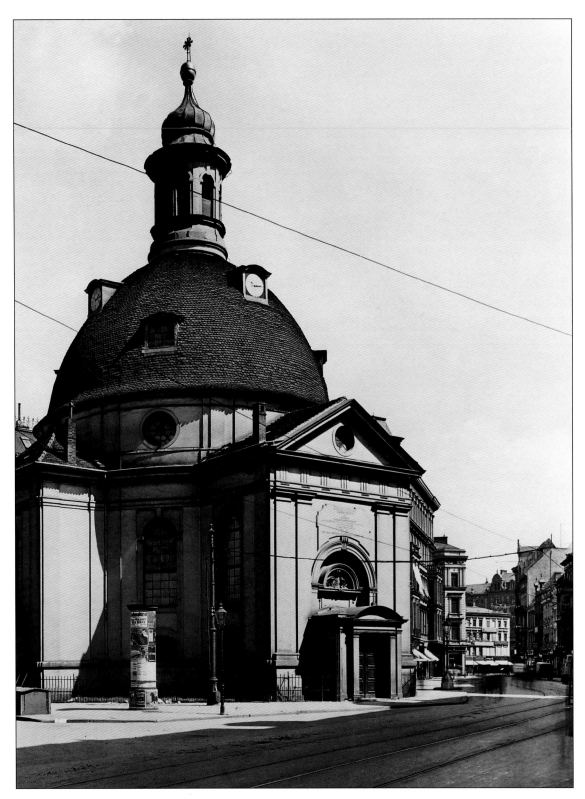

This small church dates from the mid-eighteenth century. In the early 1730s, on the invitation of Frederick Wilhelm I, persecuted Protestants from Bohemia were allowed to settle in Berlin and Rixdorf, today the city district of Berlin Neu-Kölln. Between 1735 and 1737, they were allowed to build their own church, named the Bethlehemskirche in memory of the Bethlehem Chapel in Prague, where the Bohemian Reformer Jan Hus had preached. It was located just inside the city walls on the corner of Mauerstrasse and Krausenstrasse in the Friedrichstadt, where the community had been allowed to build their homes. In the distance on the right, Mauerstrasse can be seen to run into Friedrichstrasse, which would one day become famous as the site of Checkpoint Charlie.

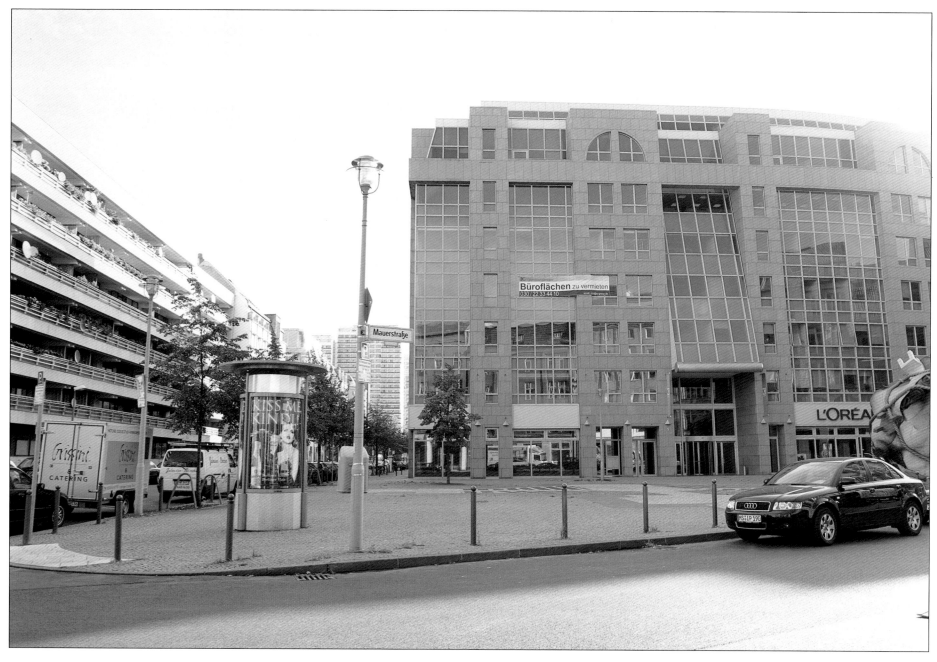

The church was badly damaged in the war, and its remains were pulled down in the early 1960s. In the years of division, this became part of the high security area around the visitor processing buildings at Checkpoint Charlie. In the 1990s, American star architect Philip Johnson designed the office building at the center right of this photo. It is a measure of his high standing that the building was named after him—Philip-Johnson-Haus. In the open space on this side of the new building in 1999, the authorities demarcated where the walls of the Bethlehemskirche were, marked out in pink, white, and gray in the cobblestones. On the far right-hand side of the photo can be seen part of the twenty-seven-foot-high sculpture, *Houseball*, by Claes Oldenburg and Coosje van Bruggen. Installed in 1996, it symbolizes the meager belongings of a person in exile.

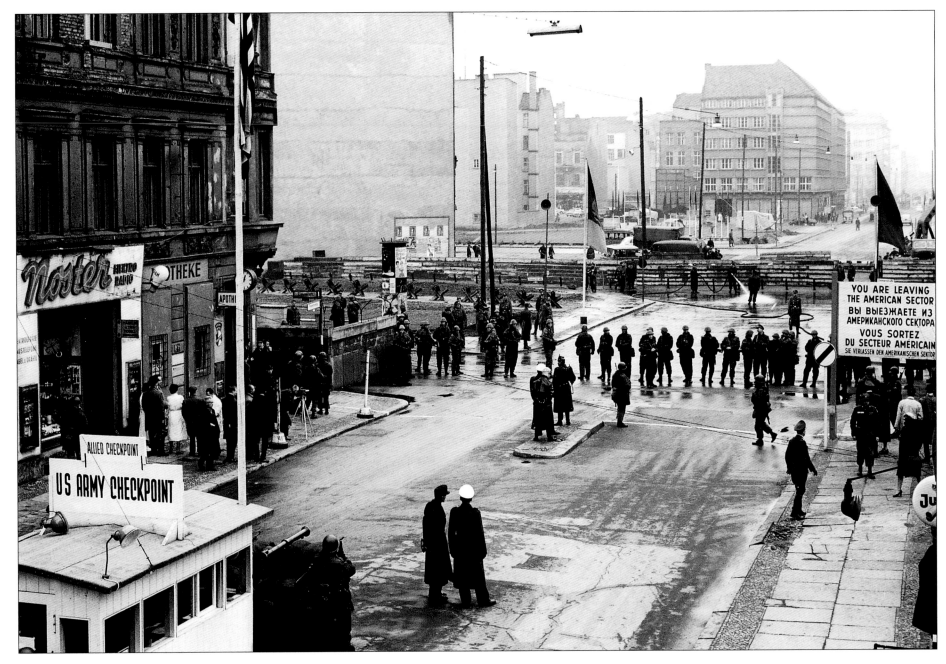

In the early hours of August 13, 1961, East German troops began to seal off the border surrounding West Berlin as 50,000 East German troops constructed the first barbed wire "wall" within a few hours. They concentrated on the thirty miles that separated West Berlin from East Berlin. Over the following weeks, the entire hundred-mile perimeter of West Berlin was surrounded with a wall of bricks, mortar, and barbed wire. It was built with one purpose only: to prevent East Germans from reaching West Berlin, their stepping-stone to West Germany. Shown here is the only one of seven crossing points through which foreigners, including the Western Allies, were allowed access to East Berlin; it was known as the Friedrichstrasse Crossing in the East. In this photo, from December 1961, East German border troops are in a line facing the West. The white line painted on the road marks the border and the white board warns the public where the American sector ends. In the middle distance, the Wall is already much in evidence.

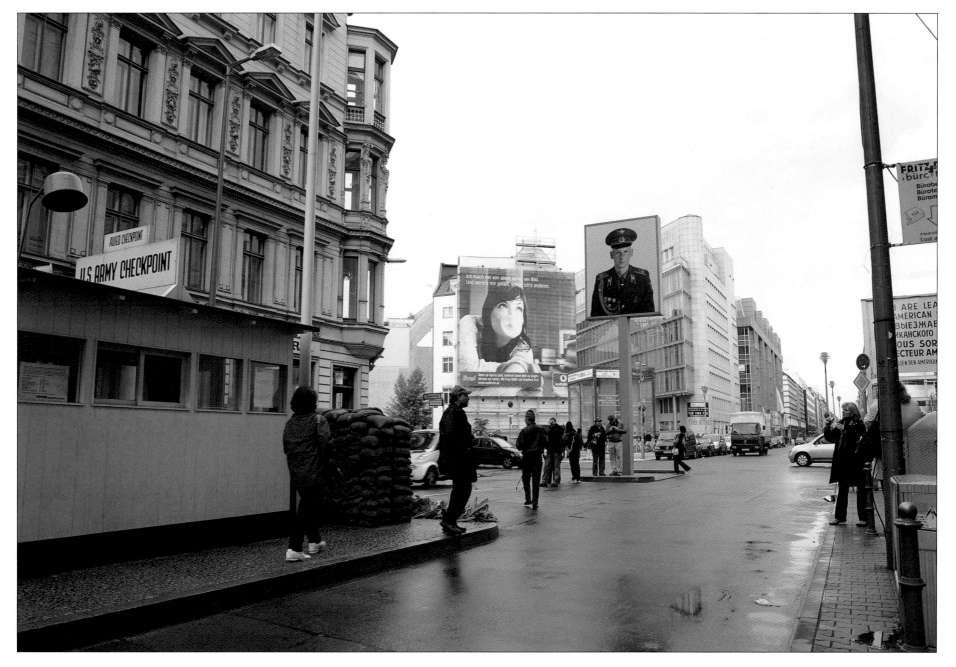

The crossing point was quickly dubbed "Checkpoint Charlie" by the Western Allies; Checkpoints Alpha and Bravo already existed at either end of the East German highway. From 1949 onward, the Western Allies used this road to access East Berlin. The hut and the board seem unchanged, but neither is in fact original. Sadly, the conservators were too late to protect any structures at Checkpoint Charlie and the structures here now are replicas. The curious photograph of a young Russian solder facing the west (mirrored by a young American facing east) was placed there in 1998 by the city and was the work of artist Frank Thiel, who won a competition to mark the site of the crossing point in 1996. The foundation that runs the Wall Museum at Checkpoint Charlie (Mauermuseum Haus am Checkpoint Charlie) was responsible for building the replica of the hut, unveiled on August 13, 2000. Since the founder of the Wall Museum, Rainer Hildebrandt, died in early 2004, there have been flowers laid on the road in front of the hut.

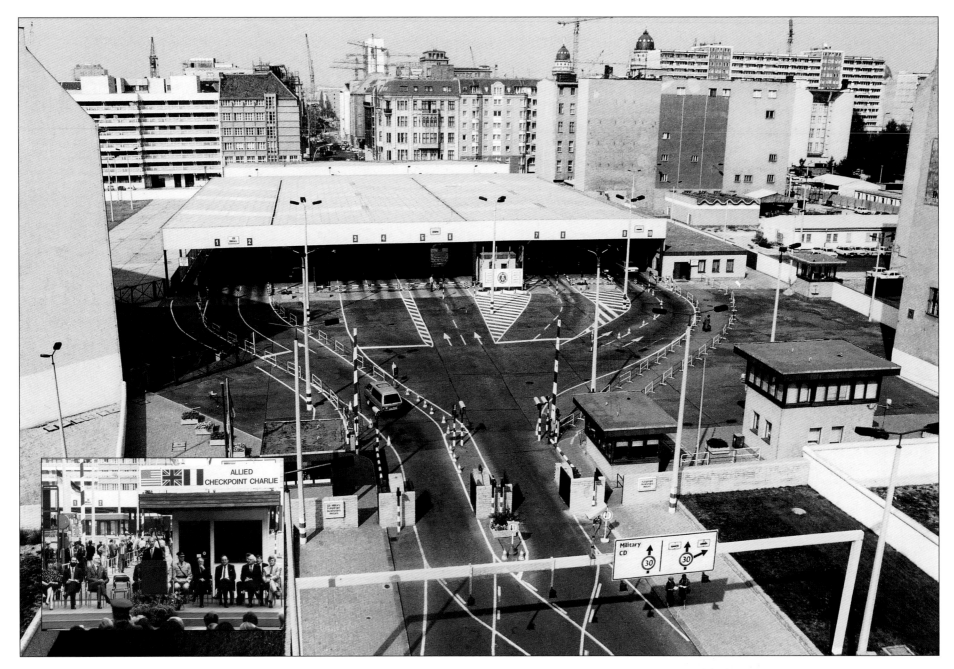

This picture was taken from the west side of the border looking at the visitor processing building constructed in 1985 on the east side of Checkpoint Charlie. Prior to 1985, there was a motley array of single-story buildings serving the same purpose. Checkpoint Charlie was the busiest of the seven crossing points. Most foreign visitors chose to use it, although they could also access East Berlin by the S-Bahn train from Zoo station to Friedrichstrasse station. Inset is a photo taken on June 22, 1990, when the Checkpoint Charlie cabin was hoisted away into the history books. The U.S. Secretary of State, James Baker, is on the rostrum flanked by, among others, his Soviet counterpart Edward Shevardnadze. In the distance, the redundant visitor processing building on the east side of the border still stands (numbers 1 and 2 are visible on the white background), but it, too, was about to disappear.

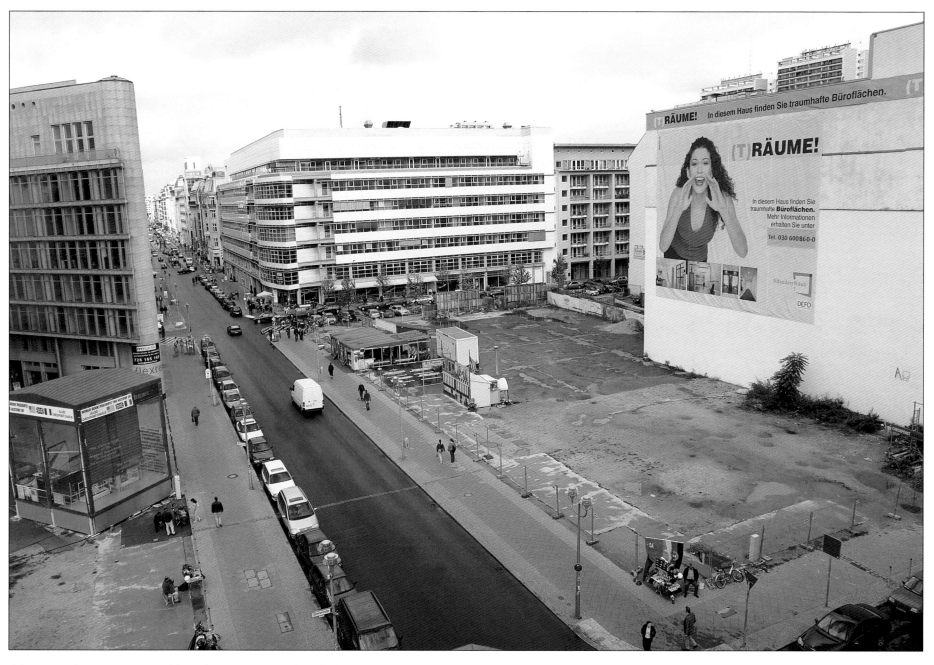

Almost nothing is recognizable today since more than half of the original site now houses new commercial buildings. Sadly, none of the border-control buildings were protected by the city authorities at Checkpoint Charlie and the last remaining building (the watchtower seen in the previous photo) was torn down by developers in December 2000. Despite the removal of the border-control buildings on both sides in 1990, it was not possible to traverse the whole length of Friedrichstrasse, as seen in this photo, until the late 1990s—such was the number of buildings along the street. Today Checkpoint Charlie is one of the major tourist attractions in Berlin; where once people waited in line to enter East Germany, people now wait their turn to take photos of the Checkpoint Charlie hut, while Berliners make use of gyms and Italian restaurants in the new buildings on Friedrichstrasse.

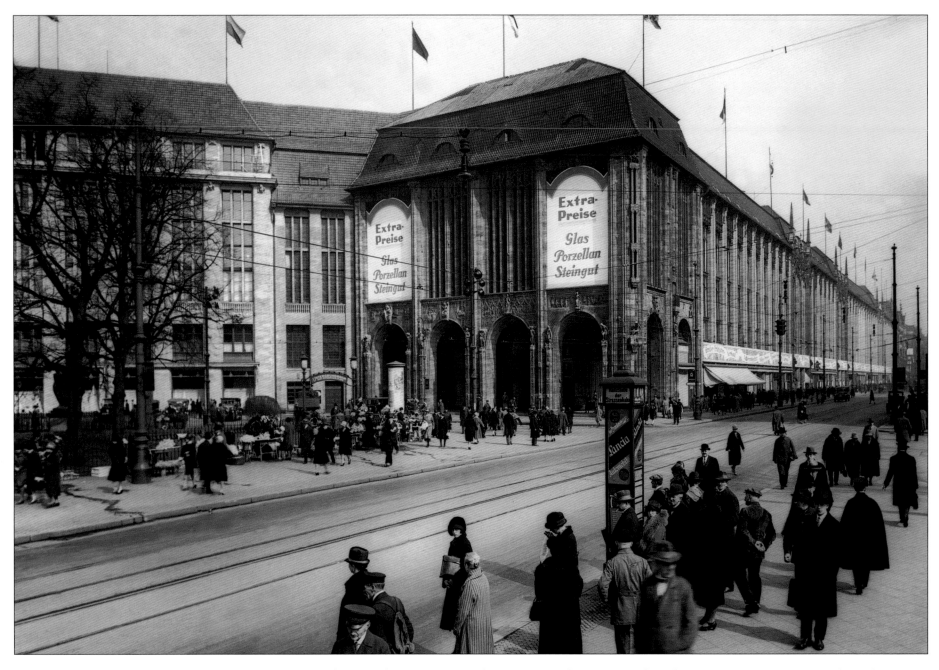

By the time this photo was taken in the 1920s, the flagship Wertheim department store rivaled KaDeWe in the "new west" as the leading department store in the city. It fronted both Leipziger Platz, from where this shot is taken, and the Leipziger Strasse disappearing to the right. The Jewish family after which the business was named originally came from Stralsund. George, the oldest son of the founder, and his two brothers moved the business to Berlin, opening their first store in 1890. Two years later they opened this store here on Leipziger Strasse, but the building, designed by Alfred Messel, was not built until 1905. Dubbed a "cathedral to shopping," the enormous atrium inside was a major attraction, especially when decorated for Christmas. In the late 1930s, the business was "Aryanized" and the Wertheim family went into exile.

The store buildings were damaged by bombing in 1943 and then burned out a year later. Today, unlike Potsdamer Platz next door, the original street layout of Leipziger Platz has been retained in the present rebuilding of the square. It is immediately east of Potsdamer Platz and suffered the same fate after 1961 of lying in or close to the Death Strip. Nothing remains of the Wertheim store and the future of this site still hangs in the balance. The heirs of the

Wertheim family were not able to secure the return of the site after 1990 on the grounds that the family had been adequately compensated after the war when Karstadt took over what remained of the Wertheim business. In the foreground, crossing the sidewalk and pink-colored cycle path, another line of cobblestones shows where the Wall ran. This is the inner wall, the one that appears whitewashed in the photo taken on page 90.

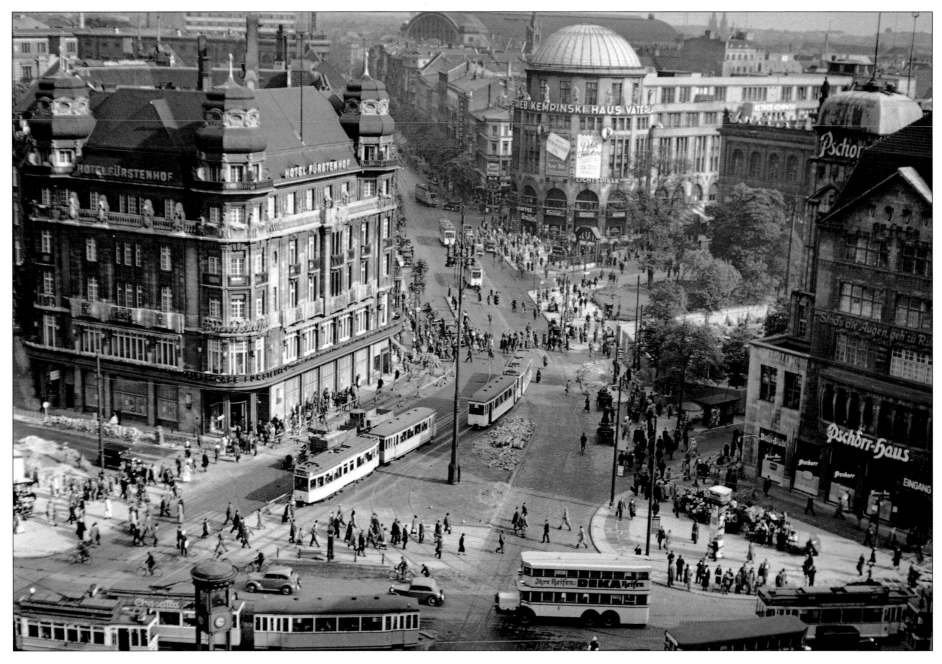

Potsdamer Platz in the 1920s was the busiest traffic intersection in Europe and this view of the south side demonstrates this. Five roads came together at one point and traffic was forced through here by the presence of railway lines to the south and the Tiergarten park to the west. The huge roof of the largest station in Berlin, the Anhalter, can be seen in the center in the distance; nearer to the junction was the Potsdam station, seen on the right behind the trees in the shade. The building with the striking dome in the center of the picture was a themed restaurant complex built in the early 1900s by the Kempinski family. Called Haus Piccadilly when it first opened, the name was changed to Haus Vaterland in 1914. In the lower left, what looks like a clock tower on stilts can be seen; this is in fact a set of traffic lights facing five ways, installed in 1924. Hotel Furstenhof is seen on the left.

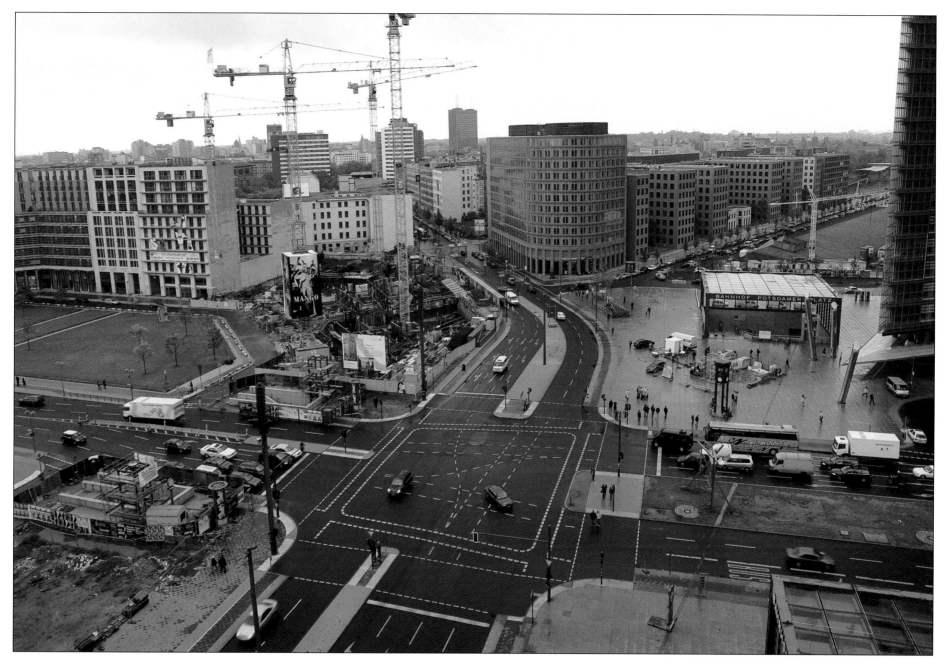

The curve of Stresemannstrasse, formerly Königgrätzer and later Saarlandstrasse, is instantly recognizable in this shot. In place of Haus Vaterland stands the curved front of a new office building designed by Georgio Grassi, the curve recalling its predecessor. On the right-hand side of the photo stands the knife-edge corner of one of the office buildings designed by Renzo Piano for Daimler Chrysler's new development. This corporation is the largest investor at Potsdamer Platz; between 1994 and 1999, a seventeen-acre site was developed with offices, stores, and apartments. Behind Piano's building, a green lawn marks the site of the Potsdam station; the rail lines have been moved into tunnels and a new station is being built underground. To ease traffic, a new Potsdamer Strasse has been created, seen here lower right. A replica of the old traffic light first installed in 1924 has been built on the sidewalk, seen directly behind the green bus. On the center left, the Sony Corporation is building on the site of the Hotel Fürstenhof.

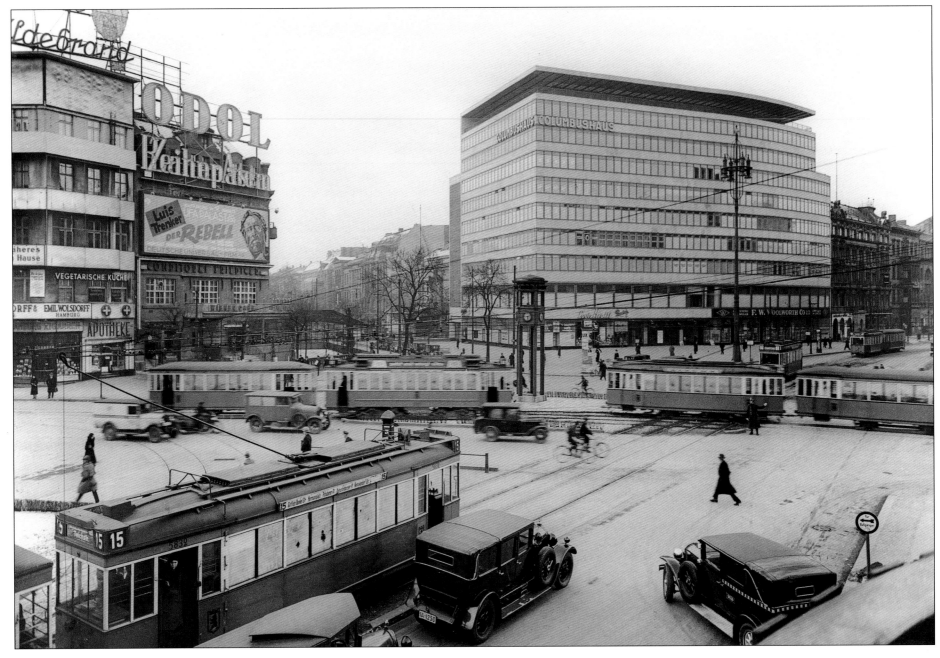

The traffic light pentagon in the middle of the photo tells us that we are still on Potsdamer Platz, looking north. Center right is the Erich Mendelsohn–designed Columbus Haus; the block on the left housed the famous Café Josty until 1932. To the right, Ebertstrasse (later Herman-Goering-Strasse) disappears northward and to the left is Bellevuestrasse. When this photo was taken in 1933, Columbus Haus was only a year old.

Built on the site of the Hotel Bellevue, it was going to be the first new building in a radical modernization of the area; however, the Nazis were never fond of modernism and many other countries benefited from the exodus of leading avant-garde architects from Germany in 1933. Mendelsohn designed some of the most interesting buildings in Germany during the years of the Weimar Republic, including the Einstein Observatory, in Potsdam.

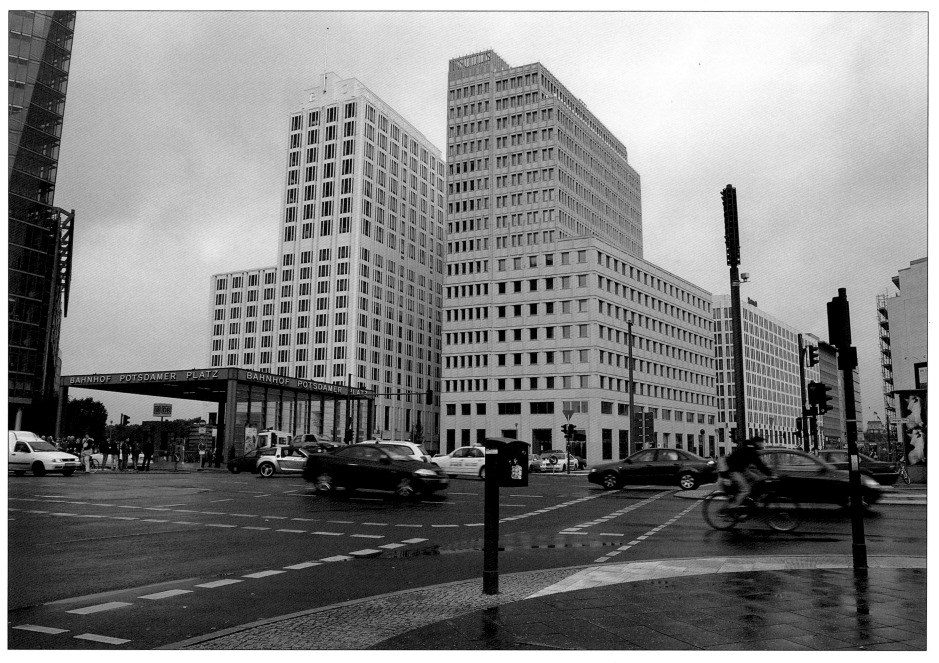

The new blocks of the Beisheim Center fill the center of this photo; they were completed in 2003 and named after its investor, the retail magnate Otto Beisheim. There are two major hotels contained in this scheme, a Ritz-Carlton and a Marriott, as well as luxury apartments and offices. Columbus Haus could have been rescued after the war, but two misfortunes befell it: in the June 1953 uprising, demonstrators set fire to the ground floor of the building because it housed a police station; then after 1961, its remains were isolated by the building of the Wall. Although technically in East Berlin, the triangular site was effectively abandoned by the East Germans. On the left, across the junction, is an entrance to the new regional train station, being built underground, to be completed in 2006. On the far left looms the Helmut Jahn–designed DB Tower, part of the Sony Center. The highest new building on Potsdamer Platz (twenty-six stories) incorporates remains of the old Esplanade Hotel, including the Kaisersaal ballroom.

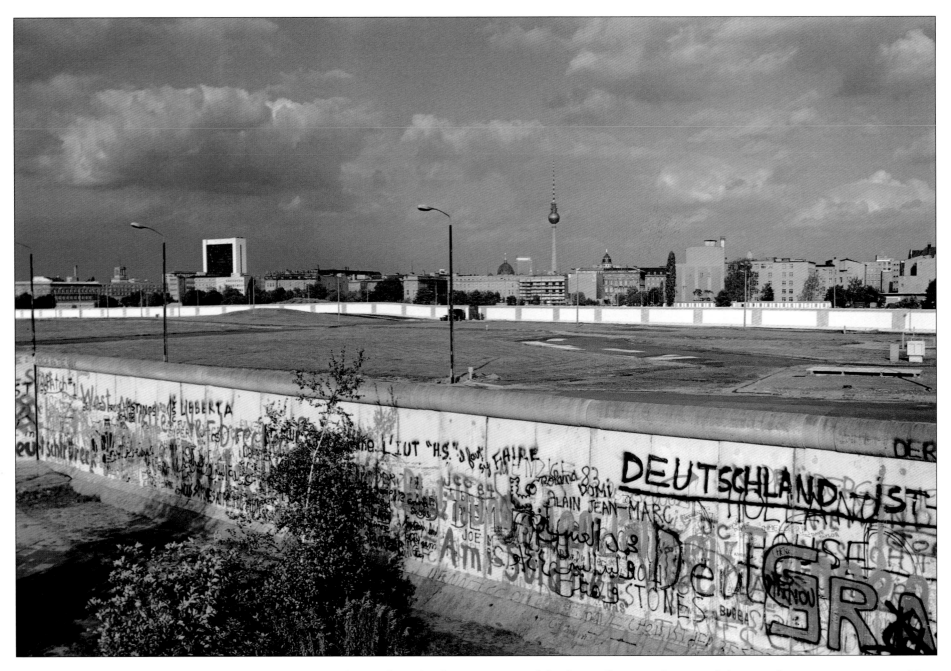

The two-walled nature of the Death Strip at Potsdamer Platz is clear, thanks to the viewing platform in West Berlin, from which this photo was taken. This eleven-foot border wall, comprising precast vertical L-shaped sections topped with concrete piping, was the third generation and was built in 1976. The first brick-and-mortar wall of 1961 had already been replaced with the second generation, a concrete slab wall, in 1966. Barbed wire was only used on top of the first wall; it was discovered that people trying to escape could grasp the barbed wire to help them get over. The blank space between the walls looks benign but every angle was covered by guards in watchtowers, positioned inside and outside the strip; within the strip, guards patrolled along a track (visible on the left), assisted by thousands of guard dogs.

This present-day view is a few yards south of where the viewing platform was, but the double line of bricks in the sidewalk and the tarmac showing where the Wall stood are easy to distinguish. The new buildings on the left are being built on the northern half of the Leipziger Platz octagon, although this photo was taken nearer to the Potsdamer Platz junction, demonstrating how close the two Plätze are. On the far left, one can see the sides of the newly completed Canadian Embassy. The large empty site in front of the Easyjet advertisement used to be occupied by Wertheim's largest department store before the war (see page 84). In the distance, the Fernsehturm (TV Tower) on Alexanderplatz is visible on the horizon.

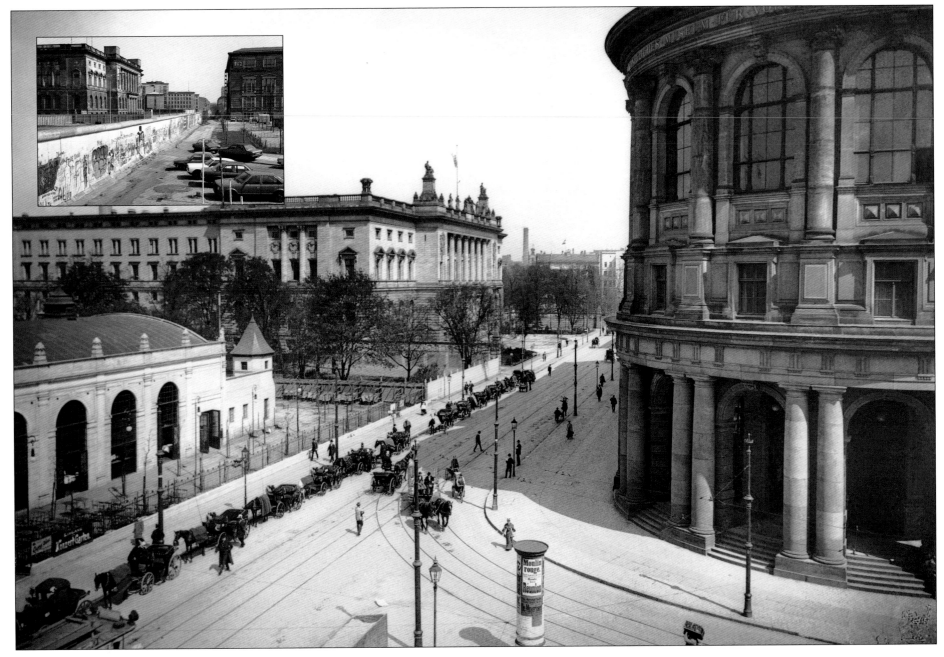

Looking east into Prinz-Albrecht-Strasse from Königgrätzerstrasse, the building on the right is the Ethnologisches Museum (Museum of Ethnology), dating from 1886. In the center is Abgeordneten Haus, the Prussian parliament, finished in 1898. In the distance, at the end of Prinz-Albrecht-Strasse, are the buildings on Wilhelmstrasse, which were later replaced with Goering's Air Ministry. Prinz-Albrecht-Strasse would become notorious after 1933 as the location of both the secret police and SS headquarters.

Diagonally opposite the Prussian lower house stood a former university building, which happened to be empty in 1933; Goering, wearing his hat as the head of the Prussian police, set up the Geheime Staatspolizei (Gestapo) in this building. Next to the Gestapo stood a hotel constructed in 1888; in the early 1930s, the hotel had been much used by the Nazi leadership for conferences and was thus well known to Heinrich Himmler; in 1934, it was requisitioned by the SS as their new Berlin headquarters.

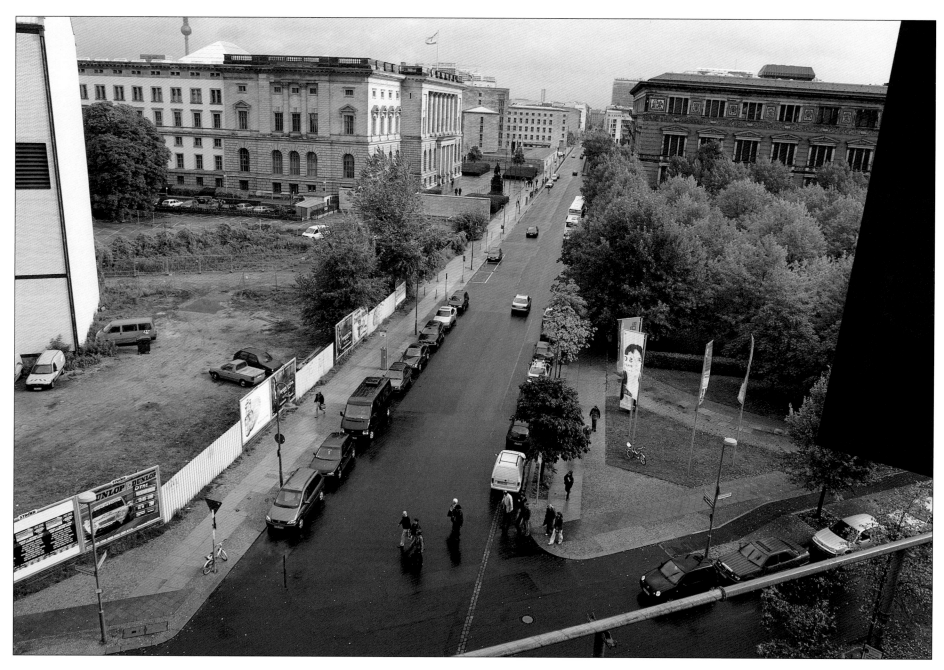

Prinz-Albrecht-Strasse, now renamed Niederkirchner Strasse, was scarred by the building of the Wall. The Ethnology Museum was swept away in 1963, revealing the Museum of Applied Arts building behind. The line of bricks in the tarmac and running across the sidewalk in the foreground of the photo marks where the Wall ran. The Wall continued into Zimmerstrasse and on into the far distance. On the horizon, on the right of the street—the West Berlin side—can be seen the outline of the Axel Springer Building beyond Checkpoint Charlie. Springer was a West German newspaper publisher who deliberately built a high-rise office building next to the Wall in 1962 so that his journalists could see into East Berlin; the East Berlin authorities responded by building a line of four high-rise apartment buildings along Leipziger Strasse to block the view. In the lower right, a temporary water pipe snakes its way down Stresemannstrasse. A familiar sight in Berlin, they are used for getting rid of unwanted groundwater from construction sites.

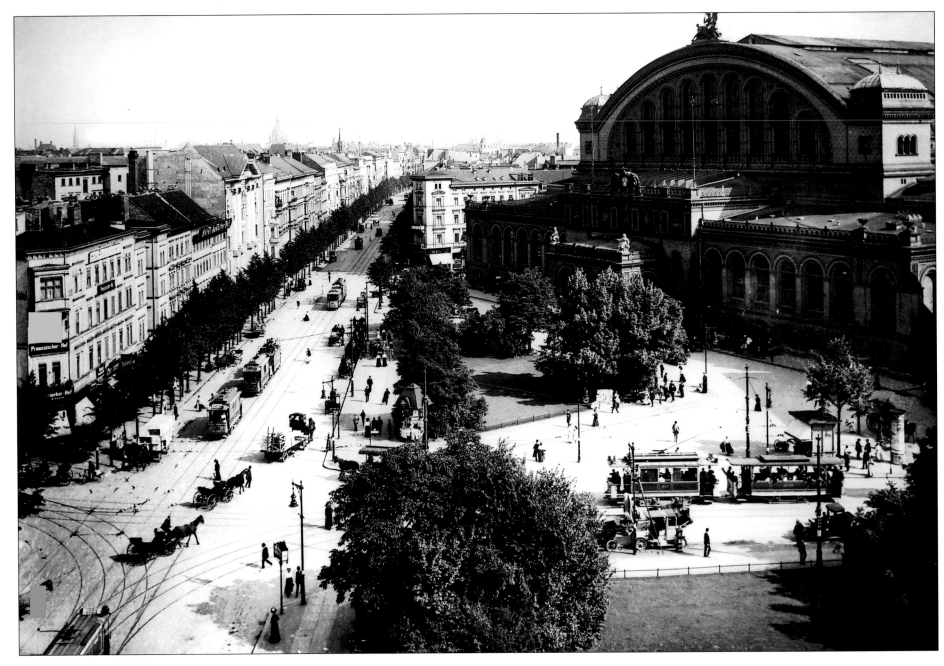

Dominating this photo is the huge form of the Anhalter station. One of the first train stations in Berlin, it opened in 1840 and was enlarged and rebuilt by Franz Schwechten, architect of the Memorial Church, in the late 1870s. Also called the "Gateway to the South," it was the terminus for trains from Bavaria and Saxony. In early October 1938, Hitler arrived at the station to a rapturous reception after signing the Munich agreements: the western democracies had been manipulated into siding with the dictatorship in the separation of the Sudetenland from the rest of Czechoslovakia, making it militarily defenseless; war had seemingly been averted—at least for the time being. The station stood on the junction of Königgrätzerstrasse, now Stresemannstrasse, seen disappearing into the distance, and Schönebergerstrasse, on a square called Askanischer Platz.

Looking from opposite what is left of the station, across Askanischer Platz. The name Anhalter Bahnhof still exists today in the form of a station on the underground S-Bahn line, the S1, built in the late 1930s—hence the green S sign in front of the scaffolding. The aboveground station is a piece of history today, a fate it shares with the Potsdam Station close by. The huge Anhalter Station was a roofless ruin by 1945, but the roof was removed and the lines restored so that trains continued to use the roofless building from 1946 until 1952. After 1949, however, the cities that this station served were in East Germany, though this station was in West Berlin. This anachronism continued until 1952, when traffic was diverted into East Berlin itself. Seven years later, most of the ruins were demolished, leaving only this small segment of the front entrance as a reminder.

This villa is typical of many on prewar Tiergartenstrasse, the street that ran along the southern edge of the Tiergarten park. In October 1939, on the direct orders of Adolf Hitler, "specially appointed doctors" were authorized to perform "mercy killings" on supposedly incurably sick people. The agency that ran this first Nazi program of mass murder was headquartered in this building; misleadingly called the "euthanasia" program and code-named "T4" after the address of this building, its "doctors" demanded information on the fitness of patients in sanatoriums and hospitals all over Germany. These patients were then sent to six locations, where they were murdered by gas or lethal injection. Bodies were immediately cremated and relatives sent falsified death certificates. A leading Protestant bishop was sent clear evidence of these murders, and in August 1941, he denounced them from the pulpit; the murders were temporarily halted, but up to this point, 70,000 people had already been murdered. Many of those involved in T4 were later sent to the East, where they helped organize more mass murders.

In the sidewalk, a memorial plaque reminds visitors that this is where the villa stood; today, the back of the site is filled with the Hans Scharoun–designed auditoriums of the Berlin Philharmonie. These concert buildings form part of the postwar Culture Forum, which is clustered around the Matthäuskirche. Most recently, the Gemäldegalerie (Picture Gallery) opened in the late 1990s to display the city's collection of medieval and early modern art. The earlier and larger Philharmonie building on the left opened in 1963 with a concert conducted by Herbert von Karajan; its design was considered revolutionary. In 2002, Simon Rattle became chief conductor of the orchestra, taking over from Claudio Abbado. The smaller Kammermusiksaal, seen on the right, was also designed by Scharoun and opened in 1987.

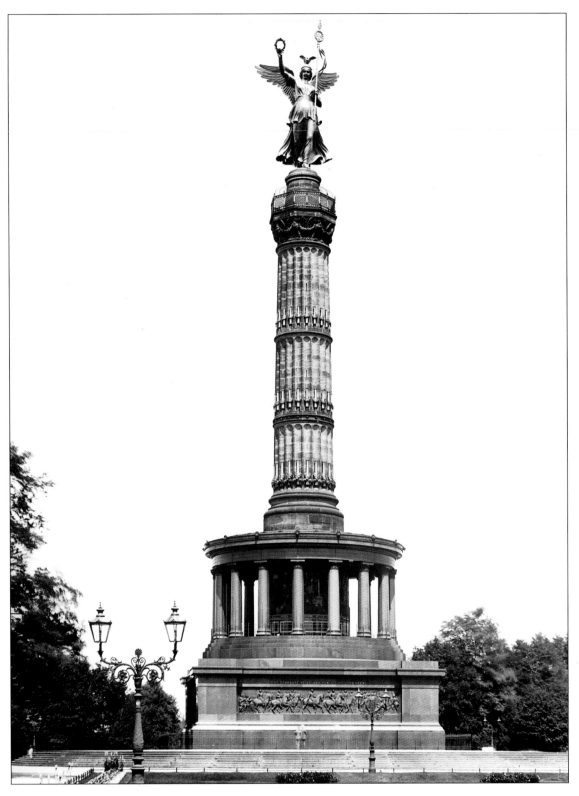

The Siegessäule was originally designed to celebrate Prussia's military achievements in the 1860s, but events unfolded so quickly that it ended up being the earliest national monument in the newly founded empire, only being finished in 1873. After the defeats of Denmark in 1864 and Austria in 1866, foundation stone–laying ceremonies had taken place on the Königsplatz north of the Tiergarten; the third and final ceremony took place after the defeat of France (reclaiming Alsace) in 1871 and the declaration of the new, united Germany. The monument was a direct instruction from the kaiser himself; there were no competitions or committees involved. Johann Strack was responsible for the column and Friedrich Drake for the bronze statue of Victoria (allegedly modeled on his own daughter). Gilded cannons captured in these wars were used as decoration on the sides of the column, which was divided into three drums representing the three wars. At its base, bronze reliefs showed scenes of battle and victory being conferred on Prussia; not surprisingly, Prussia alone is shown as victor in the war against Denmark, although it should be remembered that Austria fought alongside Prussia in this war.

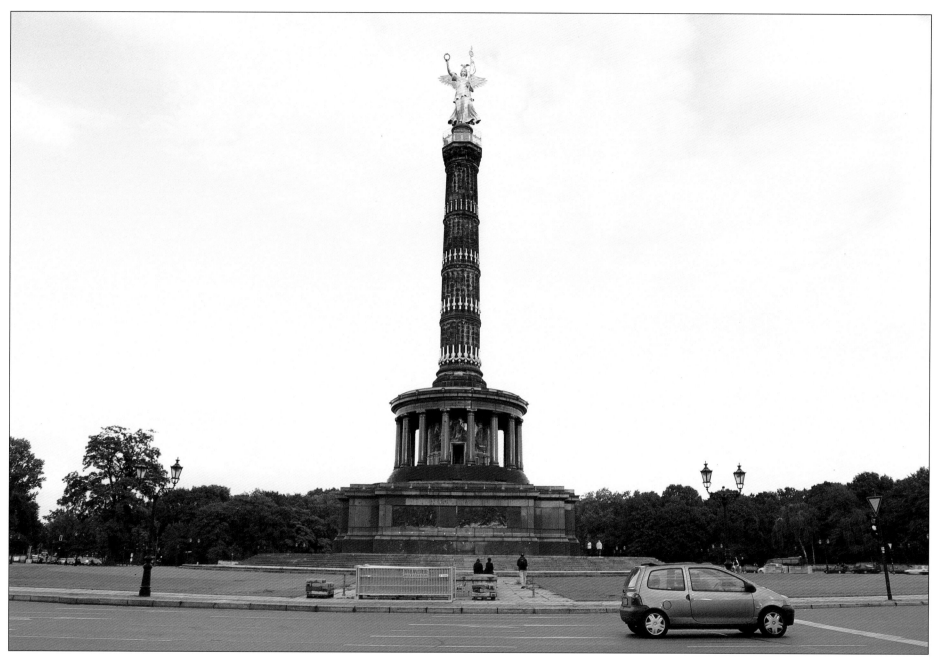

In the late 1930s, the Siegessäule was dismantled and rebuilt in the center of the Tiergarten, along with other vestiges of the Prussian Second Empire past, such as the stature of Bismarck in front of the Reichstag. A comparison of the two photos reveals that the column now has four drums and has grown in height by about twenty feet. Hitler and Albert Speer wanted to restyle the area of the Spreebogen, the bend in the Spree river, in the image of Germania and planned to build an enormous Volkshalle (People's Hall); if this had ever been built (and the foundations were sunk in the Spreebogen just before the war), the Siegessäule would have been dwarfed alongside it. Instead, the column was rebuilt to boost the so-called East-West Axis and Victoria was turned ninety degrees so that she looked to the West. Against all expectations, the Siegessäule was still standing at the end of the war; camouflage netting had been draped from the top of the statue to the trees in the park so that it could not be used as a landmark by Allied bombers.

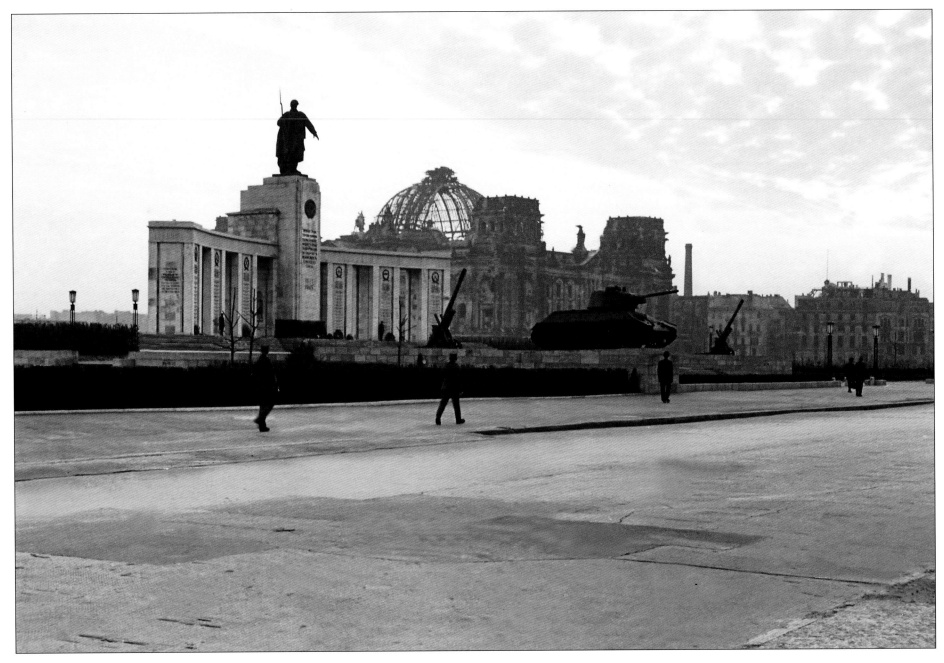

On Armistice Day, November 11, 1945, this Soviet war memorial was unveiled in the Tiergarten by Marshall Zhukov while the armies of all four allied powers paraded in front of the memorial. Two T-34 tanks and 152-mm howitzers used in the Battle of Berlin flanked the marble-clad memorial; the marble had been taken from the battered New Reichschancellery. Behind the memorial, over 2,000 Soviet troops were buried, including those who had died in the battle for the Reichstag. The ruins of the Reichstag were fiercely fought over in the final days of fighting in the Battle of Berlin. The famous picture of the Red Flag flying over a defeated Berlin was taken from the roof of the Reichstag, although this was a photographic reenactment taken after the fighting had finished. Two years later, the ruins of the Reichstag can be seen behind a deforested Tiergarten. The postwar winters were particularly hard for the Berliners, and most of the Tiergarten was cut down for firewood and then turned into a giant vegetable patch in the summer months.

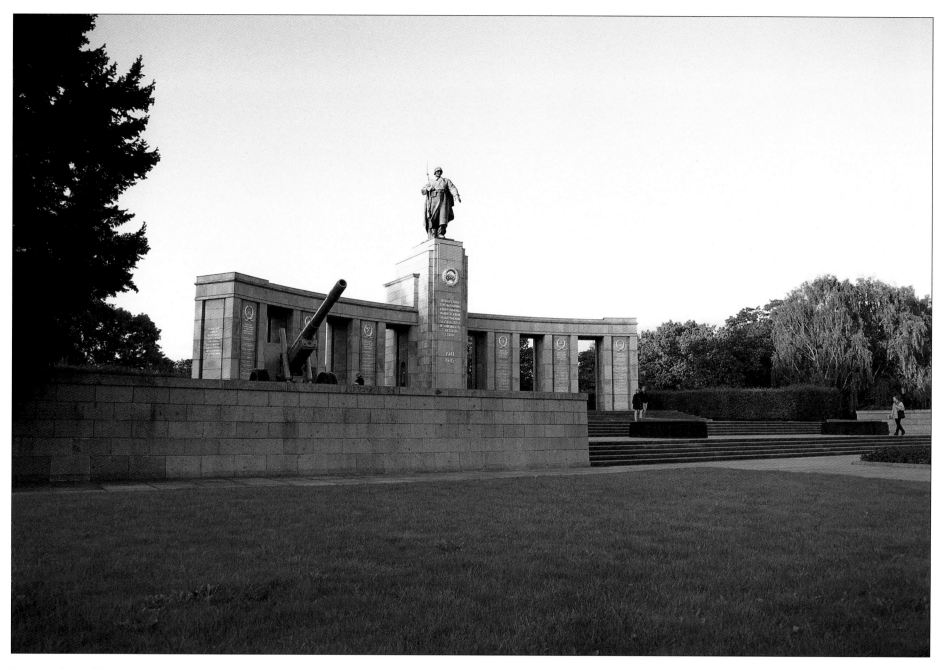

T-34 tanks and howitzers still stand on either side of the memorial. What has gone is the Red Army honor guard; since 1990, this has been the responsibility of the City of Berlin, and in the 1990s, the entire memorial was restored. The Tiergarten is once again a wonderful park; indeed, the replanting has been so successful, it is hard to believe that the park was almost entirely deforested less than sixty years ago. Today, this street is called Strasse des 17. Juni (Street of June 17); it is the continuation of Unter den Linden and runs from the Brandenburg Gate, a few hundred yards right of the memorial, to the west end of the Tiergarten at what is today called Ernst-Reuter-Platz. The street name honors the victims of the uprising in June 1953, when Soviet tanks crushed a revolt in East Germany against the Communist regime, killing between 150 and 200 people.

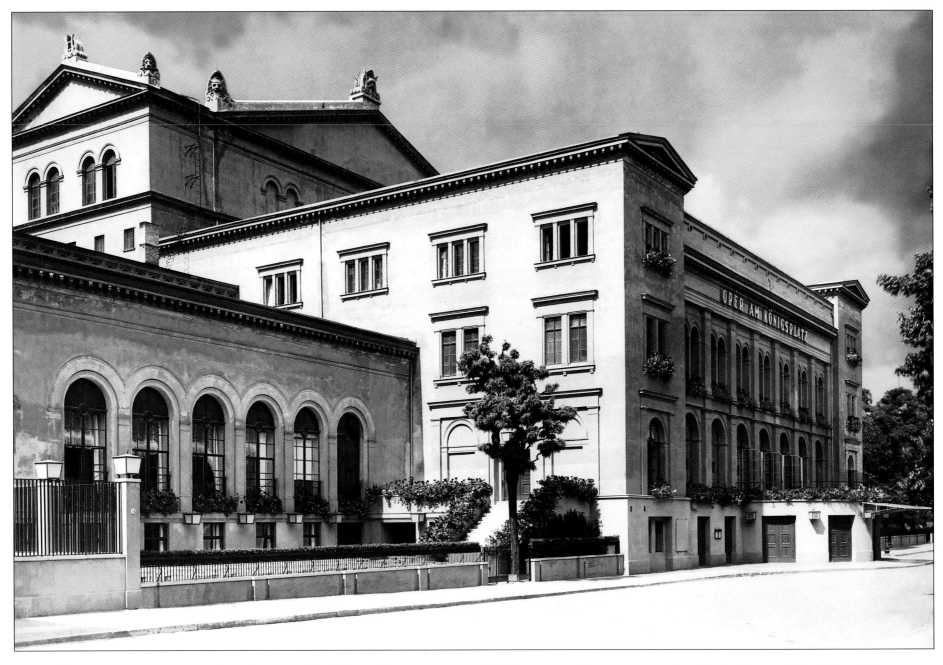

The Kroll Opera House was situated on the west side of Königsplatz, now Platz der Republik, and was opened in 1844. As well as a main hall seating 5,000, it had seventeen rooms for private functions. After a fire in 1851, it was rebuilt even more luxuriously. At the end of the nineteenth century, it suffered as the fashionable West End gained in prominence, and at the start of World War I, parts of the building were about to be demolished. However, the outbreak of war prompted a change of use to a temporary hospital. In the late 1920s, opera productions resumed under the directorship of Otto Klemperer, but in 1931, it abruptly closed for financial reasons. Following the burning of the Reichstag building in February 1933, the Reichstag met in the Kroll. The passing of the infamous Enabling Act, forced through Parliament by the Nazis on March 23, 1933, was stage-managed in this building, and allowed Hitler to create his one-party state. Seriously damaged in the war, the remains of the building were dynamited in the 1950s.

The former site of the Kroll is now a park, an extension of the Tiergarten. More interesting is the huge building behind the site, the New Chancellery, completed in May 2002. This is the work of a Berlin partnership, Axel Schultes and Charlotte Franke, who had previously won the contract to plan the entire central government area around the Reichstag and the Spreebogen. The New Chancellery lies in the middle of a mile-long, east-west swath of land, the "Band des Bundes," which runs from the Schloss Bellevue (the Presidential Palace), in the west to the new buildings for the Bundestag east of the Reichstag, thereby bridging former East and West Berlin. The design of the New Chancellery was closely associated with Chancellor Helmut Kohl. It was criticized by the opposing Social Democrats for its scale and dubbed the "Kohlosseum" by Berliners when it was completed.

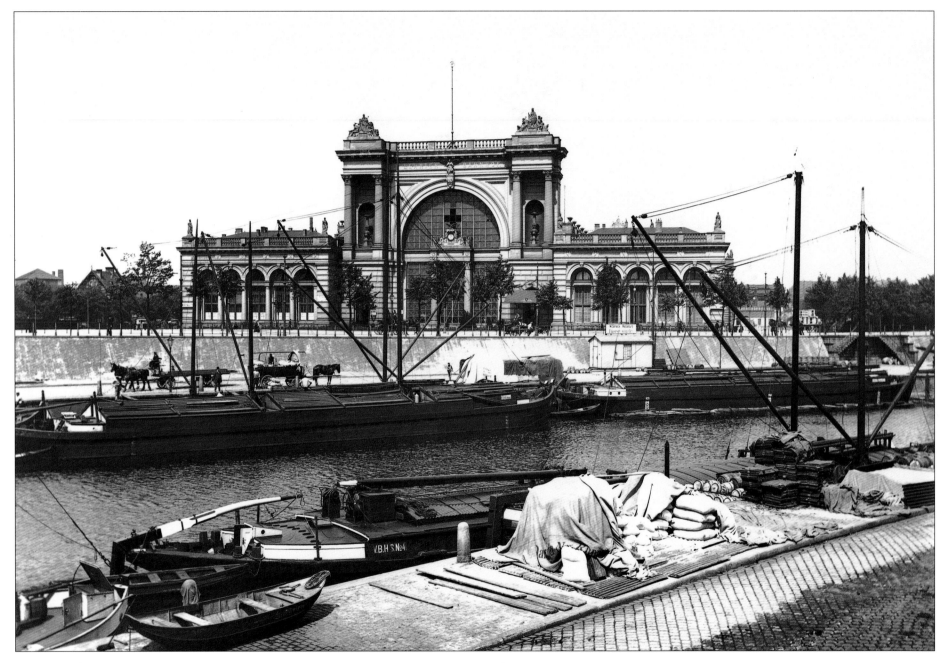

This photo shows how a hundred years ago the Spree was still a major factor in the life of the city; barges line both sides of the waterway in front of what looks like a palace but is in fact a railway station. The Lehrter station was built in 1871 in monumental Renaissance style by a company that was building a new line to Hannover. The station was so grand, in particular, the south front seen here, that it was called the "Palace." After 1884, all traffic to Hannover was diverted over the Stadtbahn (the overhead line that still runs east-west through the city), so a new purpose had to be found for this station; with the closure of the old Hamburg station nearby, the Lehrter became the new terminus for Hamburg and the northwest. In the late 1930s, the famous diesel-powered "Fliegende Hamburger" reached speeds of one hundred miles per hour.

The barges are gone, replaced with some street art called *Kuchenstück* (Piece of Cake), designed to draw the public's attention toward the entrance to a garden overlooking the Spree, laid out by the federal government as part of the greening of the new government quarter. In the distance is the largest building project in Berlin in the mid-2000s. The "DB" on the tower stands for Deutsche Bahn (German Rail); 500 million euros is being invested in the first-ever central train station for Berlin, a project first conceived in the early

twentieth century but thwarted by war and the subsequent division of the city. The new Lehrter-Hauptbahnhof will combine the existing east-west lines with a new north-south connection underground. Tunnels have been dug from the south side of Potsdamer Platz under the Tiergarten and the Spree (running right under the center of this photo) and will be served with underground platforms in the new station. Completion is forecasted for 2006, when Berlin is hosting the soccer World Cup.

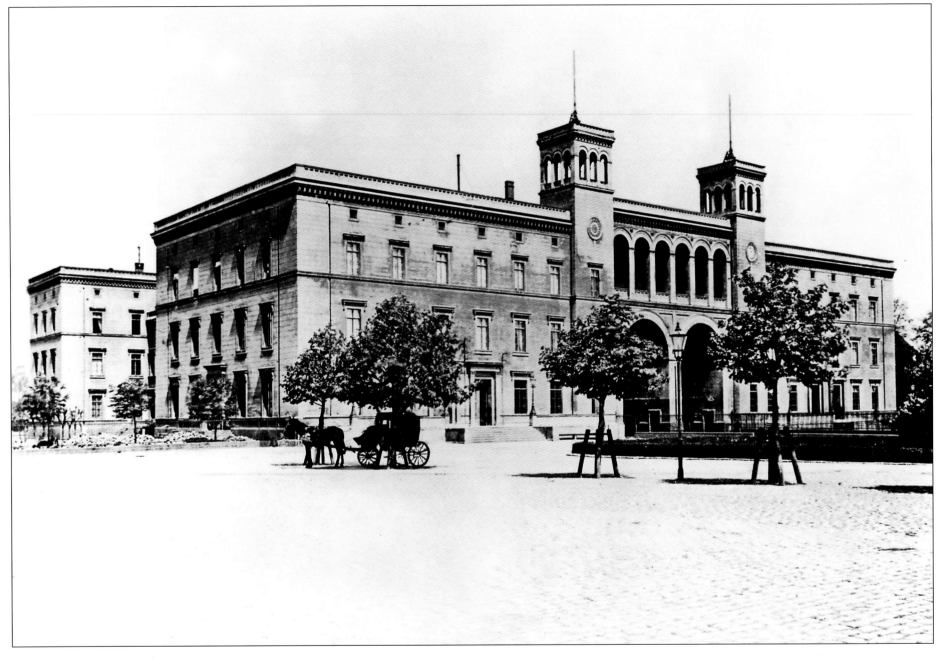

In 1838, the first train line in Berlin opened, connecting Potsdamer Platz with Potsdam itself. The Hamburger Bahnhof (Hamburg station) shown here was the third terminus to be opened, built between 1845 and 1847 by Friedrich Neuhaus and Ferdinand Holz for the new Berlin-Hamburg railway line. The station was situated on the northwest side of town, just outside the last set of city walls, because the railway builders were not allowed to build any of the terminals in the city itself. Just after this photograph was taken, the station was remodeled so that the trains did not pass through the two portals seen in the photo. In the 1880s, it was decided to run the Hamburg line out of the Lehrter station (see previous page) and the station was taken out of service, the buildings used as accommodation for station staff and as offices. In the early 1900s, the station was rebuilt as a railway museum but was severely damaged in World War II. It remained unused after the war until it was finally rebuilt in the 1980s as an exhibition space.

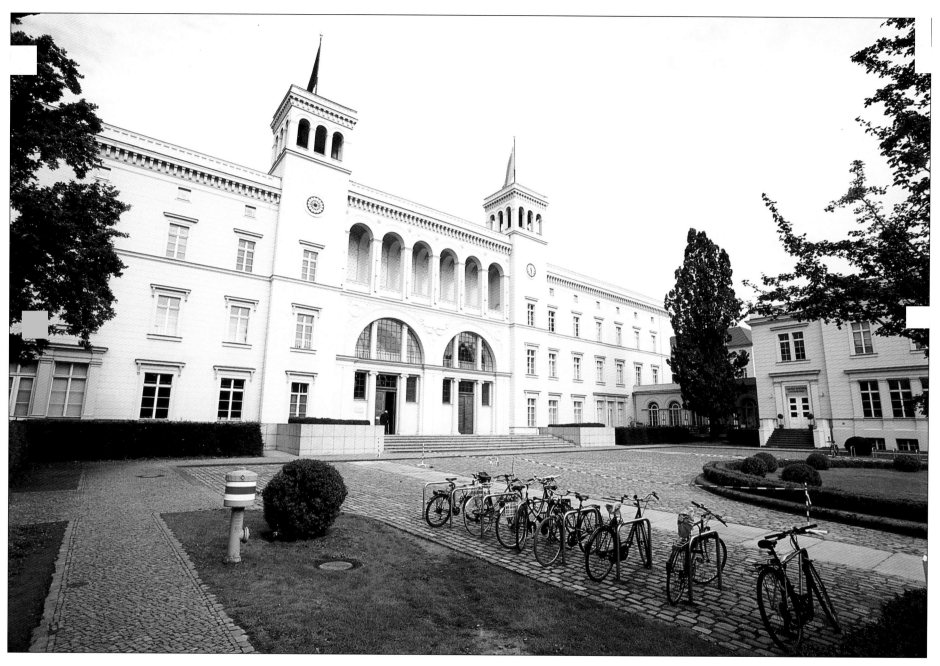

After reunification, the building was remodeled by Berlin architect Josef Paul Kleihues, and it opened in 1996 as the new permanent Berlin Museum of Contemporary Art, with works by Joseph Beuys, Andy Warhol, Cy Twombly, and many others, thanks to private collectors, such as Erich Marx, bequeathing works to the museum. The building has also been used as a showcase for major exhibitions, the first being of works by Sigmar Polke in 1997. In September 2004, the museum was extended with the addition of the Rieck building immediately west of the old station building (to the left of the photo). This was paid for by Friedrich Christian Flick, who has loaned his private collection to Berlin for seven years. The fact that the city of Berlin agreed to house this collection was controversial because Flick is the grandson of one of Nazi Germany's most notorious industrialists, who used tens of thousands of slave laborers in his coal mines and steelworks. The controversy did not prevent Chancellor Gerhard Schroeder from attending the opening.

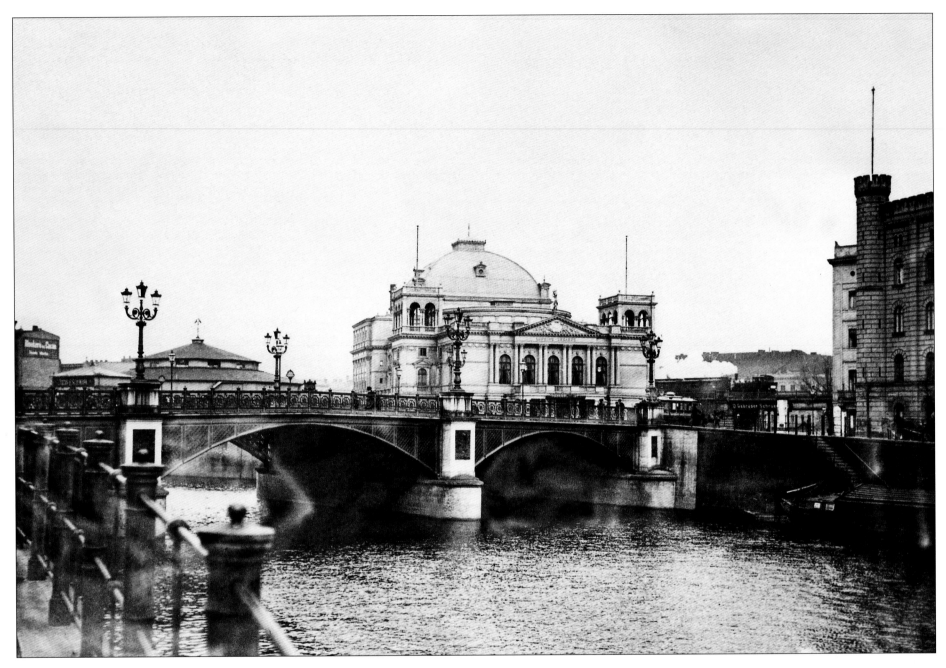

The Kronprinzenbrücke (Crown Prince Bridge) connected the west bank of the Spreebogen with the north side of Mitte. Replacing an earlier nineteenth-century bridge, this iron bridge was named after the crown prince and future kaiser, Friedrich I, when it was finished in 1879. It was destroyed in World War II and its ruins were removed in the 1970s. In the center of the photo sits the Lessing Theater, built in the 1880s. This was one of the most famous theaters in early-twentieth-century Berlin and was the venue for several premieres, including works by Gerhart Hauptmann, Arthur Schnitzler, and Carl Zuckmayer. It suffered the same fate as the bridge in the war. Behind the theater ran the Stadtbahn, the overhead railway connecting east and west; a steam train can be seen pulling carriages in this photo. To the left of the theater stands the low, squat roof of the Krembser circus; this was the heyday of the circus, before vaudeville and the movies drove it out of fashion later in the twentieth century.

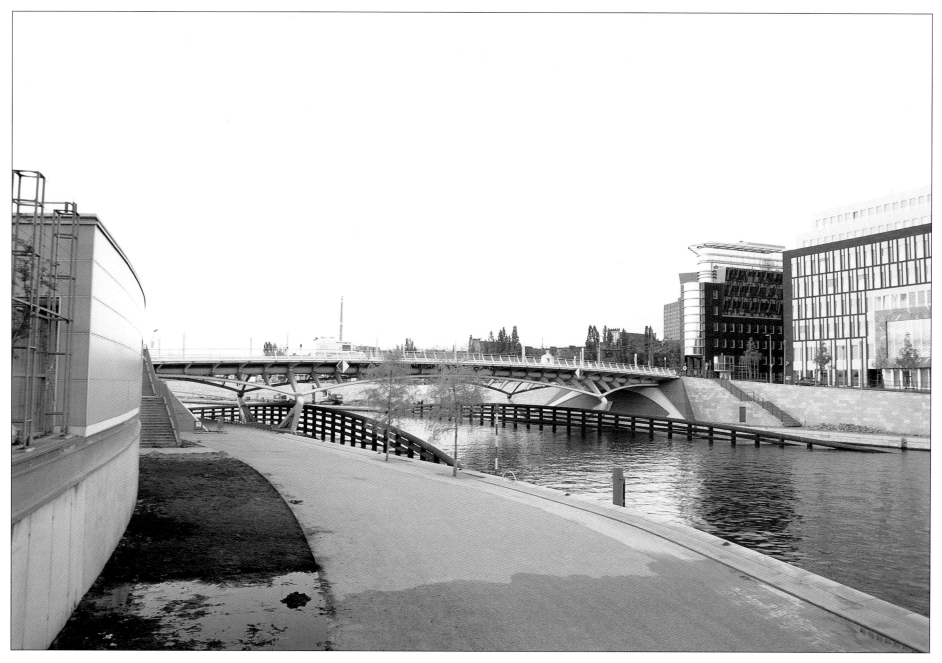

After the war, large areas of Berlin were blighted by the building of the Wall. Here the border ran along the near bank of the Spree, so there was little point in the Kronprinzenbrücke being reconstructed. Where water marked the boundary, there were always weaknesses. Soon after August 1961, when the Wall was completed, most people were escaping by crossing the waterways; indeed the first casualty on the Wall was someone who was shot and drowned in a canal on the border. As late as April 1989, three men succeeded in crossing the secure zone on the East Berlin bank and swam the Spree at this point; two were able to scramble out onto the West Berlin bank, but the third was grabbed by a boat hook wielded by East German police. The British Army's response to this was to install swimming pool–type ladders to ease the passage of future escapees. No trace remains of the ladders because the bank here has been completely rebuilt, and in 1996 a new bridge, designed by Spanish architect Santiago Calatrava, was added.

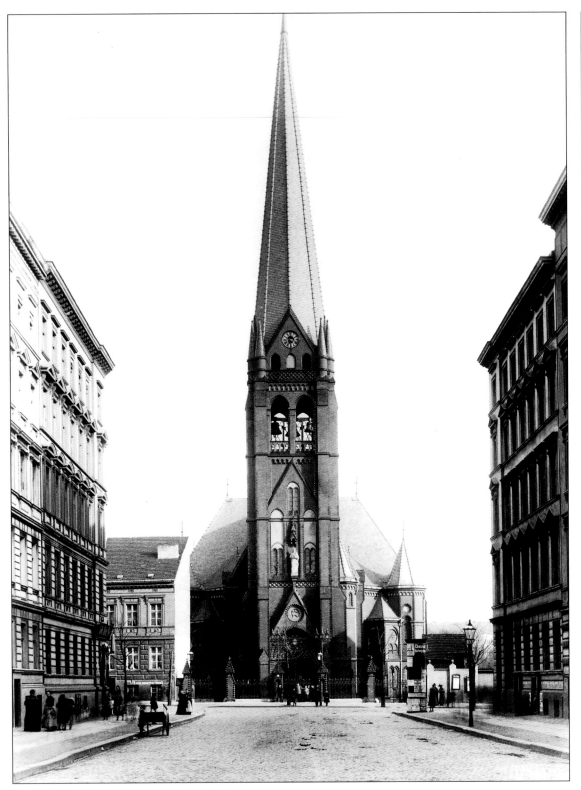

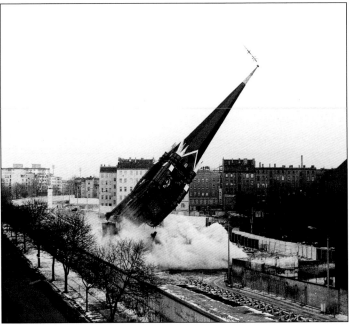

This view of the street front of the Versöhnungskirche shows the elegance of the tower of this 1890s-built church. The hall of the church was built in the shape of an octagon without pillars, allowing the minister to be seen by all of his 1,000-member congregation. The church was built on the northern side of the district of Mitte on the border with Wedding. Damaged in the war, it was repaired and reused from 1950 onward. In August 1961, the Wall was built right across the front door of the church (Wedding was in the French sector) and thereafter the church was sitting in the Death Strip. The above photo shows the tower coming crashing down in 1985 when the hall was cleared away and the tower dynamited. The double Wall structure can clearly be seen with a late vintage watchtower in the distance. It was under this part of the Death Strip that "Tunnel 57" was dug in 1964 from West Berlin into East Berlin; fifty-seven people, including the sister of the initiator of the project, succeeded in escaping to the West before the authorities found out about it and filled it in.

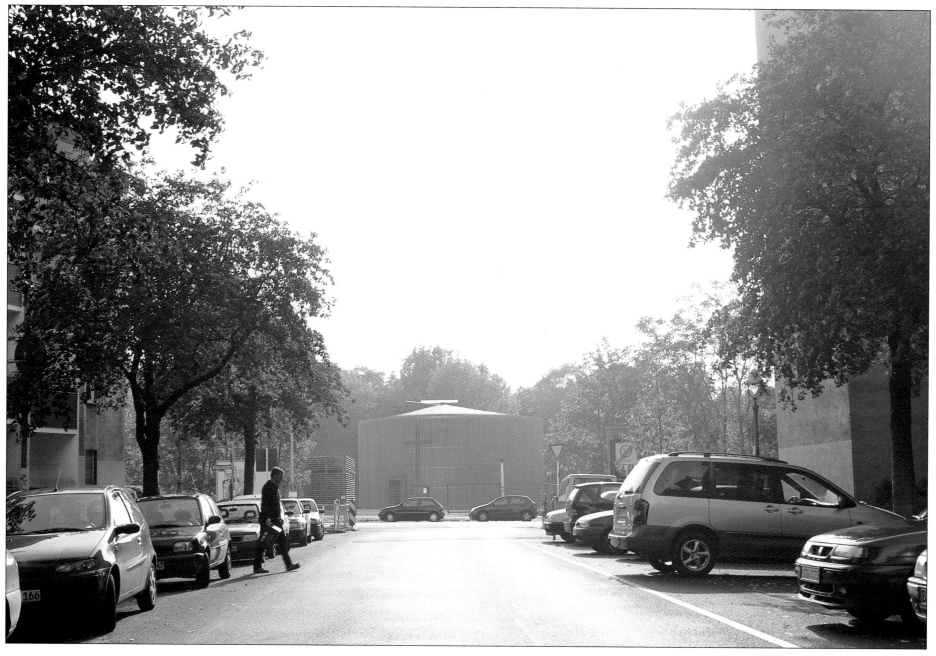

This view shows the low shape of the extraordinary new Chapel of Reconciliation. Dedicated in 2000, it sits on part of the site of the old church and has been built to complement the official Wall Memorial further down the hill on Bernauerstrasse. The Berlin architects Rudolf Reitermann and Peter Sassenroth won the contract to build the chapel and initially planned to use concrete and glass as the main materials in the construction. Such was the strength of feeling of the congregation against the use of concrete, given its association with the Wall, that the architects found a different solution: compacted earth. This was the first building in a hundred years to be built in Berlin in this way, and it is finished with a covering of strips of wood, as seen in this photo. In 1998 the official Berlin Wall Memorial was opened close by, having been listed as a historic monument in 1990. A 200-foot section of wall has been bracketed off with twenty-foot-high steel walls. Slits have been left in the inner wall so that visitors can peer into the Death Strip.

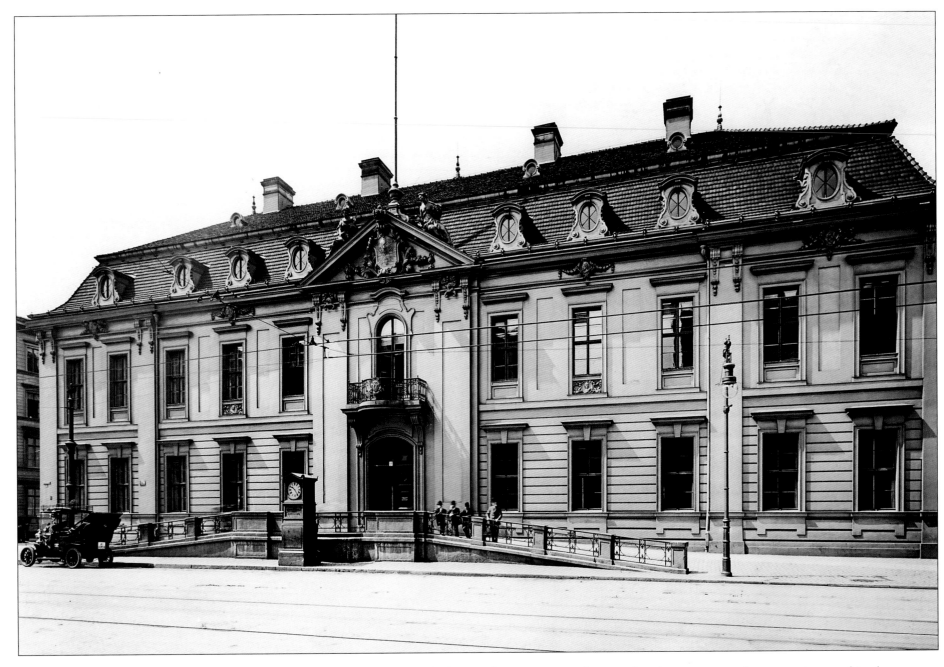

This baroque structure was completed in 1734 to designs by Philipp Gerlach, and it served as the first purpose-built office building in the city. Called the Collegienhaus, it provided accommodation for bureaucrats and a home for the Königlichen Kammergericht (Royal Superior Court). By the start of the nineteenth century, it was used exclusively by the Kammergericht, which was now independent of royal influence. By the time this photograph was taken, the Kammergericht was already outgrowing these premises, and in the early 1900s, a new court building was built in Schöneberg (pages 120–121). During World War II the building pictured here suffered serious damage; after the war, it was only thanks to the city conservators that the ruins were not cleared. In the late 1960s, it was rebuilt for use as the Berlin Museum in West Berlin, since the existing city museum was in East Berlin.

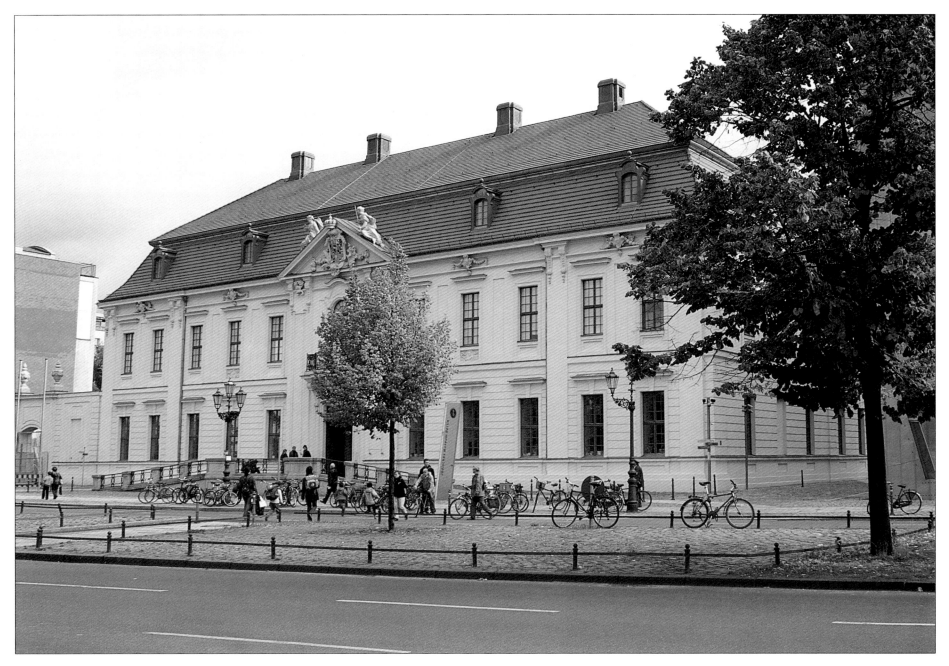

As early as 1971, the idea of a new Jewish Museum in Berlin was discussed and an association was founded in 1975 to promote the idea. With the help of the Jewish Department of the Berlin Museum, a site was found next door to the Collegienhaus, and in the late 1980s, an architectural competition was held for the design of the new building—won by Daniel Libeskind. On the right of the photo, it is possible to make out a small part of the extraordinary zinc-covered metal facade of the new building, accessed by tunnel from the old building. The museum performs two functions: it is a work of architectural sculpture, using voids, unsettling angles, and other devices to symbolize the tortured nature of German Jewish history; and as a museum, it displays the wonderful cultural and artistic legacy of the German Jewish community and charts the history of German Jews over two millennia.

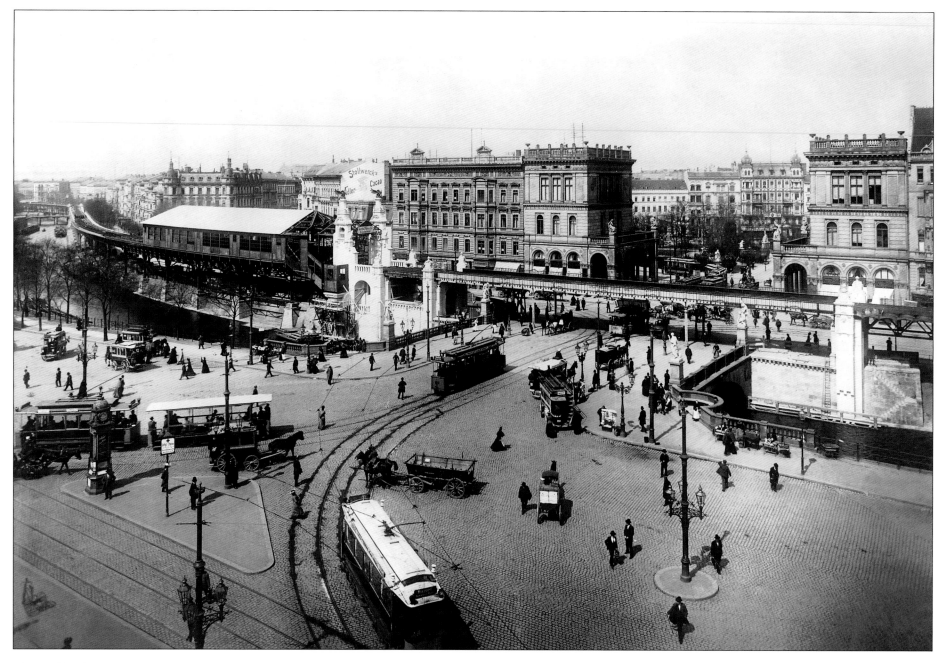

The Hallesches Tor subway station, under construction in 1901. It opened the following year and connected Warschauer Strasse to the east with Knie (today Ernst-Reuter-Platz). The Hallesches Tor, the Halle Gate, was removed in the late 1860s to make way for increasing traffic; it was one of fourteen gates in the last set of city walls. In the eighteenth century, there was a parade ground, the Rondell, immediately inside the gate; after the defeat of Napoléon Bonaparte, it was renamed Belle-Alliance-Platz in remembrance of the alliance of Prussia and Britain in the defeat of the French at Waterloo. On this side of the tracks, the Landwehr Canal can be seen. Constructed in the mid-nineteenth century, it connected two parts of the Spree, relieving congestion on the river. Crossing the canal was Berlin's widest bridge, decorated with allegorical figures of shipping, fishing, and fruit sellers.

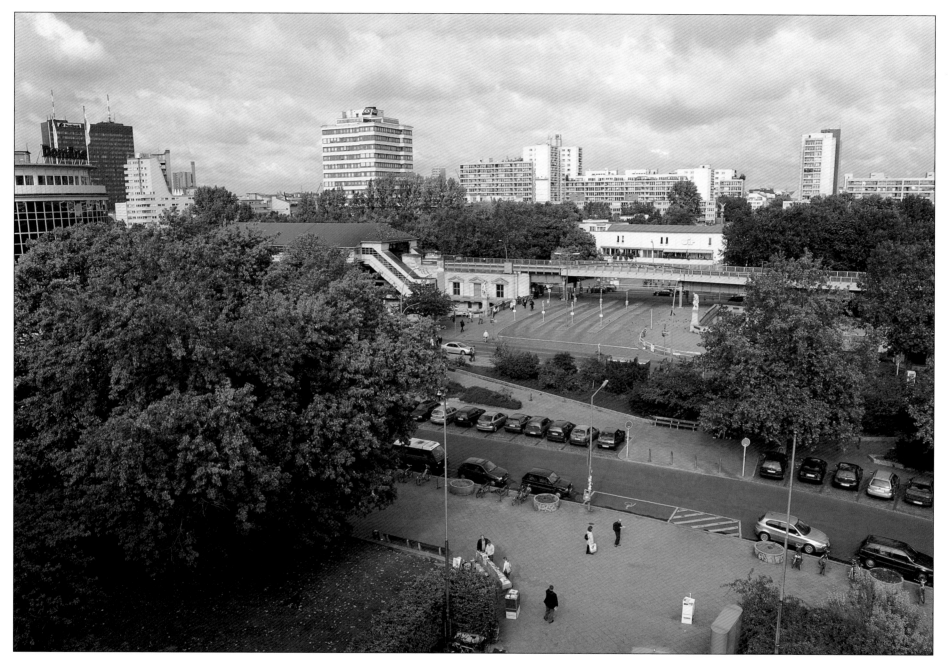

Belle-Alliance-Platz had the misfortune of being one of the targets for 937 bombers of the U.S. 8th Air Force (accompanied by over 600 fighters) on a clear day on February 3, 1945. It is estimated that 25,000 Berliners died on this one day alone, and all the railway lines on the south of the city center were put out of action. In a remarkably short time, the central overhead rail lines in Berlin were rebuilt and running again after the war. However, the whole of the south side of Kreuzberg needed to be rebuilt following this massive destruction, and Belle-Alliance-Platz was renamed Mehring Platz after Franz Mehring, the socialist writer and critic. The design of the area, built in circular form, was carried out by Hans Scharoun, and he retained the Peace Column in the center (just visible in this photo, a green winged figure on top of a red marble column).

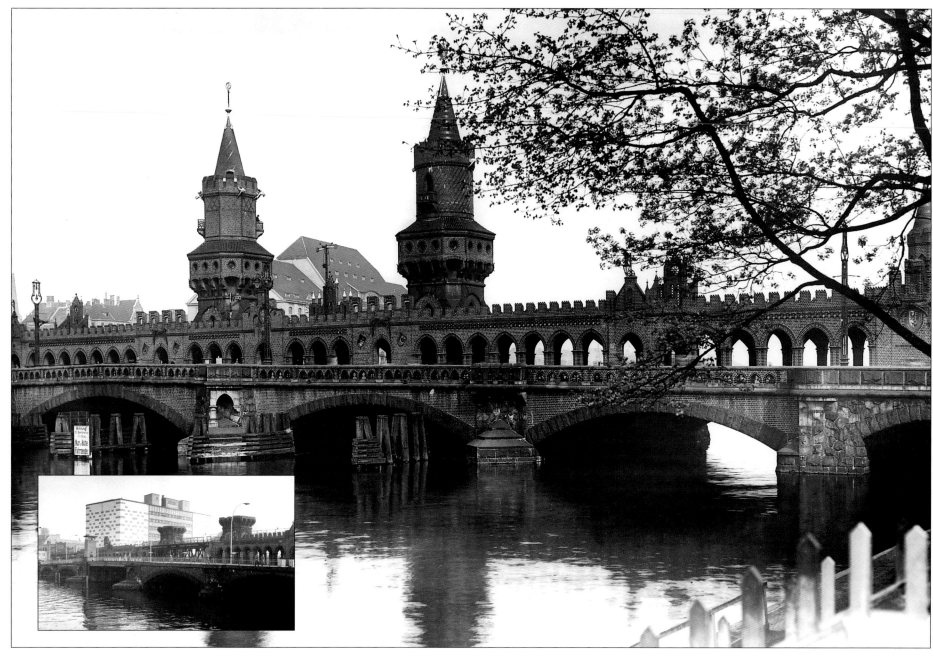

Unique among the Berlin bridges, the Oberbaumbrücke, seen here in 1925, was devised to carry a subway line, foot passengers, and road traffic. Although the bridge itself was finished in 1896, the subway trains only started to run in 1902. The name of the bridge comes from a former wooden toll bridge that raised taxes from boats plying the river and used a row of tree trunks to close the river at night. In April 1945, the middle section of the bridge was dynamited in an attempt to slow the Russian advance into the center of Berlin; the explosion also damaged the brick towers. Within six months a provisional bridge was made for the U-Bahn, and through the 1950s, the subway continued in use. In August 1961, the building of the Wall stopped all traffic. From 1963 onward, pedestrian traffic was allowed across the bridge, so long as West Berliners had the necessary visas to enter East Berlin. The inset photo shows a watchtower on the war-damaged bridge as late as March 1989.

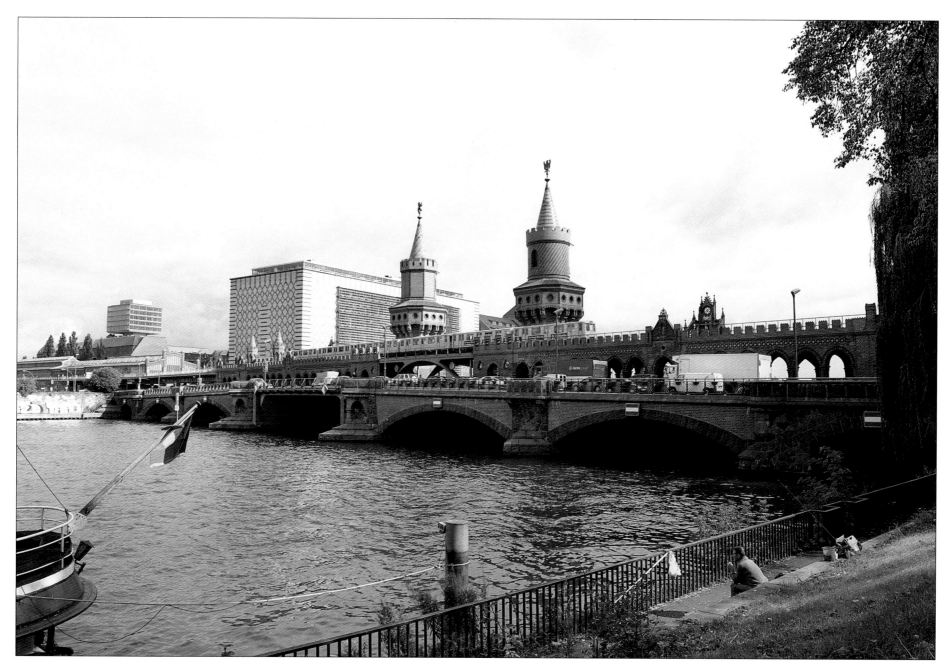

Today the bridge has returned to its early 1900s splendor, with the towers also having been rebuilt. Since 1995, the U1 line trains have been able to complete their journey to Warschauerstrasse and a yellow subway train crosses the bridge in the photo. Spanish architect Santiago Calatrava was responsible for reconstructing the middle section of the bridge, as well as building the new Kronprinzenbrücke. Behind the bridge, to the left, is the Cold Store, constructed in the late 1920s and enlarged in 1940. Inside the building and insulated with a thick layer of cork, perishables such as eggs, butter, and meat were stored for the markets of the city. In 2002, Universal Music converted it into their new German headquarters, providing offices and studios overlooking the river, while preserving the windowless facade with the patterned brickwork on the side facing the bridge.

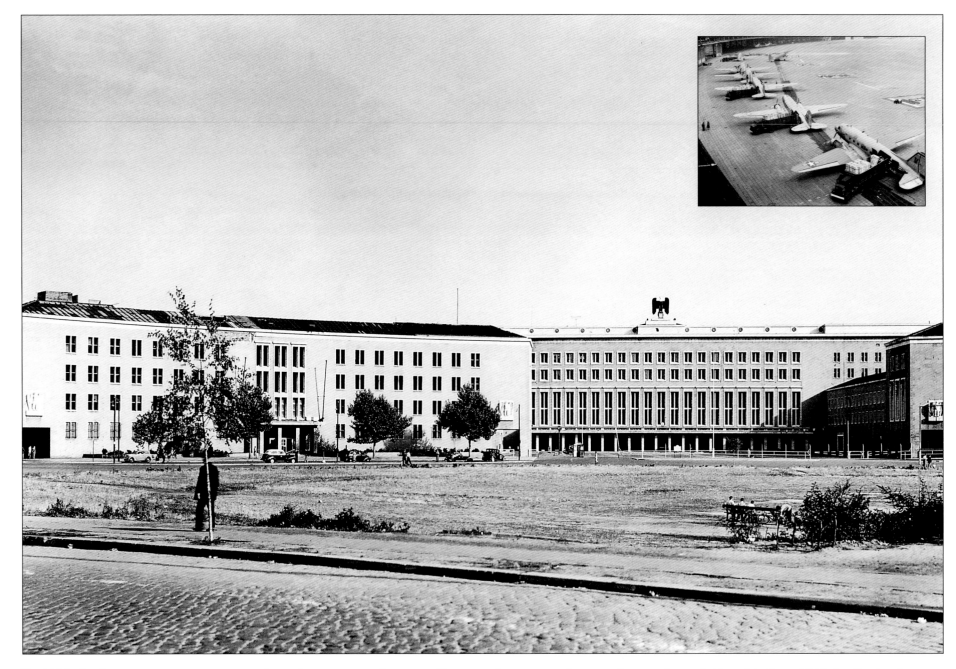

By 1925, the first airport was in operation here, but it was much too small for the grandiose ambitions of the Third Reich. In 1934, Ernst Sagebiel was commissioned by Herman Goering to design a building that would be able to handle up to six million passengers a year. Work was not completed at the outbreak of the war and was only finished in 1942. The main photo shows how the building looked from the street; it still has the Nazi eagle above the main door, even though the photo was taken in 1949. In July 1945, the American military took over the airfield and in June 1948 the Soviets began their land blockade of West Berlin. The Soviet blockade lasted until May 1949, by which time one and a half million tons of food and fuel had been flown in. The C-47s pictured (inset) on the hard standing during the airlift were the first transports used by the U.S. Air Force, but their limited capacity of just over three tons meant that they were soon replaced with C-54s (Skymasters), which could carry around ten tons.

Today the eagle is gone, and in the middle of the plaza in front of the building is the Airlift Memorial, a three-pronged concrete sculpture erected in memory of the seventy-eight crewmen and civilians who died during the airlift. The three prongs represent the three air corridors in the Soviet Zone, along which the Allied planes were forced to fly. The future of Tempelhof today is uncertain; its relatively short runways were one of the main reasons it was replaced as the main international airport in West Berlin by Tegel Airport in the mid-1970s.

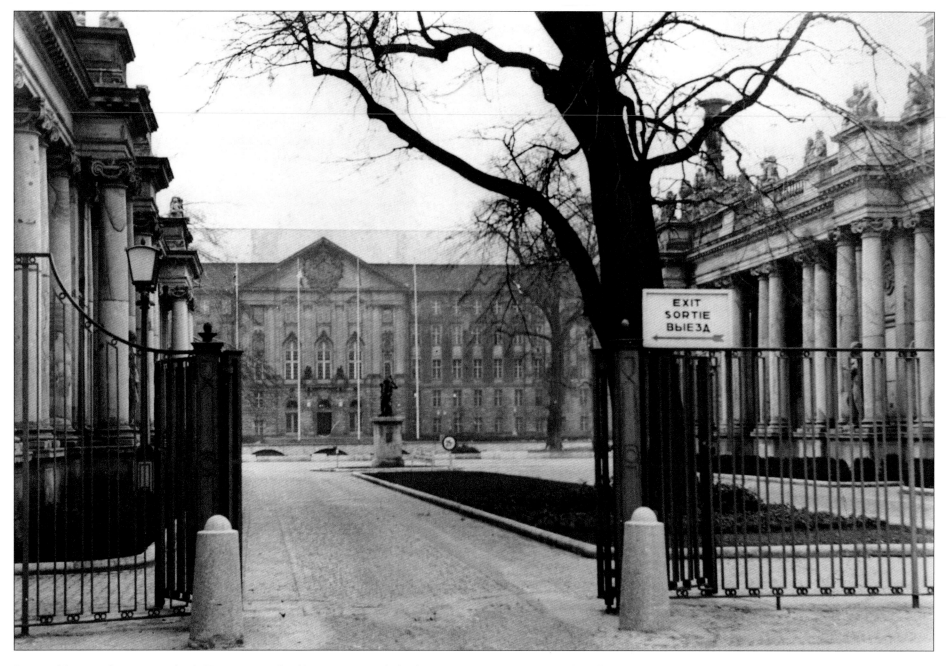

Pictured here is the purpose-built Kammergericht (Superior Court), built in 1913 to replace the old building on Lindenstrasse. This photo was taken in 1945 shortly after the Allied Control Council (ACC) had moved in, explaining why the sign says "Exit" in French and Russian also. The ACC was responsible for the Quadripartite Administration of all four zones of occupation (U. S., British, French, and Soviet) and of the four sectors of Berlin. In 1946, agreements were reached in the ACC regarding air traffic control over the Soviet Zone and Berlin itself, creating the Berlin Air Safety Center, also meeting in this building. The last meeting of the ACC took place on March 20, 1948 when the Soviets walked out of the meeting, after they had been excluded from discussions in London about the creation of a new West German state. Three months later, the Soviets were blockading West Berlin. The Berlin Air Safety Center, however, continued to operate here throughout the Airlift and indeed right up until reunification in 1990.

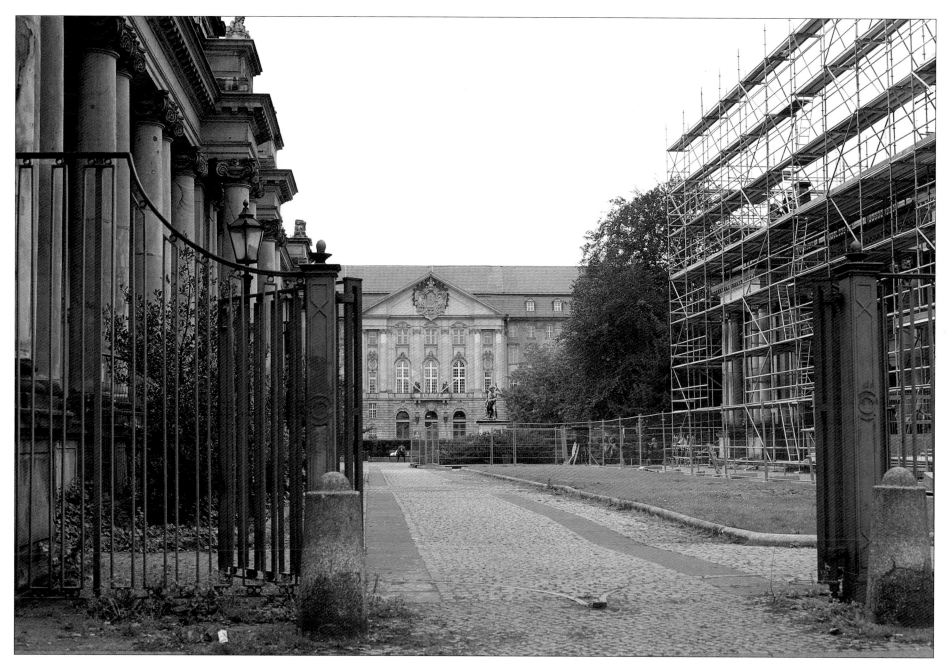

Scaffolding has gone up on one side of the Königskolonnaden (King's Colonnades), seen in the foreground, which were originally built in the 1770s by Karl von Gontard near Alexanderplatz. They were brought to this location in 1910 to allow the Königstrasse, now Rathausstrasse, to be widened. In 1991, the building behind was returned to the Kammergericht which moved back in 1997 after restoration work. Between 1945 and 1990, this building played host to the ACC (see previous page). During World War II, it housed the notorious Volksgerichtshof (People's Court). In 1942, Roland Freisler became the senior judge in a system which had comprehensively subjugated the law to the will of the Nazi state. Here, Freisler handed out many death sentences to those who had resisted the regime, including those who had attempted to assassinate Hitler on July 20, 1944.

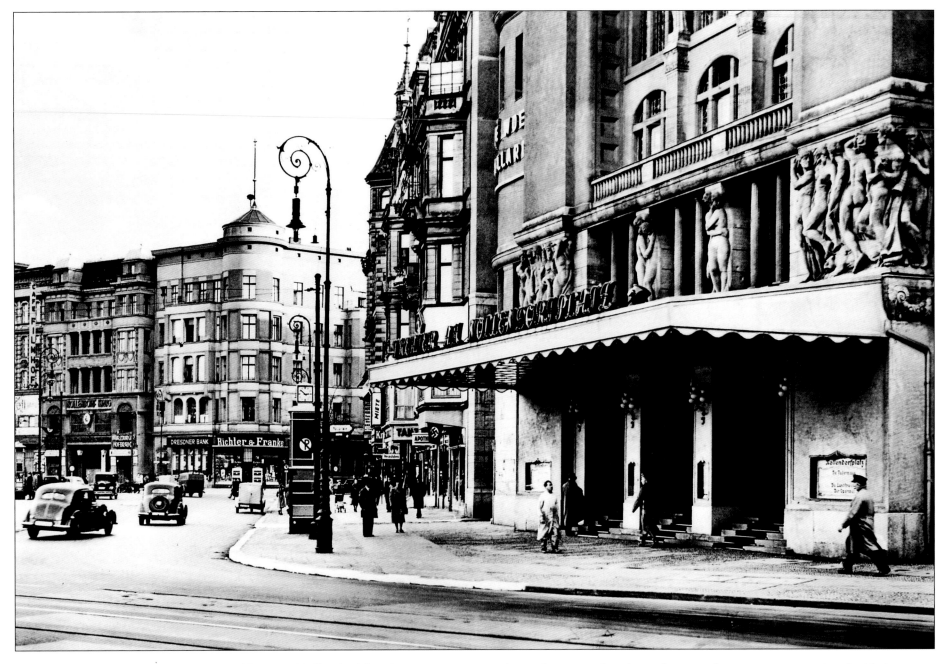

In 1902, the first subway station opened here on Nollendorfplatz (connecting Ernst-Reuter Platz and Warschauer Strasse), meaning that this area was between the "new west" and the old historical center. Within four years, the first theater, called simply the Schauspielhaus, had opened; it can be seen in the foreground on the right of this photograph taken in 1935. However, nothing stood still for long in pre-1914 Berlin, and within five years, the theater had been converted into a cinema. In the 1920s, it was once again used as a theater, and perhaps the most famous name associated with it was Erwin Piscator. He was a leading theater director during the years of the Weimar Republic, founding Das Proletarische Theater (The Proletarian Theater) in Berlin after World War I, an overtly political theater that was closed down by the police in 1921. In the late 1930s, the Nazis ran the theater to stage operettas, a far cry from the avant-garde nature of the Piscator productions from ten years before.

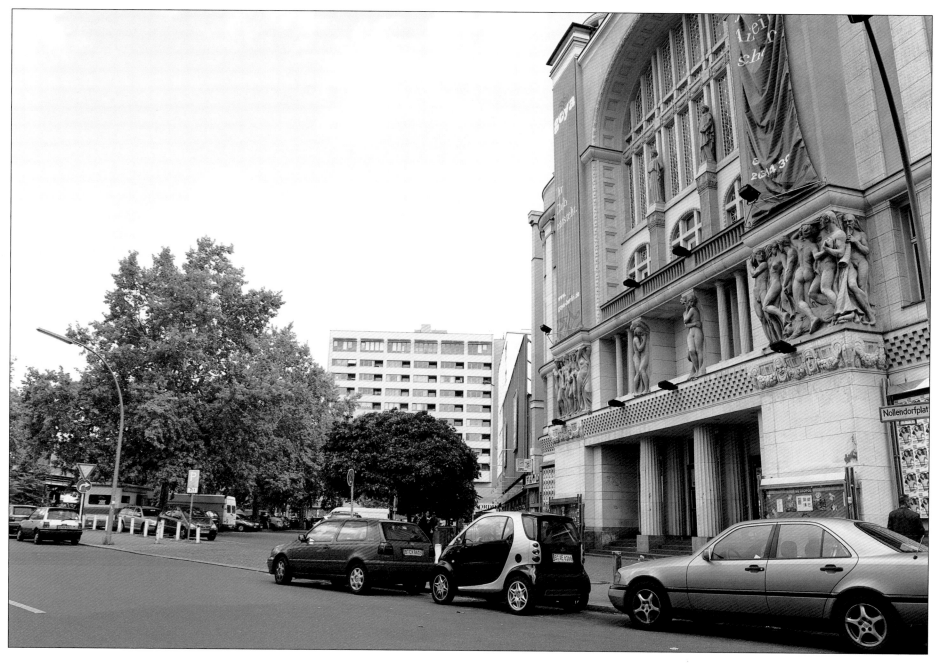

One of the few buildings on the square to survive the devastation of the war is the theater building, which is now called the Metropol and used as a dance club. This area of Berlin is today the gay district of the city, as it was in the 1920s. At the other end of Nollendorfstrasse, the road in the foreground, hangs a plaque in memory of Christopher Isherwood, the gay English novelist, who lived on this street. He wrote the stories on which the musical *Cabaret* was based and created the character of Sally Bowles.

This photo was taken when the Schöneberg Rathaus, the town hall, was nearing completion in 1915. It was built at a time when many of the new districts of Berlin were vying to create the most impressive district town hall. Heavily damaged in World War II, rebuilding work was carried out in the late 1940s. In 1950, the tower was strengthened so that a replica of the Liberty Bell could be installed. Every Sunday afternoon, the chimes of the bell could be heard on RIAS (Radio in the American Sector). With the creation of a civilian government, this building was chosen as the seat of the mayor of West Berlin and the location of the West Berlin parliament. In 1963, Mayor Willi Brandt invited President Kennedy to deliver an address in front of the town hall. Before 250,000 West Berliners, Kennedy declared, "as a free man, I take pride in the words 'Ich bin ein Berliner.'"

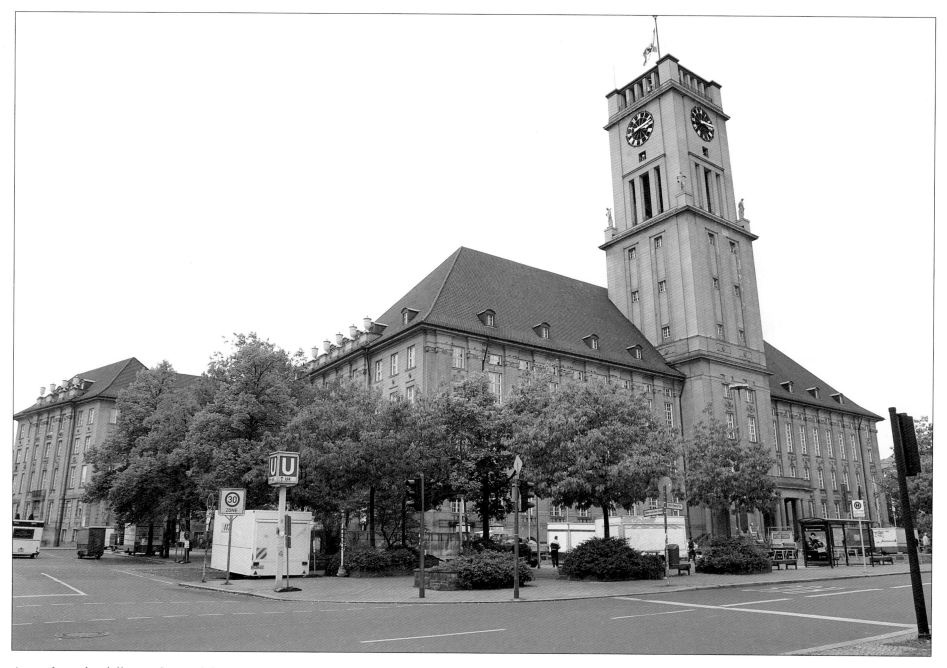

Apart from the different shape of the top of the bell tower, not much appears to have changed in this photo. The square was renamed John-F.-Kennedy-Platz after the president's assassination in the same year that he made his visit to Berlin. Today the building once again serves its original purpose as the district town hall for Schöneberg, the center of local political gravity having returned to one building in Mitte, the Rotes Rathaus (Red Town Hall). In 2001, the city forced various districts to come together to save costs and Schöneberg is now joined with the more southerly district of Tempelhof. Citizens of Schöneberg included film star Marlene Dietrich, born here and buried in nearby Friedenau Cemetery. Rudolf Steiner, social philosopher and father of anthroposophy, lived in Motzstrasse for twenty years, and Albert Einstein lived in the Bayerischer Viertel for fifteen years.

This photo from 1896 shows the Kaiser-Wilhelm-Gedächtnis-Kirche, or Memorial Church, from Hardenberg Strasse. It was built in Charlottenburg in the "new west" of Berlin with public funds to honor the memory of the last kaiser's grandfather, Kaiser Wilhelm I. Both the Kaiser and his wife Kaiserin (Empress) Auguste Victoria were present at both the laying of the foundation stone and at the church's inauguration in 1895. It was completed at a time when the district of Charlottenburg was fast expanding and there was an urgent need for new schools, hospitals, and churches. The original construction was impressive in size; it was designed in the neo-Romanesque style according to plans by Franz Schwechten. Intricate mosaics inside the church depicted scenes from the life and work of Wilhelm I. Between the wars, this was *the* church for society weddings. On the night of November 23, 1943, the church was destroyed during an air raid, the only remaining section being the ruins of the belfry.

After the end of the war and the division of Berlin, the Memorial Church found itself in the center of West Berlin. Today the ruined church stands at the very head of the Kurfürstendamm, Berlin's premier shopping street. In 1951, Egon Eiermann was awarded the task of designing a replacement church, but Berliners wouldn't allow him to sweep aside the ruins entirely; they felt passionate about retaining the broken west tower of the church. Such was the intensity of public feeling that Eiermann changed his designs to incorporate the ruins and they now house a Memorial Hall. The main section of the new church is in front of the ruined tower: the modern buildings are all constructed of honeycombed concrete sections into which blue glass bricks are set. The replacement bell tower is just visible behind the ruined tower. The Memorial Church is now viewed as a monument to peace and reconciliation and as a reminder of the futility of war.

This ornate building in the neobaroque style made cinematic history. It was completed as early as 1896. The architect, Franz Schwechten, also designed the adjacent Memorial Church. Inside, the building was lavishly fitted out to include seven staircases, three elevators, a mirror-lined winter garden, crystal chandeliers, marble steps, and silk wallpaper. It was here that the first German talkie made its debut in 1930 with the classic *The Blue Angel*, starring the then-unknown Marlene Dietrich. The film made Dietrich a star—she headlined as a louche nightclub singer who seduces and ruins a pompous schoolmaster. In 1943, three years after this photograph was taken, the building was bombed and burned out during an air raid. The exterior was rebuilt in 1948, and the building underwent several remodelings before the theater eventually closed in 1998.

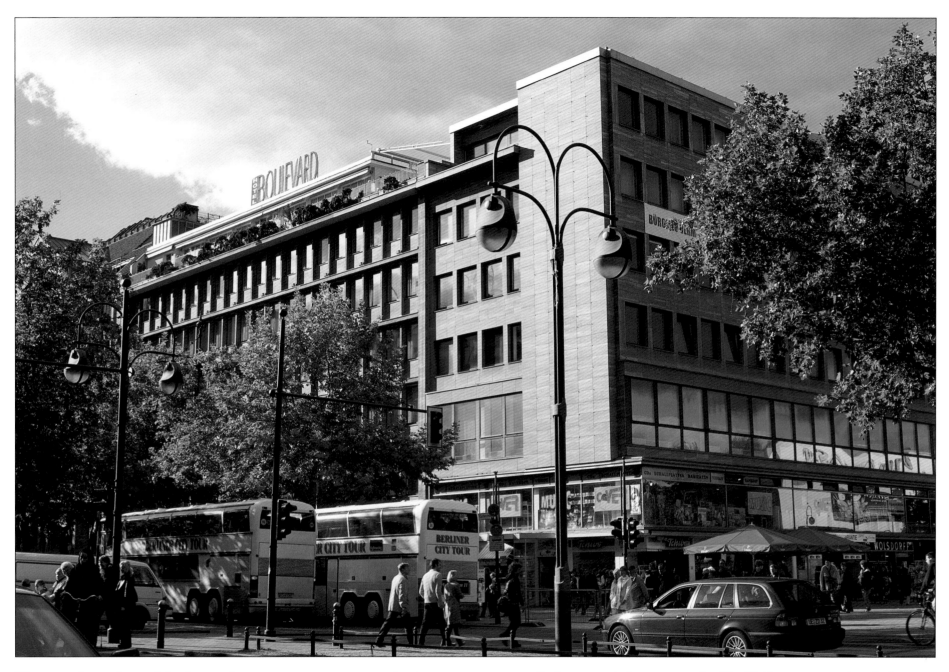

The magnificent foyer of the former theater survives, containing the box office and a spiral staircase, behind a bland postwar facade. Now occupied by a clothing store, it is one of many similar boutiques that line Berlin's famous shopping street, the Kurfürstendamm, which starts at the Memorial Church next door. The Kurfürstendamm, or "Ku'damm," as it is universally called, was first laid out in the 1540s by Elector Joachim II. During the late nineteenth century, Berlin expanded exponentially. The Ku'damm was widened after 1875 with the direct involvement of Bismarck's government, which was keen to create a boulevard to match the Champs-Elysées in Paris; the opening of the suburban train (the S-Bahn) in 1883 also spurred on construction. The Ku'damm soon became the new fashionable shopping area serving these districts.

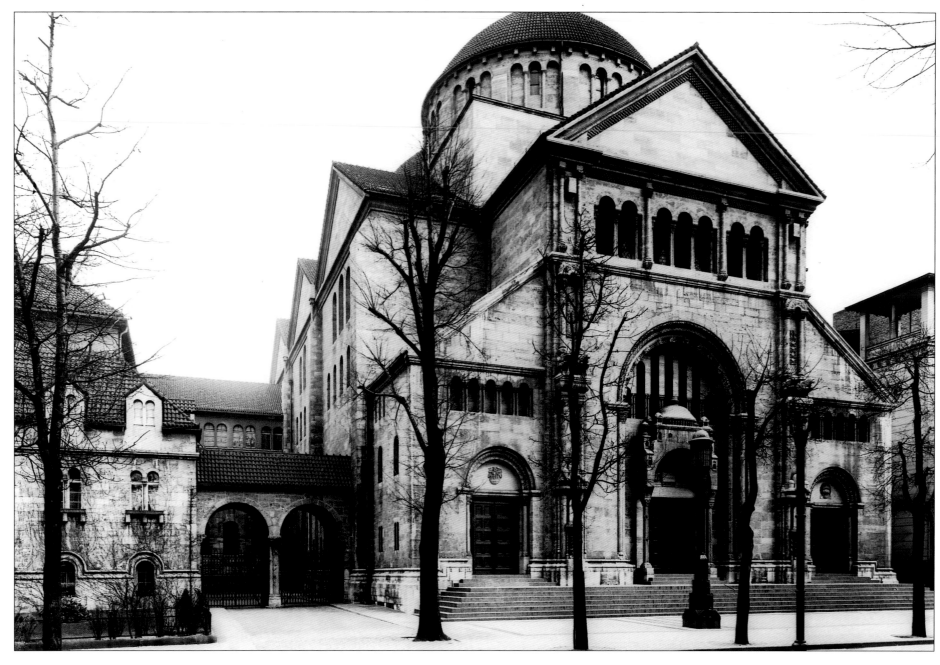

Finished in 1912, the Fasanenstrasse Synagogue was one of the grandest in Berlin, situated close to the Kurfürstendamm. Even before the Nazi dictatorship was set up, the streets around this synagogue witnessed violence that presaged the Holocaust. On September 12, 1931, some 1,500 Hitler Youth and SA men gathered in groups near the synagogue and attacked and chased members of the congregation as they left the synagogue on the second day of Rosh Hashanah (Jewish New Year). On the night of November 9, 1938, this synagogue, like most in Berlin, was set alight and severely damaged; Reichskristallnacht (Night of Broken Glass) was also marked by the arbitrary arrest of 20,000 Jewish men all over the country, including 6,000 in Berlin, who were taken to the Sachsenhausen concentration camp. Over ninety people died and many hundreds more over the following weeks. What was left of the buildings was seized by the government in 1939; these were further damaged in the war and the ruins were demolished in the 1930s.

Today the pilasters on the left and the stone portal on the right stand as reminders of the original building. In 1955, the site was returned to the Jewish community, and in the late 1950s, the West Berlin parliament agreed to finance the building of a new community center on the site. In 1957, the chairman of the West Berlin Jewish community, Heinz Galinski, laid the foundation stone, and the new building opened in 1959. In addition to a large library, the buildings also contain Berlin's only kosher restaurant, Arche Noah, and a hall that can be used for services. To the right of the main entrance is a prayer wall on which are listed the names of all the Nazi ghettoes and concentration camps, a reminder that 59,000 members of the Berlin Jewish community died in the Holocaust.

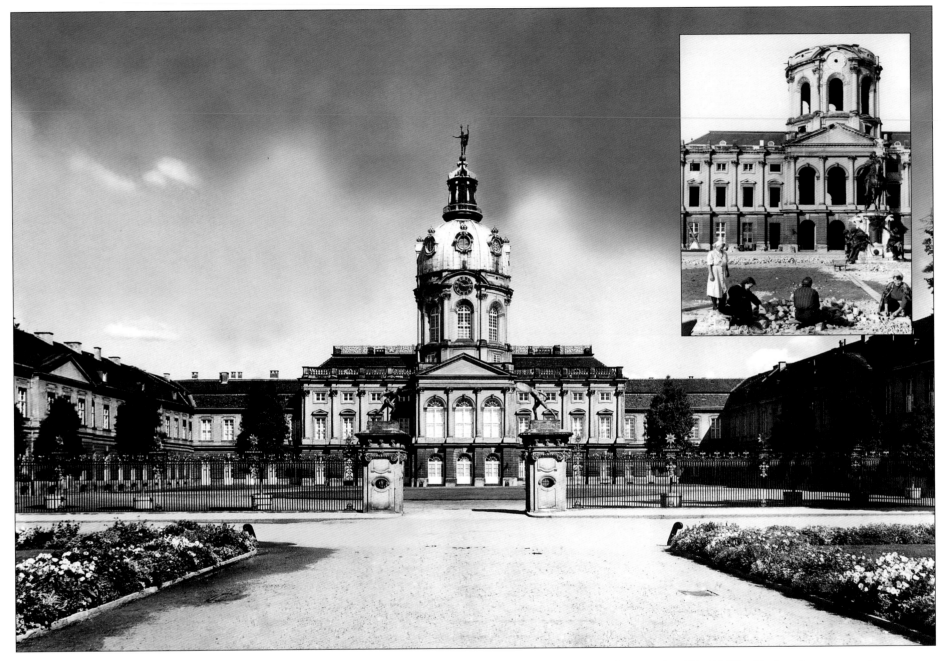

Built for Queen Sophie Charlotte in the late 1690s and early 1700s as a summer palace, this photo shows the original part of the palace, originally called the Lietzow Palace. The location was chosen because it was surrounded by forest and it could be accessed by boat, the Spree running next to the gardens behind. Sophie Charlotte was a lively, intelligent queen who unfortunately died young not long after the first part of the palace was completed. The king renamed it the Charlottenburg Palace in her memory.

Seventy-five per cent destroyed in World War II, the photo inset shows "rubble women" at work in 1953. Note also the bronze equestrian statue of the Great Elector by Andreas Schlüter in front of the ruins. Created in the 1690s to grace a bridge near the City Palace in the city center, it was removed by barge during the war for safe-keeping, but by accident the barge sank in the Tegel Lake on the west side of Berlin. Salvaged in 1952 by the authorities in West Berlin, it was given a new home in front of the palace.

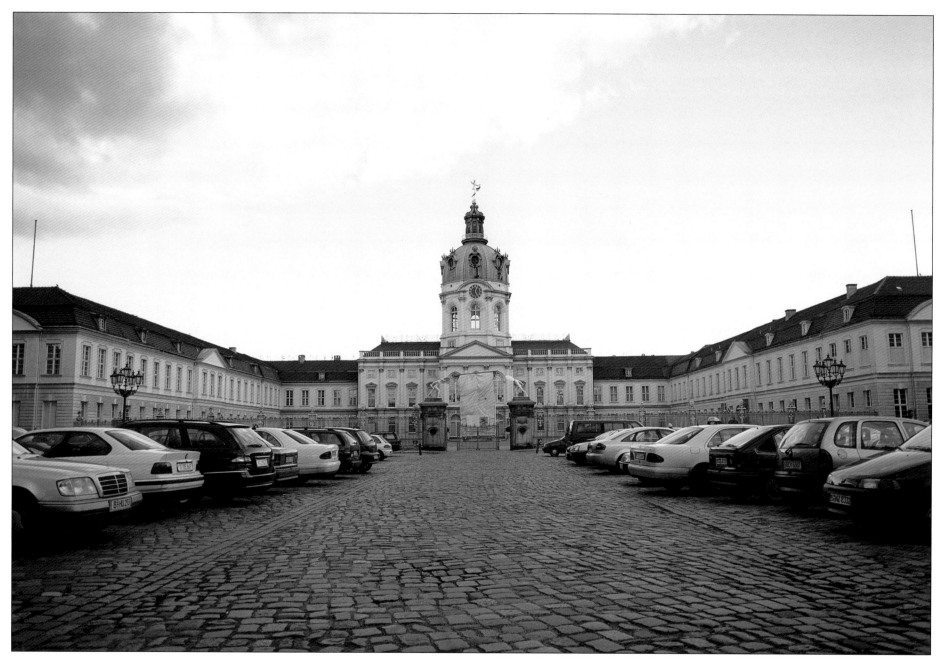

Although the reconstruction of the outside of the palace was completed in 1962, it was not until the late 1970s that internal restoration was completed. In the early 1990s, the city authorities in Mitte, where the statue of the Great Elector used to stand, requested that the statue be returned to them; the palace authority declined the request. In late 2004, the bronze statue was cleaned, which explains why it is covered in scaffolding in this picture. Today the palace and gardens are a major tourist attraction. Among the many interesting buildings in the gardens are the Schinkel Pavilion and the Mausoleum for Queen Louise and King Frederick William II; the sarcophagus of the young queen, carved by Christian Daniel Rauch in 1814, established the young artist's reputation—he later created the equestrian statue of Frederick the Great on Unter den Linden.

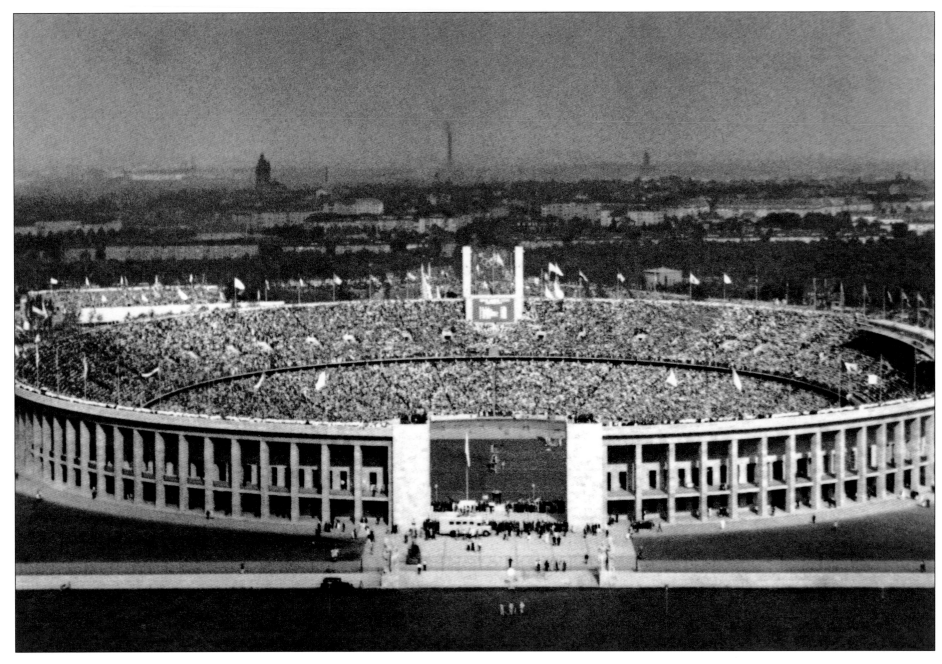

This 1936 photo of the Olympic Stadium was taken from the Bell Tower (Glockentürm), which stands directly west of the stadium. As early as 1906, this site was chosen for the building of a horse-racing track, which was then upgraded into an all-purpose stadium for the Olympics scheduled in 1916. Canceled because of World War I, the Olympics were rescheduled to be hosted by Berlin in 1936. Hitler and the Nazi leadership turned the games into a dazzling spectacle and introduced several innovations: this was the first Games to be started with the Olympic flame being carried from Olympia and brought into the stadium by a runner. In addition, Germany ended up winning more gold medals than any other nation. However, the games will always be best remembered for the extraordinary achievements of African American athlete Jesse Owens, who won four gold medals and shattered the myth of Aryan supremacy.

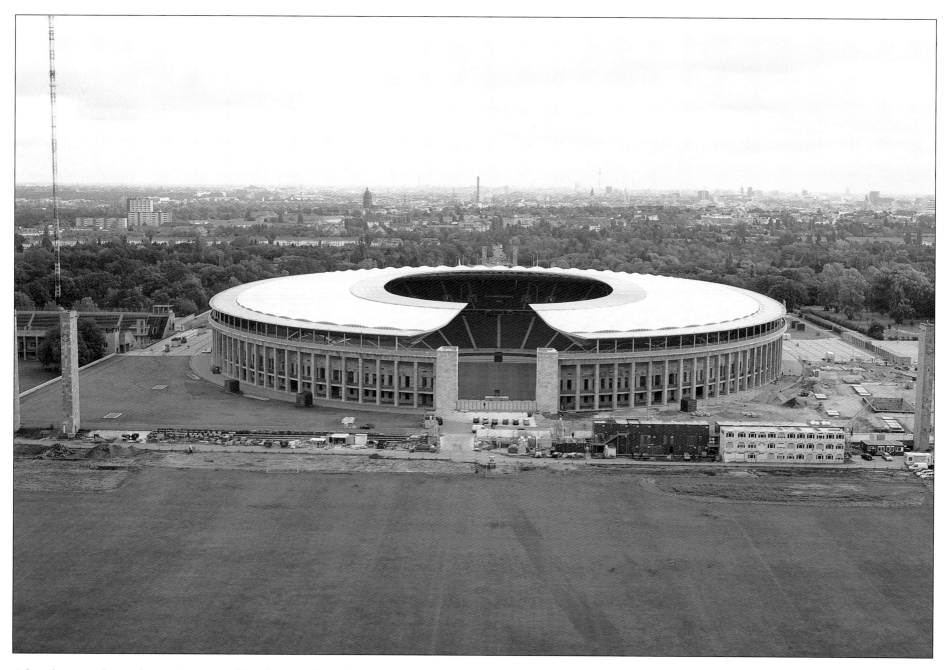

After the war, the stadium was repaired by the British and used intensively by British troops, as it was in the center of the British military area; indeed, the stadium was used as the British military headquarters. In recent times, it has served as home to Hertha BSC, the leading soccer club in Berlin. From 1999 to 2004, the building was completely reconstructed so that only the outside stonework is original; approximately $350 million was spent on the fabric of the building to modernize it and provide covered seating for all 70,000 spectators. During the entire project, Hertha was able to use it as a soccer stadium, thanks to a phased building program that took advantage of the summer months, which fall during the soccer off-season.

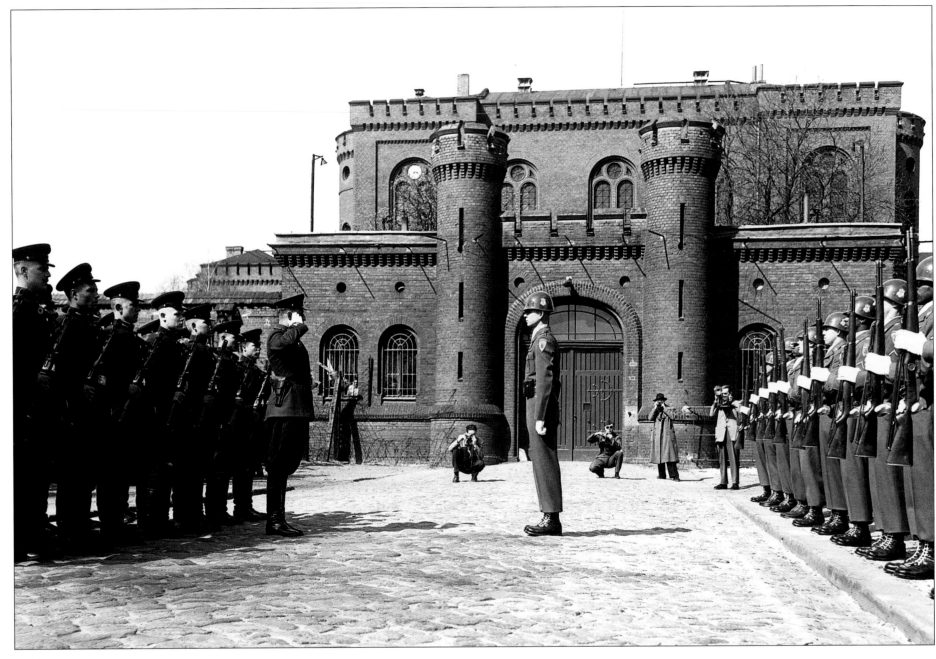

This nineteenth-century prison building would have left no mark on history if it had not been chosen for the imprisonment of the seven Nazi war criminals given sentences by the International Military Tribunal at Nuremberg in 1946. It was conveniently surrounded by military barracks and lay in the British sector of West Berlin. However, from the time the prisoners arrived in July 1947, it would be closely watched by all four wartime allies over the next forty years. This photo was taken on April 1, 1953, and shows the Russians handing off to the Americans; the guard rotated on the first day of every month on a rigid plan so that each of the four powers was in charge for three months every year. Of the seven prisoners, three were released on health grounds in the 1950s and three were released after serving their terms, including Albert Speer who was released in 1966 after serving twenty years. This left Rudolph Hess as the sole remaining inmate of a prison originally designed for 600 people, until he died in 1987.

Immediately after Hess's death, the old prison building was bulldozed for redevelopment and the remains were buried on the Gatow ranges—the reason for these precautions was that Hess had been an unrepentant Nazi and the authorities wanted neither the prison site nor its remaining bricks to fall into the hands of neo-Nazis. The site soon housed a shopping center for the British Army. Today, in former Britannia Center, as it was called in the days

of the British Army, now contains a Kaisers supermarket and other retailers. In 1994, all military personnel from the four powers left Berlin under the terms of the Two-Plus-Four Treaty signed in 1990, which allowed German reunification to take place, and the site reverted to the German government. Not surprisingly, the government sold this site to the private sector.

This photo shows the Outpost movie theater close to completion in 1953, before the name of the theater had been added to the facade. Nearly 900 American servicemen and their families enjoyed the latest releases here, and the theater remained solely for the military until 1994. Serving in the Berlin Brigade had its rewards: as well as the good facilities, there was a unique atmosphere in the frontier town of West Berlin. This was also enhanced by the warmth felt by the local population toward the Protecting Forces, as the Western Allies were called after the Berlin Airlift. At any one time, there would be approximately 6,000 American servicemen with 8,000 dependents in West Berlin. They had exclusive use of an eighteen-hole golf course, two movie theaters, plenty of stores, and many other facilities. As well as the fact that the West German taxpayers paid the bill for all the costs of the Western Allies, the West Berlin economy was also highly subsidized by West Germany, contributing to the good standard of living in West Berlin.

The Outpost closed for good as a movie theater with the withdrawal of the last Allied forces in 1994. By this time, the decision had already been taken to use the theater and the adjoining Major Arthur D. Nicholson Memorial Library as a museum documenting the presence of the Western Allies in Berlin. At the same time, the Russian military museum at Karlshorst was converted into a museum documenting Russian-German relations in the twentieth century. On the left, the port wing of an RAF Hastings transport aircraft used during the Berlin Airlift can be seen. The plane has recently been restored and sits next to the hut from Checkpoint Charlie. The Outpost building now houses a permanent exhibit on the immediate postwar years with special emphasis on the airlift, while the library opposite covers the events that occurred from 1951 to 1994. It is known as the Allied Museum.

In July 1945, President Truman was guest of honor at the inauguration of the U.S. Control Council headquarters pictured here; he was staying in Potsdam to attend the Potsdam Conference and fit this into the schedule of the conference. The buildings had been constructed as Luftwaffe barracks in the late 1930s on what was then called Kronprinzen Allee. The site covers more than eighteen acres, and being deep in the leafy suburbs of southwest Berlin, it suffered little damage in World War II. It was also in the middle of the American sector and therefore well placed to be the headquarters of the military governor and the Berlin Brigade. In 1949, the name of the street was changed to Clay Allee in honor of General Lucius D. Clay, the military governor in Berlin at the time of the Berlin blockade and the man who initiated the Airlift. When General Clay died in 1979, these buildings were renamed the Clay Compound in his memory.

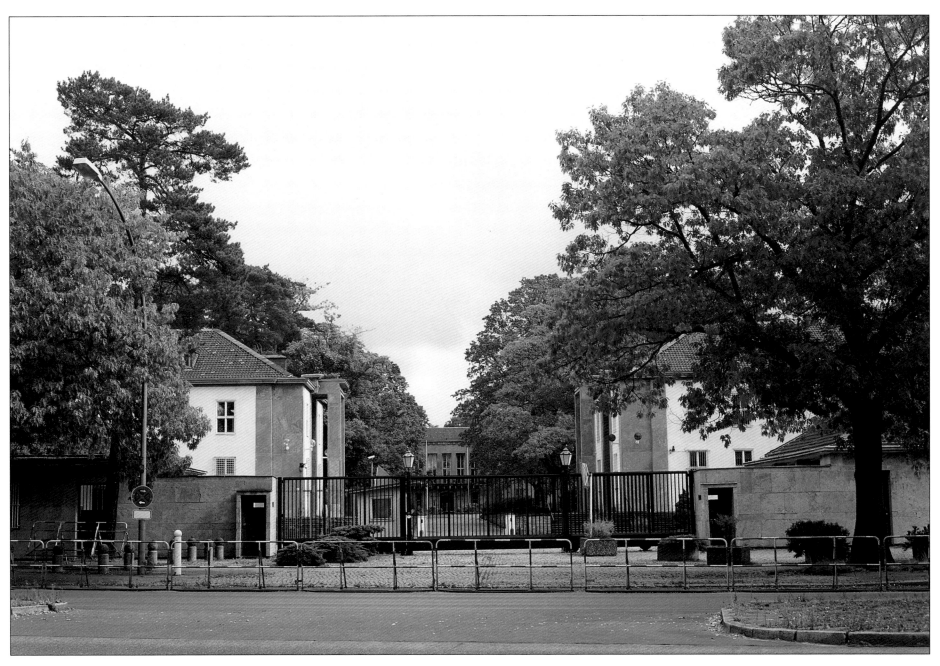

On the edge of the road, extra security barriers are visible, a sign of the continuing presence of the American Embassy's Berlin office. In 1994, the Berlin Brigade left this building for the last time, but the U.S. Mission remained and was boosted in 1999 when the embassy in Bonn, the former capital of West Germany, closed. Work is underway on the building of the new embassy building on Pariser Platz, but until this opens in 2008, the American Embassy will use these buildings, along with the American Embassy building on Neustädtische Kirchstrasse (the former embassy to East Germany). There has been much discussion about the future of this large complex when the American Embassy finally leaves. The Free University wanted to extend its campus here but could not raise the necessary $60 million for the buildings and their refurbishment. It is now likely that a Federal government agency, such as the Federal Border Guard (Bundesgrenzschutz), will use the buildings.

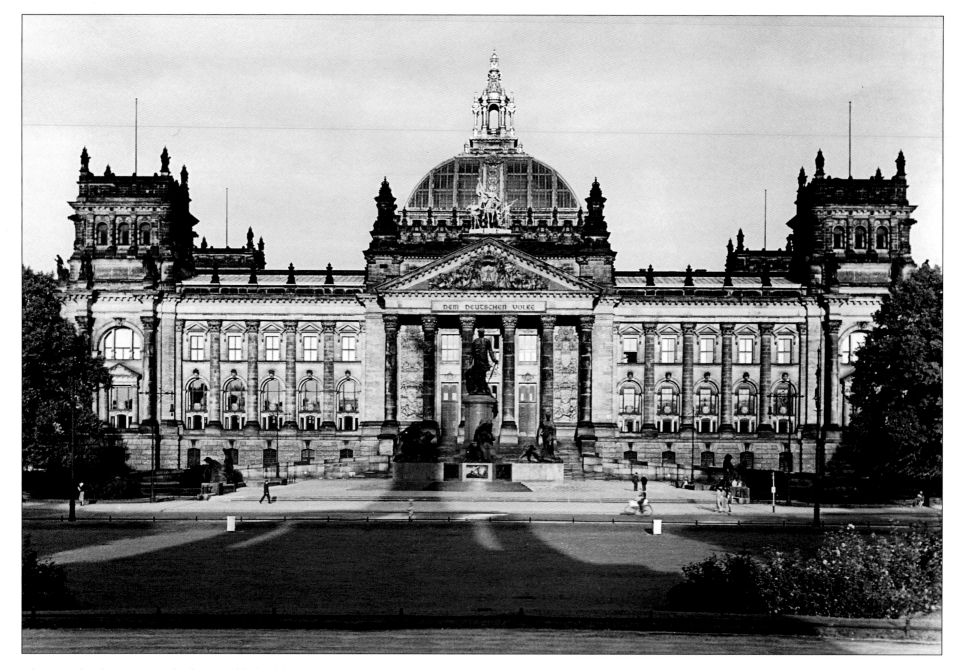

This was the first purpose-built assembly building for the German parliament, which convened in 1871. Construction started during the reign of the first kaiser and was completed in the era of his grandson, Kaiser Wilhelm II, in 1894. During the turbulent era of the Weimar Republic, it became the center of political attention until the republic started to unravel under the forces of extremism in the early 1930s. On February 27, 1933, four weeks after Hitler's appointment as chancellor and days before a vital general election, the Reichstag was gutted in an arson attack. The Nazi government blamed the Communists, but many believed the fire was arranged by the Nazis, who suppressed much of the evidence. The photograph dates from 1930.

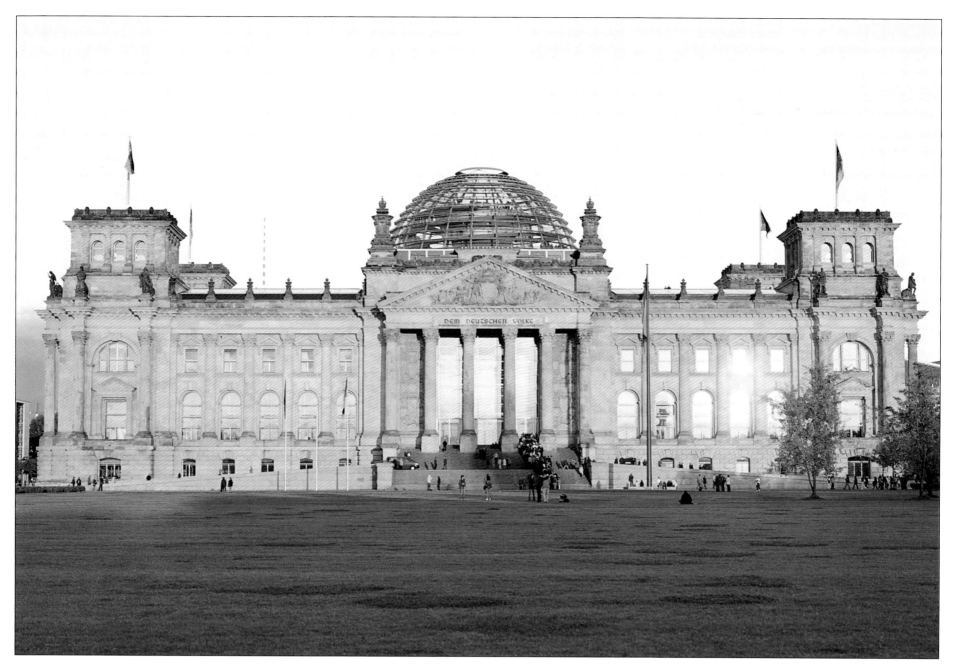

Since April 1999, the rebuilt Reichstag has once again been home to the German parliament, the Bundestag. After reunification in 1990, there was a symbolic meeting of Parliament here in December 1990, but the Bundestag and the whole machinery of government remained in the old West German capital of Bonn. The summer of 1991 witnessed a closely fought debate between the "return the capital to Berlin" lobby and the "keep it in Bonn" group. This was narrowly won by the Berlin lobby on the proviso that five of

the twelve ministries would keep their staff in Bonn even after the move to Berlin. It was also decided to rebuild the Reichstag as the main plenary chamber of the Bundestag. The ruined building had been reconstructed in the late 1950s but had been used mainly as a historical museum and did not meet the needs of a modern parliamentary building. Following a controversial architectural competition, the British architect Norman Foster won the contract and the work was carried out between 1996 and 1999.